THE PRINCIPLES OF INTERACTIVE DESIGN

LISA GRAHAM

CHAPTER 7
PROTOTYPE AND TESTING188

CHAPTER 8
ALPHA, BETA, AND FINAL VERSIONS
OF YOUR DOCUMENT200

GLOSSARY .207

INDEX .219

**PART 5
PUTTING IT
ALL TOGETHER**

PREFACE

IS THIS BOOK FOR YOU?

This book is intended as a resource for people who are interested in working with interactivity, but who have little or no prior design training. People who can benefit from this book are students designing their first multimedia project, entrepreneurs wanting to develop a web site for their business, or anyone who wants to expand their knowledge about design for interactivity.

This book is not a software or hardware tutorial. Hardware and software are constantly updated, become popular, and then become obsolete. Instead, this book is about the unique issues and basic principles of developing, prototyping, and testing interactive designs. Understanding these issues and principles will enhance your abilities to structure information, design visually interesting interfaces, and use the design process to fulfill your creative vision, no matter what hardware and software techniques you use now and in the future.

THE CONTENTS OF THIS BOOK

I have organized the information in this book in a logical progression. Each section builds upon the previous sections. The book is divided into five parts, each part with one or more chapters. Part 1 provides background information about interactive design and the interactive design process. Part 2 highlights the importance of defining your project, audience, goals, and planning the project through flowcharts and storyboards. Part 3 concentrates on the elements of interface design: navigation, interactive controls, resolution, layout, color, and more. Part 4 explores the resource media that can be used in a design, including typography, graphics, and animation. Part 5 explains the prototyping and final development phases of the design process.

I have included a number of features intended to make the information within each part and chapter more accessible for you. The introductory page of each part provides a brief introduction to the information contained within it. The first page of each chapter contains an objectives list that details the main information you will learn in that chapter. There are also numerous subheads throughout the text, and when important terms are first encountered and described, they are in **boldface.** I have striven to make the glossary and index useful resources. All of these features and resources are in place to help you target areas of particular interest to you. If you are new to interactive design, however, you will probably gain the most from this book by reading each chapter sequentially.

Every attempt has been made to make the information in this book as current, accurate, and detailed as possible in a rapidly changing and evolving field. Many of the topics are extremely complicated, however, and to discuss them in full detail would easily quadruple the number of pages in this book. Color on the computer, for example, has been (and no doubt will continue to be) the focus of entire books. Many of the other topics are equally as complex. When appropriate, I have included references to other books, magazines, and web sites you may find of interest. You will also find, scattered throughout the text, numerous tips, notes, charts, principles, and illustrations.

It is my hope that you will find the organization of this book clear and easy to follow, and the information easy to understand. A good understanding of the underlying principles of interactive design will enhance your ability to design clear, communicative, and exciting interactive documents.

ACKNOWLEDGMENTS

All illustrations in this book were created by Push Design Partnership, Blau Katz Kreativ, Curt Fain, Lori Walther, Leslie Nelson, and the author. Special thanks to Push Design Partnership for letting me peek at several of their ongoing interactive projects and enduring my never-ending questions. Without their help, this book would not have been possible.

And, of course, thanks to my parents, Don and Mary Graham, who have always known when to offer a supporting word and when to provide a swift kick in the seat of the pants.

The author and publisher wish to thank the following instructors who reviewed the manuscript and provided valuable suggestions to improve the content of this book:

Howard Austin
 Milwaukee Area Technical College

Lianne Judd
 University of Kansas

Randy Long
 Northern Oklahoma College

Paul Olsen
 Coastal Carolina University

Craig Polanowski
 Fresno City College

Starla Stensaas
 Dana College

Mick Brady
 Sage Junior College of Albany

BACKGROUND INFORMATION

In This Part:

CHAPTER 1
INTERACTIVE DESIGN AND THE DESIGN PROCESS

INTERACTIVE DESIGN AND
THE DESIGN PROCESS

OBJECTIVES

- ☑ To learn what is interactivity and interactive design
- ☑ To gain an understanding of the role of an interactive design
- ☑ To understand the importance of the interactive design process
- ☑ To learn how to think strategically about the steps in developing your project

INTERACTIVITY DEFINED

Interactivity is the combination of different types of media into a digital presentation that allows the user some degree of interaction. Some of the media used in digital presentations are typography, graphics, animation, video, sound, and virtual reality (a simulated environment with pictures, sound, and sensory input that surround and respond to a viewer's actions). If you have used an ATM, played a computer game, looked up information on a multimedia CD–ROM encyclopedia, e-mailed a friend, or visited a web site (see Figure 1–1), you have experienced the power of interactivity.

One of the reasons why interactivity is so powerful is that many traditional activities such as reading, talking, or watching a video can now be performed on the computer. You can read a multimedia book onscreen that combines text, animation, and sound to tell the story. You can log onto the Internet and talk to people halfway around the world in an online chatroom. You can even choose to download and play video on the World Wide Web. These new interactive experiences do not replace the traditional activities but, instead, offer individuals more options in how to access information.

Interactive presentations are also powerful because they allow the designer to combine information from previously separate media (text from books and moving images from video, for example). This new combination of the information can change the audience's understanding of the story. For example, a multi-

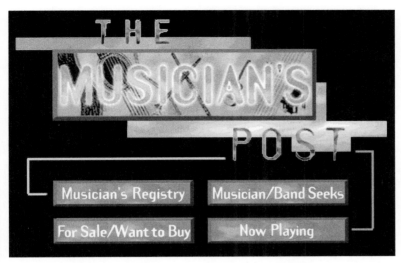

Figure 1-1 Online interactive documents such as this web site often include graphics, text, illustration, and hyperlinks (specially marked text and images that lead to other web pages or web sites). *(Courtesy Dimitrius Samudio.)*

media document blending text from the ancient Greek poem *The Odyssey* with a video sequence of astronauts bouncing across the surface of the moon may inspire the user to form new and unique thoughts and impressions. Interactivity offers unusual communication opportunities. Entrepreneurs are rushing to capitalize on this richness of sensory data with interactive documents ranging from banking programs to architects selling residential housing plans to potential clients (see Figure 1–2).

Why Is Interactivity So Appealing?

One answer might be that interactivity offers new opportunities of control to the audience. In older media such as film, the audience observes the story line but cannot alter the outcome of the story. In contrast, the audience of an interactive document can actively modify the speed, pacing, and order of information— exploring or ignoring information, depending on their individual inclination. Therefore, it is the power of individual choice that makes interactivity so engaging.

Figure I-2 A screen from *Personalized Architectural Walkthroughs,* a multimedia document created to show clients 3D views of selected residential housing designs. *(Courtesy Curt Fain.)*

WHAT IS INTERACTIVE DESIGN?

Interactive design is the meaningful arrangement of graphics, text, video, photos, illustrations, sound, animation, three-dimensional (3D) imagery, virtual reality, and other media in an interactive document. A simple interactive design could be an all-text web page with a few links to other web pages (see Figure 1–3). A more complex interactive design could be a multimedia document that uses typography, graphics, sound, and video with lots of interactive controls like buttons and **links** (connections between content or documents that, when clicked, bring that information to the screen) (see Figure 1–4). Whether simple or complex, the best interactive designs present the message clearly, have an easy to understand and navigate **interface** (the visual layout of content and interactive controls that lets the user interact with the program), and function well on the audience's **playback technology** (the hardware and software used to play the interactive document).

Basics of Winemaking

This simple online guide is intended to provide introductory information to you about winemaking. As your winemaking experience grows you will undoubtedly wish to continue to research information about this fascinating hobby. A trip to the public library will reveal many well-informed books on the subject. Also included at the bottom of this list is other online sites about wine and winemaking.

- Supplies
- Fermentation
- Fruits You Can Use
- Plants to Avoid
- Measurements
- Other Sites

Figure 1-3 An all-text web page with simple links.

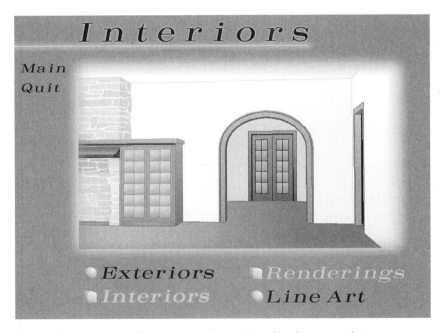

Figure 1-4 A screen from a complex multimedia document that uses typography, graphics, sound, and interactive controls. *(Courtesy Curt Fain.)*

> **NOTE**
> Links are one of the features of the World Wide Web that make it easy to find more information or navigate the Internet. Links can be hypertext or images. They are useful in that they let you access additional information in the same web page or connect to another web page on a different computer in a few seconds.

WHAT DOES AN INTERACTIVE DESIGNER DO?

Interactive designers organize the content, design the interface, and work with the hardware and software to develop the project. Their primary job is to design a document that communicates the message clearly.

On projects with a small staff, they serve as a jack-of-all-trades: meeting with the client; researching hardware and software options; finding, licensing, or designing images and icons; scripting interactive controls; constructing the prototype; testing the prototype; and in general, participating in all phases of the project. On projects with a larger staff, the interactive designer may work primarily on designing the images, icons, interface, and constructing the prototype. Interactive designers should have a good technical background and a strong sense of visual style.

■

Successful Interactive Designs Depends on . . .

> Clear presentations can speed communication, while unclear or complex presentations hinder communication.

❑ simple, clearly defined goals;
❑ a strong message;
❑ an intuitive interface;
❑ a firm knowledge of effective screen layout; and
❑ the technological knowledge to create and test the document.

ADDITIONAL RESOURCES
Careers in Multimedia: Roles and Resources, Hal Josephson, and Trisha Gorman, Brooks/Cole Publishing Co., 1996.

THE INTERACTIVE DESIGN PROCESS

Building a successful interactive document can seem like an overwhelming task. One way to make the whole project more manageable is to understand there is an interactive design process that can be followed. Figure 1–5 depicts one possible way to approach your project. Following the interactive design process allows you to break down a complicated interactive project into smaller, more manageable steps (see Figure 1–6). By working through each step in the process, you can gather and organize critical information more effectively. The completion of each step serves as a milestone of achievement.

> All projects benefit from the organization of forethought, rather than hindsight.

The interactive design process may be broken down into five major steps: problem definition, fact finding, idea finding, project visualization, and implementation[1]. If you are a novice interactive designer, you will probably want to follow these steps sequentially on several projects until you are more confident in your judgment and skills. More experienced designers, on the other hand, may skip over steps in the design process if the client

The Interactive Design Process

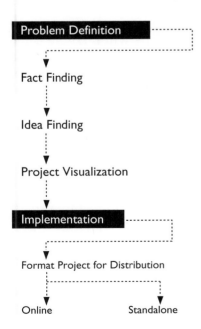

Figure 1-5 A schematic of the interactive design process.

[1]Meggs, Philip B., *Type and Image: The Language of Graphic Design*. New York, N.Y.: Van Nostrand Reinhold, 1989, p. 153.

Meggs provides an excellent discussion of the design process as it relates to graphic design. In *The Principles of Interactive Design,* I have significantly revised and elaborated on this theory to apply it to the medium of interactivity. For those wishing to know more about designer as communicator, there is no better reference than Meggs's *Type and Image.*

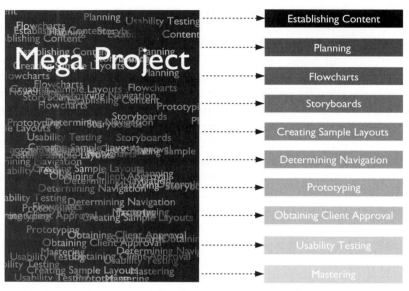

Figure 1-6 Separation of the design process steps breaks a large task into smaller, more manageable tasks.

has provided extensive background information or they have worked on similar projects before.

While the interactive design process is presented here as a series of sequential steps, not all of the steps will take the same amount of time and effort. In general, the problem definition and fact finding stages will take less time than the project visualization and implementation stages. All the steps are important, however, and each activity that takes place in these steps will help you as you strive to create an interesting and functional interactive design. The next sections explore the steps.

> A thorough understanding of the goals of the interactive project is critical to the creation of a good interactive document.

Problem Definition

The problem definition step begins when you accept a project from a client. Problem definition requires you to analyze the project—examine goals and objectives, define the product niche, brainstorm on distribution formats, establish the message, and identify limitations (like time and budget). The background information gathered during the problem definition stage is critical to understanding the client's goals and the project's requirements. It may be tempting at this point to jump ahead and start to design the screen images and interface. This can be a mistake. Without

clearly defined goals and requirements, it is all too easy to concentrate on the bells and whistles of the technology instead of building a design that communicates clearly.

Certain critical pieces of background information can profoundly affect the design of the document. Some interactive projects, for example, are intended to transfer existing information to a digital format. In these situations, existing information and media pieces (such as posters, brochures, videotapes, and so on) offer a rich image and text base for reuse in the interactive project. The existing design will influence the interactive design.

The image on top in Figure 1–7 shows an interior spread from a brochure designed for Walters Millworks. When the business decided to create—mostly as an experiment—a limited edition

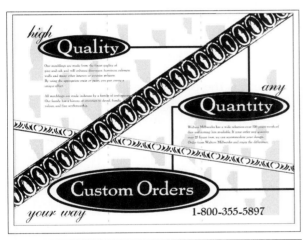

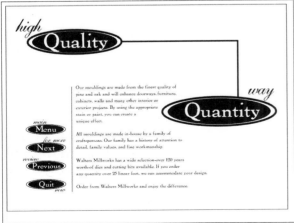

Figure 1-7 The established layout style and content of the brochure (top) clearly influenced the development of the interface design for the Walters Millworks multimedia document *Custom Wall & Window Mouldings* (bottom).

multimedia CD–ROM, much of the existing information used in the brochure was easily recycled into the multimedia format shown as the bottom image in Figure 1–7. The existing artwork, text usage, and layout style of the brochure naturally influenced the look of the interface design.

Other projects have no existing precedence and therefore allow greater design freedom. It is important to establish this background information before beginning to design your project.

During the problem definition stage, you should also begin to consider what distribution format will best fulfill project goals. In general, there are two main categories of distribution formats for interactivity: standalone multimedia formats such as CD–ROMs or kiosks and online formats such as Internet, Intranet, or World Wide Web pages. You will go on to identify the audience and their technological requirements in the fact finding stage—information that will help you confidently choose a specific interactive format.

Interactive Design Principle

Define your
problem thoroughly.

Fact Finding

Fact finding is a follow-up to the problem definition stage that involves researching the project further. Fact finding includes:
- ❏ learning about the client's needs and area of concentration,
- ❏ surveying other projects with similar goals and objectives,
- ❏ researching the audience and their requirements (including the environment in which the interactive document will play), and
- ❏ targeting technological limitations that may affect your design.

Further fact finding requires the interactive designer to:
- ❏ analyze design resources by determining what existing equipment can be used to create the interactive project,
- ❏ choose the authoring tools (the program used to create the interactive document), and
- ❏ determine what skills and personnel are needed to complete the project on time.

Once information about the client, the audience, and available design resources has been gathered, a preliminary flowchart of the project may be developed.

FLOWCHARTS. A **flowchart** is a diagrammatic box outline of the navigational scheme, showing the access routes to infor-

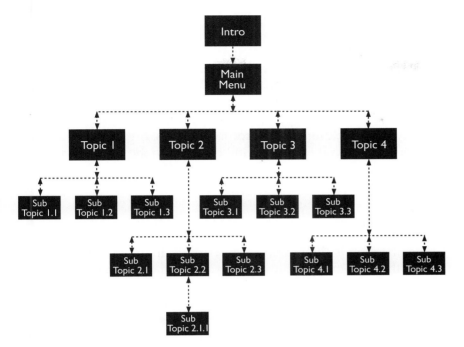

Figure 1-8 An example of one possible way to structure a flowchart. The rectangles represent screens, and the arrows the pathways the user can follow from screen to screen to access information.

mation in the project (see Figures 1–8 and 1–9). Understanding how a user will navigate through the interactive document to follow information helps everyone working on the project stay focused on the importance of clear communication. A critical function of a flowchart is to reveal those parts of the navigational scheme that are too complex to be easily followed.

> A good flowchart will inspire organization and quickly lay out the information paths in the project.

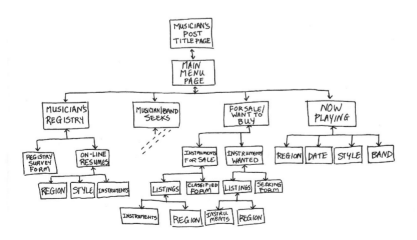

Figure 1-9 An early (and rough) flowchart from *The Musician's Post* web site.

Figure 1-10 Screen sequence from an early (1990) interactive project. Unfortunately for the user, no "quit" command is included—the user must either force quit the presentation using keystroke commands, or endure the entire sequence.

You may sketch several alternative flowcharts before defining one that works. Those designers who skip this task before beginning a project run the risk of creating unclear and chaotic interactive links—links that take the user through multiple levels of information screens without letting the user go back to previous screens, access the main menu, quit the document, or worse (see Figure 1–10). This happens when interactive designers dive directly into working with a prototype before organizing the project. Organizational tools like flowcharts ease the management of complex interactive projects. (For more information about flowcharts, see Chapter 2.)

Idea Finding

Idea finding is the search for a working interactive visual layout with clear navigation controls. During this stage, you will produce many quick sketches to try out possible layouts for screen elements and the look of navigation controls. Experienced designers start this stage with **thumbnail sketches** (small quick drawings designed to rapidly capture ideas on paper) and then progress to **roughs** (larger, more refined sketches based on thumbnail ideas). In the project visualization stage, the roughs will be further refined in **comps** (short for "comprehensives", very detailed mock-ups of the final design). For a graphic example of this progression, see Figures 1–11 and 1–12.

Thumbnail sketches should be quickly executed in pencil or pen without prejudging the quality. The goal is to record the ideas as they flow—you can decide later if any of them are worthwhile. Even if only a few of the thumbnails are any good, having a body of sketches to look at opens up the possibility of comparison. Side-by-side comparison allows for the possible recombination of ideas in a new and unexpected manner. Sometimes even an ugly thumbnail sketch may contain an element that, when extracted from the sketch and combined with elements from other thumbnail sketches, may surprisingly form a winning solution.

Once a body of thumbnail sketches has been developed, you can refine several of the better sketches into roughs. Roughs are also fairly quickly executed, but with a finer eye for detail. After several roughs are on paper or **onscreen** (short for "on the screen"), you can proceed to the project visualization stage.

Project Visualization

The earliest part of the project visualization stage is the development and critical evaluation of comps. Some elements that designers create comps for are title screens, navigation controls, and sample screen layouts. These comps are commonly shown to the client. Many clients require the designer to present comps before giving permission to proceed with the project.

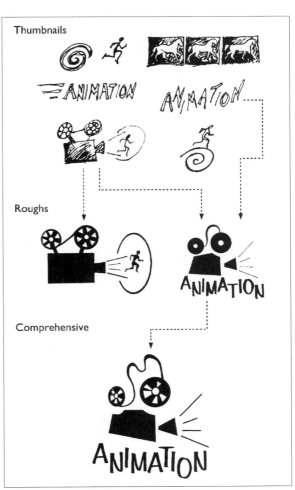

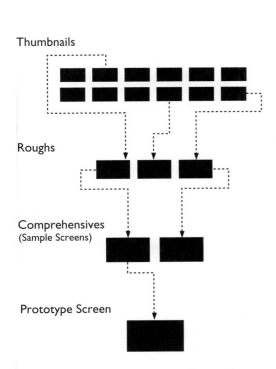

Figure 1-11 The progression of the refinement of a visual idea: thumbnails, roughs, comps, to final screen elements.

Figure 1-12 A sequence of thumbnails, roughs, and comps from the multimedia project *The Cat & The Mouse.* Note the progressive refinement of the imagery from top to bottom. *(Courtesy Push Design Partnership.)*

> **NOTE**
> Interactive designers commonly create comps on the computer. The sample screen layouts can then be printed to show them to the client or to carry them into meetings. One advantage of working in this manner is that any changes to the sample screen layouts can be indicated by marking alterations on the printouts, or even by editing the layouts on the computer.

Project visualization involves educated critical evaluation. Evaluating a comp layout requires that the project's goals are clearly stated. Once the goals are understood by all involved in the project, a list of criteria should be drawn up. These criteria may change from project to project, but at least some of the criteria should lead to evaluation of the effective use of screen elements and overall screen layout. These criteria questions often evolve along with the project and may need to be periodically reworked. Some possible criteria questions that assist in the examination of an interactive document might be the following:

❑ Why is this document being created, and does the layout make this purpose easy to understand?

❑ What sort of content should be placed in the document to help it perform the communication goal?

❑ Which pieces of the content selections still need legal permissions? (Lack of legal permission may require the deletion of this content from the interactive document.)

❑ Are the navigation controls clear and easy to use? Do all the interactive controls in the document function as desired?

❑ Does the user have the option of quitting out of every screen?

❑ Is there any confusion about the message?

❑ Is the type legible and appear onscreen properly choreographed with supporting media like graphics, photos, and video?

❑ Do the color choices of type, images, backgrounds, and navigation buttons work well together? Are there any color choices that have a negative or positive connotation?

Once a group of comps fulfill the project goals and criteria, the next step in the project visualization is to make storyboards.

STORYBOARDS. A **storyboard** is a visual document depicting the style, layout, action, navigation, and interactivity on every

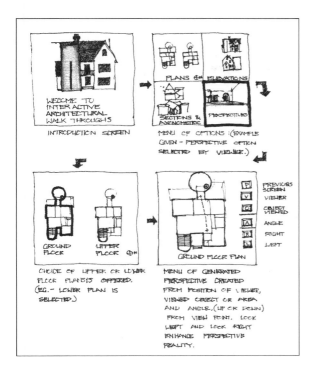

Figure 1-13 A segment of the initial rough story-board from *Personalized Architectural Walkthroughs*. Even at this early stage, the storyboard suggests the style, layout, navigation, and interactive controls to be used in the document.

screen in the document, as shown in Figures 1–13 and 1–14. At the very least, the storyboard organizes the content and functionality of the document. At its most detailed, the storyboard illustrates the interactive links within the document, informing everyone working on the project *what* occurs *when* in the interactive document.

The storyboard also serves as a sales tool, illustrating to the client the functionality of the document. Presentation of the storyboard to the client marks another milestone in the design process, with go-ahead approval necessary to proceed with the interactive project. Once the client approves the storyboard, you reach the end of the project visualization step. The approved sam-

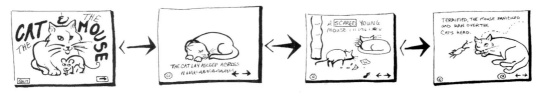

Figure 1-14 A portion of a rough storyboard.

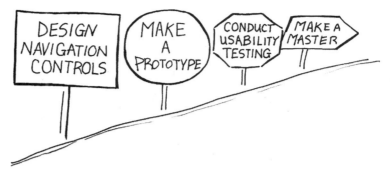

ple screens and storyboards are then developed further through prototypes and final versions in the implementation stage. (For more information about storyboards, see Chapter 2.)

Implementation

The implementation process is where sample screens and storyboards are translated into a functional interactive project. You will develop **prototypes** (preliminary on-screen versions of the project), conduct **usability testing** (testing that checks the overall user friendliness of the document), and progressively refine the project. The implementation process ends with the final interactive document ready for **mastering** (the creation of the master digital file used to make copies)or online distribution. These steps serve as milestones of achievement that, as they are completed, can help encourage every person involved in the project.

PROTOTYPES. Prototypes are the first experimental models of the interactive document. When building the prototype, the designer takes information from the completed storyboard and translates it into a partially functional interactive document. A working prototype allows for stringing together the access links of interactivity within the **authoring program** (the program used to choreograph content and build a navigable interface containing multiple media). The prototype may be as simple as a few navigational paths with a limited number of functional links, or it may have multiple navigational paths with most of the links programmed and working. In either case, the prototype should be considered preliminary, incomplete, and open to change.

USABILITY TESTING. Once the prototype is created, usability tests are run on a limited sample of the target audience to

determine the effectiveness of the design and reveal early bugs in the programming. At this point, the emphasis is on creating a clear and stylish design, as extensive programming and **debugging** (finding and eliminating all programming flaws) takes place in the mastering stage. Usability tests often find the first prototype in need of revision to increase functionality. Almost inevitably, prototypes are tested, reworked, tested, and reworked—often more than once or twice.

Testing should be an ongoing task that begins with the prototype and continues through to the final version of the project. Problems that are not discovered and solved through early and continuous usability testing can grow into insurmountable problems when usability testing is delayed. Remember to test early and often.

 Interactive Design Principle

Test early and often.

MASTERING. Once the series of usability tests confirms that the content, interface design, and navigational pathways in the prototype work and provide the user with a rich interactive experience, you can flesh out the prototype into a fully functional interactive document. To develop a fully functional interactive document, you will proceed through a number of design phases, including the following:

❑ *Production*, where all artwork, audio, video, animation, virtual reality, and other media are prepared for placement within the document

❑ *Programming*, where all production elements are placed into the authoring program along with any special computer codes that enhance the functionality of the interactive document

❑ The *alpha version*, the first complete interactive document that is thoroughly tested for correctness and general functionality

❑ The **beta version,** the second complete interactive document that undergoes extensive usability testing by actual users in real-world situations

❑ The *master*, the final version of the interactive document recorded onto the target media. If the final version is recorded onto a compact disk (CD), this version is often called a **golden master,** after the color of the disk.

At the end of the mastering process, the final document goes online (in some cases, it may already have been online and "under construction"), or the master is taken to a media production house to make copies for mass distribution.

PART 2

PROJECT PLANNING AND VISUALIZATION

In This Part:

CHAPTER 2
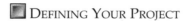 DEFINING YOUR PROJECT

The time spent planning ahead, organizing your project, and establishing project goals will eventually pay for itself in increased productivity. Thoroughly defining your project *before* initiating the creation of the expensive and time-consuming digital version of the project will help you avoid false starts and pitfalls along the road to completion.

DEFINING YOUR PROJECT

OBJECTIVES

- ■ To learn to critically analyze the benefits that interactivity can bring to your project
- ■ To understand your audience in order to create a functional interactive project tailored to their needs and requirements
- ■ To gain a better understanding of the necessity of establishing goals, defining personnel needs, and researching hardware and software options
- ■ To learn the importance of thinking strategically in organizing your project
- ■ To consider the importance of flowcharts and storyboards as project visualization tools

JUSTIFYING YOUR PROJECT

Every project has unique goals, audiences, budgetary constraints, and production issues. Justifying your project as an interactive document requires that you examine the goals and objectives of both the client and the proposed project. What you must consider is the unique issues and advantages that interactivity could bring to the project, and whether creating an interactive document will best fulfill the goals of the client.

Producing a project as an interactive document has many advantages, including adding functionality and a greater depth to the information. Interactive encyclopedias could offer greater functionality than book versions for the reader by letting them run searches with keywords. A multimedia CD–ROM biography of a famous artist could add greater depth and breadth to her story than the book version by displaying images of her best works along with the paintings and spoken opinions of her most celebrated artistic rival. These are only a few of the advantages interactivity offers to interactive designers. You will need to determine, project by project, if the advantages of interactivity outweigh any

possible disadvantages. In other words, you will have to decide if the rewards are worth the work.

Producing an interactive project can be a complex task. It often requires a significant commitment of your time and energies. Before embarking on a large interactive design, it is wise to realistically examine the proposed timeline, budget, technology, and personnel involved with the project. A lack or deficiency in any one of these areas may lead you to ask: "Does this project really require interactivity?" A negative answer may point the production of the project in the direction of a more traditional medium like print. A positive answer suggests that interactivity is required.

HOW MUCH INTERACTIVITY IS NECESSARY?

Once you have decided to proceed with an interactive design, you have to decide just how much interactivity is needed to convey the message. This decision will have repercussions on project budget, personnel, and how much time you can spend on the design. Defining the complexity of the project will provide a clearer picture of the feasibility of the project.

Interactive projects range from very simple, slide-show presentations to fully developed interactive 3D worlds. The simpler the interactivity in the project, the easier—and faster—it is to create. The more complex the interactivity in the project, the more time, planning, development, and testing are required to create a working document.

Projects with low levels of interactivity may provide users with only limited menu choices or perform basic actions like starting, pausing, or quitting the program. Slide-show corporate presentations, product demonstrations, and business transactions often have streamlined interactive choices. In contrast, projects with extremely high levels of interactivity allow the user to adapt existing document content, input information, and influence how the content and information are used. Examples of such projects are databases, teleconferencing, and online virtual worlds. These interactive documents often let the user add sound, video, comments, create graphics, rearrange the sequence of content, and many other options.

The computers available to the audience will help you determine how much interactivity you can build into the project. If a large number of your proposed audience will access your file

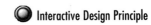

with a relatively older and slower computer, you will want to simplify the document. If most of your proposed audience has access to the latest-greatest computer technology, you can build in intricate levels of interactivity.

DEFINING YOUR AUDIENCE

Successful interactive designers research information about their prospective audience to help them design user-friendly interfaces. Researching your target audience includes finding out more about their demographics, culture, disabilities, interests, **playback environment** (the environment in which the interactive document will be viewed), and technology. This information will influence your choice of the content, vocabulary, language choices (see Figures 2–1 and 2–2), style, graphics, and the design of screen layouts in your interactive document. Audience research will also help you determine which computer platform the document will play on.

⬤ Interactive Design Principle

Know who your audience is.

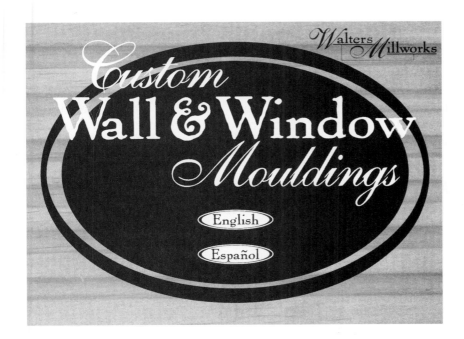

Figure 2-1 Audience analysis determined that many of the Walters Millworks customers were located in the southwestern United States. Consequently, it made sense to offer a Spanish language option in the interactive document.

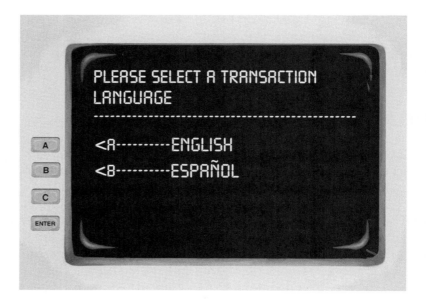

PLEASE SELECT A TRANSACTION
LANGUAGE
--

<A----------ENGLISH
<B----------ESPAÑOL

A
B
C
ENTER

Figure 2-2 Many ATM screens offer the user the option of choosing a transaction language.

Demographic Data

A good place to start your research about your audience is to gather demographic data about them. Demographic data includes age, gender, educational level, profession, income bracket, and so on. This data will help you determine what sort of images and style are appropriate for the piece. For instance, an interactive project aimed at a preschool audience would be significantly different in the choice of imagery, music, vocabulary, and pacing than a project developed to market building supplies to architects. Demographic data also helps clarify the market niche of your product and approximately how much the audience might be willing to pay for your product.

Market and Technology Research Sources

Market and technology research is a vital portion of planning a project. Thoroughly researching your target audience, special needs, likes and dislikes, and technology base helps you to determine if market interest is high enough to justify project resources and budget, and to target a price range affordable for the normal user. The target price of the product influences how much time,

money, and reasonable effort goes into the project. A few research sources are:

- ❏ customers,
- ❏ colleagues and other developers,
- ❏ focus groups (a group of individuals from the proposed audience who review different project solutions ranging from storyboards to prototypes),
- ❏ trade shows and organizations (Seybold, SIGGRAPH),
- ❏ vendor information (product brochures, mailing lists),
- ❏ computer and interactivity magazines (*MacWorld, PC Week, WebMaster, Wired*), and
- ❏ online services and surveys such as Neilson Media Research (http://www.neilsenmedia.com/) and GVU WWW User Survey (http://www.cc.gatech.edu/gvu/user_surveys/).

Multicultural Audiences

With the world becoming increasingly interconnected into a *global village* (a term referring to the connection of the world via the Internet and the World Wide Web), it is important to understand more about other cultures and other people. This is especially true if your prospective audience is a multicultural one.

Knowing more about the cultural backgrounds of your audience will help you figure out how to communicate your message more effectively to them. What is acceptable to an audience in one culture may be objectionable to an audience in another. Interactive projects intended for multinational distribution often require special consideration of language, imagery, interactivity, screen layout, and copyrights.

Language obviously is one of the first components that will have to be altered; but changing language involves more than simple replacement of screen text and narration. In replacing screen text, ample room should be left for possible expansion of the text when translated into another language, as shown in Figure 2–3. The conversion of roman text to nonroman text may require additional screen space, both vertically and horizontally, as some written languages read from top to bottom. In areas where user input is desired, extra space may be necessary, as the formats for addresses, phone numbers, dates, numbers, names, money, times, and measures differ from culture to culture.

doorways, furniture, cabinets, walls and many other interior or exterior projects. The possibilities are endless!

#332-568 Corner Block used with 2055 not only creates a stylish baseboard, but also eliminates mitering. (Outside Corner Blocks Crown Blocks are also available.)

Figure 2-3 Comparison of these two close-up views of the same screen from *Custom Wall & Window Mouldings* shows that the Spanish text version requires substantially more space than the English text version. The designer accommodated this text expansion by leaving plenty of space for the text to "grow."

mejorarán la apariencia de sus puerta de entrada, muebles, gabinetes, paredas y muchos otros proyectos interiores o exteriores. ¡Las posibilidades son inacabables!

El Bloque de Esquina #332-568 al ser usado con la moldura 2055 no solamente crea un elegante rodapié, pero también elimina el tener que sesgar las esquinas. (Los Bloques de Esquina y los Bloques de Corona también se ofrecen a la venta.)

Narration should be provided by a person who is fluent in the foreign language and has a neutral accent. You will also need to carefully consider the gender and the age of the narrator in comparison to the content. For instance, the voice of a elderly man with a French accent might not serve as the best narrator for a multimedia CD–ROM that documents the lifestyles of teenage gang members.

Images and interactive controls also may need reconsideration and revision if the document is to be distributed across borders. While some images and symbols can cross cultures easily, others may not hold the same meaning across cultures. The standard skirt-

ed women's restroom symbol, for instance, is not as effective in a culture where both men and women commonly wear long robes.

Color, groupings of objects, and image choices may have unexpected meanings in the target culture. Everyday objects do not always look the same worldwide. Telephones and mailboxes, for example, are manufactured in a wide variety of forms across the globe. What is considered an everyday, well-known object or action in one culture may have unexpected interpretations in another.

It is important to test all interactivity controls on individuals from the target culture. The metaphor of "clicking" a button to advance to the next screen may actually seem confusing and/or counterintuitive in that culture. Other navigational metaphors may need development for cross-cultural portability. Even internationally used icons do not always have exactly the same meaning in all cultures. It is a good idea to have an individual from the target culture view the interactive project to catch any possible cross-cultural misinterpretations.

Special Design for an Audience with Disabilities

Projects designed for target audiences with special requirements require additional planning to maximize usability for those audiences. The list in Figure 2–4 shows how users com-

User/ Computer Interactions

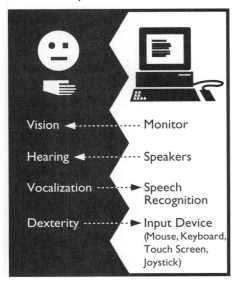

Figure 2-4 Humans interact with computers using vision, hearing, vocalization, and dexterity. A disabled individual may have impaired usage of some or all of these functions. When designing for an audience with disabilities, it may be necessary to change the design of the interactive document; for instance, a person with limited mobility may use an infrared control to input and manipulate information. If such is the case, support of this device must be coded into the interactive document.

Figure 2-5 You can enhance functionality by letting the user select between several input device options.

monly interface with the computer. When designing for an audience with disabilities, any one or almost all of these interface elements can demand special design accommodations. Text size, color choices, sound levels, **interaction speeds** (how fast controls function and how quickly images and text cycle on timed loops), and programming support for special input devices are all possible design accommodations (see Figure 2–5).

Designing for individuals with limited vision affects selection of typeface and type size as well as impacting on color choices. An audience with low vision (vision correctable to no better than 20/50) benefits from an enlarged type size with a higher color contrast in the text. A color-blind audience requires that the designer avoid using certain color choices. Designing for individuals with hearing disabilities may require the simultaneous playback of onscreen text as well as narration. Individuals with impaired motor skills may need a slower playback speed, especially during portions of the interactive document that ask for user input. When specialized input devices are available to assist individuals, special programming code can be written to take advantage of the devices.

A worthy goal in designing an interface is to make the design accessible and usable for everyone. While this goal may not be practical to achieve in all interactive documents, trying to make your document user-friendly for people with disabilities often yields enhanced legibility for everyone.

NOTE

One out of every twelve men and about one out of every two hundred women are affected by color blindness, or unable to see the full range of colors. Many color-blind individuals have difficulty seeing red and green, and a smaller number have difficulty seeing red, green, and blue in varying combinations.

One technique you can use to enhance the readability of your content is to make sure there is good contrast between colors, especially in type.

CUSTOMIZATION. One of the advantages of creating interactive documents is that these digitally based documents are relatively easy to customize for specific audiences. Once you have developed the programming, it can be easily reused by copying it into another computer file. This new file can then be used as the framework of a new project. This allows you to add special programming code or interactive design components to the new file to better serve the needs of the audience.

The multimedia prototype *The Cat & The Mouse,* is a good example of a project that is undergoing customization for a specific audience. This electronic book is intended for release as two versions: the regular version and a special large-type version for children with vision disabilities. Both versions contain the same content, but the large-type version has larger type, interactive controls, and images than the original version (see Figure 2–6).

From the beginning of the project, everyone involved knew there was a possibility of converting the document into a large-type edition. Interactive controls and screen layouts were designed with an eye for simplicity and legibility (see Figure 2–7). A text typeface was selected for its thickness of strokes and serifs, as these characteristics are helpful to the reader in identifying the letterforms. (Serifs are the little "wings" commonly found on the ends of letters.) All programming was deliberately simplified in order to speed later conversion.

Once the first edition was created, it was saved into another file. Using this second file, the designers are easily able to convert the existing framework of programming code, screen designs (minus the illustrations and text), and interactive controls into the new version. The simple programming code permits the quick swapping of the normal-size text, illustrations, and navigation

controls with large-size versions. In this way, Push Design Partnership is developing a legible interactive document for both a wide audience *and* an audience with a special disability.

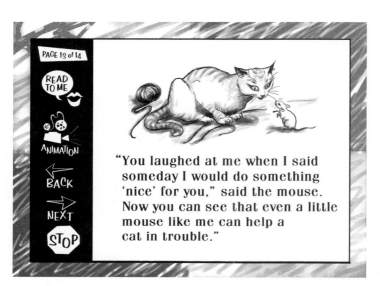

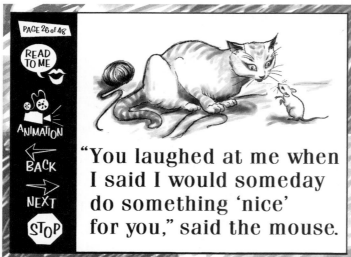

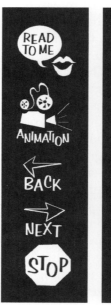

Figure 2-6 The top screen shows normal-size type and navigation controls. Text, image, and navigation controls in the bottom screen are all bigger to accommodate children with low vision (vision correctable to no better than 20/50). *(Courtesy Push Design Partnership.)*

Figure 2-7 The interactive controls from *The Cat & The Mouse.* Shown here is a side-by-side comparison of the regular-type navigation controls and the large-type navigation controls.

ENGAGING AUDIENCE INTEREST

Figuring out what will interest your audience will influence the content of the document. A highly educated audience with an interest in a particular subject may expect detailed information in the document. An audience with limited exposure to a particular subject may be satisfied with a less detailed presentation of the information. In either case, vocabulary choices, imagery, databases, reference materials, bibliographies, quotations, videos, animation, and other screen elements should be tailored to the audience's needs and desires.

The best interactive documents engage the user's interest and participation. Most individuals enjoy the process of exploring and discovering new information. When possible, building in multiple levels of information or alternative pathways through the content can help engage the user's interest. For instance, a designer working on an interactive CD–ROM about Michelangelo might display images of the Sistine Chapel, highlight his travels across a map of the Italian peninsula, define artistic vocabulary, provide recipes for the grinding and mixing of pigments, and comment on his rivalry with Leonardo da Vinci. The unique presentation of the information adds a new depth to the historical perspective.

The Element of Fun

Providing fun experiences in the document is one way to gain the user's attention. Care must be taken, however, to create fun experiences that speak to the audience's age level and interests. A product aimed at elementary students might dwell intensively on riddles and action games, while a product aimed at antique car enthusiasts might include car trivia questions or engine horsepower simulations.

The most obvious way to add a fun element to the document is through games. This is not your only option, however. Designing fun into an interactive document also can take place in unexpected ways. Walters Millworks adds an bizarre element of humor to their multimedia CD–ROM by, in some screens, adding the buzzing sounds of several kinds of saws—the tenor twang of a handsaw, the baritone rasp of a low-speed band saw, and the manic scream of a circular saw—into the functions of a few interactive controls (see Figure 2–8). When the user waves the mouse

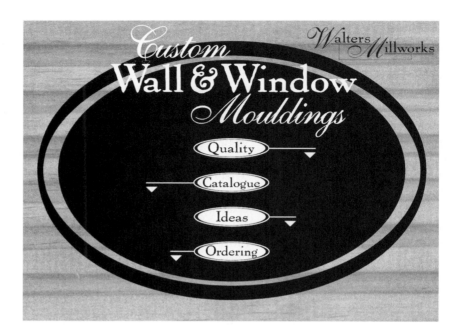

Figure 2-8 The main menu screen from *Custom Wall & Window Mouldings.*

pointer over each of the topic choices, a different saw sound plays. Rapidly waving the pointer across the different choices produces hilarious garage-band style sounds. Crossing the pointer into the Walters Millworks logo creates a reverb (echoing) amplification of the notes. The playfulness of the sound encourages a detailed examination of other screen elements to search for other sounds and fun elements, and adds an unexpected richness to the presentation.

PLAYBACK ENVIRONMENT

Researching the target audience will help you understand the special conditions that may exist within the playback environment. These special conditions (such as noise and light levels) should be considered while you are designing your document.

A common problem within the playback environment is the level of background noise. The sound played by a multimedia kiosk in an airport might have to compete at varying times of the day with the roar of airplane engines revving up for takeoff. In this environment, a recording of a narrator with a low voice may be too soft to be heard over the loud environmental noises. To

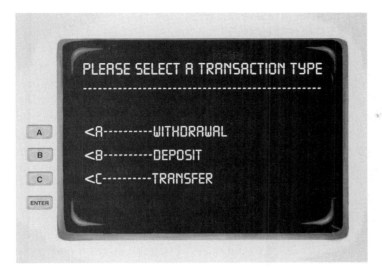

Figure 2-9 ATM machine screens are often difficult to read, due to the glare from reflected sunlight. To enhance readability in a difficult environment, ATM screens often use high contrast between text and background (usually white text on a black background).

overcome this situation, you might choose a narrator with a strong voice and clear enunciation, and you might have volume controls readily available to the users, allowing them to quickly raise or lower the sound levels as needed to overcome loud background noises. In contrast, in quieter environments like a library, a narrator with a softer voice is preferable. You may even, in this environment, include headphones along with the kiosk.

Another consideration to take into account in the playback environment is the level of lighting. Some interactive kiosks (such as ATMs) are often placed in brightly lit areas. ATMs are commonly built into the side of banking buildings, and at certain times of the day, they are in full sunlight. This bright environment can result in glare on the screen, accentuating the need for high contrast between colors (especially in the text) to make the information more readable (see Figure 2–9). On the other hand, a kiosk placed in a dark environment can use bright vibrant colors to attract potential users to the screen and enhance readability.

Other aspects of the playback environment to consider are whether the document will be used in industrial, combat, or home conditions; and how many people will need to use the document in a short amount of time. Understanding and designing for these environments will help you build a more effective communication document.

ASSESSING YOUR AUDIENCE'S PLAYBACK TECHNOLOGY

◉ Interactive Design Principle

Understand the capabilities and limitations of the playback technology, and build your document to work well with those capabilities and limitations.

No matter how exciting the interactive document, some users will avoid the document if it will not play back well on their computer. You will be able to reach a broader audience if you tailor the document to run on the most commonly available computer used by the proposed audience. Designing interactive documents to run efficiently on the most commonly available computer widens the number of potential purchasers, while designing a complicated document that will run well only on a high-end computer narrows the number of potential purchasers.

Clearly, some compromise is in order. Designing for the lowest technological denominator limits the use of graphics, video, and sound, as such media make a lot of demands on a computer's memory and processing capabilities. These demands consequently slow down playback speeds. Designing for the highest technological denominator allows for more complex graphics, video, and sound as these computers can play back complex media faster. The more complex the document, however, the more problems some users will encounter trying to play it. In some cases, the document may be complex enough that the user's computer may play it slowly or not at all. When in doubt, keep it simple.

Designing for the most common computer platform is especially critical when creating online communications. User hardware and software capabilities vary widely. Computer hardware capabilities range from machines able to download text-only files, to cutting-edge multimedia machines handling text, video, sound, and animation with ease. Software programs connecting users with online communications also vary from text-only to full-text and graphics capabilities. Determining the capability of the most commonly available computer can impose limits on the design complexity of graphics, links, and sound; but overloading a document with complex graphics, links, and sound forces users with slower machines away. When "surfing" the online services, many users simply avoid interactive documents with large, slow graphics files. Including information such as the data size of graphics, video, and sound files on the opening web page helps users decide if their computer can handle the document (see Figure 2–10). Not all users have the interest, time, or patience to download large, complex interactive documents.

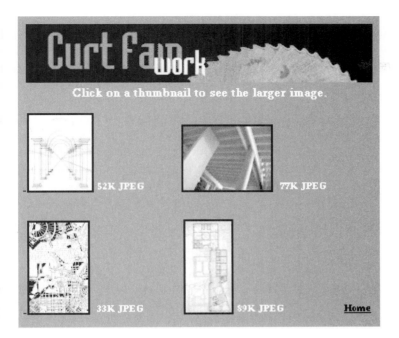

Figure 2-10 The thumbnail images (small versions of each of the graphics) and file sizes included in this web page let the user decide whether to look at the full-size version of the image.

ONE LAST WORD ABOUT RESEARCHING YOUR AUDIENCE

By gathering research about the prospective audience, you should become more aware of the range of individuals who may use the document. Understanding the special needs and requirements of your audience will help you to create an appealing interactive experience for them. Understanding the playback environment and technology will help you to create a functional interactive document for a broader segment of your audience. Even the most complex and content-rich interactive document will fail if only a small segment of the audience can play it on their equipment. By avoiding complex and cutting-edge technology, the designer communicates the message to as many of the target audience as possible.

RESOURCES

Resources include the hardware, software, personnel, and budget needed to complete the project. Many projects fail because of

an inadequate assessment of available resources, and it is better to make plans up front than to have to stop mid-project to try to gather additional resources from outside sources.

A realistic look at resources will identify areas that need more support. For instance, you may find that additional hardware, software, and personnel are needed to complete the project in a timely manner. Consequently, researching resources will affect budgetary and timeline decisions. Some designers find it necessary to campaign for financial support from an outside source, while others find the available budget adequate for the project. All these are important considerations to keep in mind when gathering information about the project.

Hardware and Software

One resource area that requires ongoing research is hardware and software technology, as digital technology is constantly being updated. Constantly improving technology forces designers to stay knowledgeable and well-read about current hardware and software tools (such as faster computers and more efficient interactive authoring programs). With every new project, you will have to review the adequacy of your hardware and software tools.

Good sources for researching changes in hardware and software are magazines such as *WebMaster, NewMedia,* and *Desktop Video World.* (There is a host of interactive magazines available, and more are appearing every year.) Studying the manuals that come with the equipment is also helpful. Diligent research about hardware and software often means you will have to read, read, read, and read.

Of course, eventually you will have to apply the information you have gathered into a series of equipment tests. After selecting the software and hardware for the project, you should create several simple sample interactive documents to see whether these tools function as expected. By running quick checks, many of the problems that arise from hardware and software incompatibilities can be discovered and eliminated.

In a world in which technology is constantly improving, computers purchased for previous projects may become quickly outdated. Hardware and software technology are updated on a regular and expensive basis, and to stay competitive, you will have to reach deep into your pockets. New products are released and

become a part of the interactive designer's tool kit. Learning the most recent hardware and software is an ongoing task. An effective designer not only is well-read and knowledgeable about the changes moving through the interactive industry but also can fluently use that knowledge in his or her work.

Collaboration with Others

In general, the more complex the project, the more likely you will need to collaborate with other professionals. If the project is small and relatively simple, such as a web page with a few links, it may be easily completed by one interactive designer. Intricate multimedia games, on the other hand, may require a team of experts to meet project objectives, deadlines, and budgets. A realistic analysis of the project, the proposed deadline, and available skills soon reveals whether there is significant need to involve more personnel.

A few of the personnel needed to complete a large interactive task might involve copywriters and editors; marketing, audio, video, and sound specialists; photographers; graphic and interactive designers; programmers; compression and distribution experts; and, of course, the client. Smooth integration of all these individuals into the project demands extensive planning. The more that planning is performed up front in the project, the easier the design process will flow. Skimping on team resources early in the developmental process often results in time and budget overruns later.

Rules of collaboration should be carefully delineated, with a hierarchy of command and clearly assigned tasks. Collaborations work best when all coworkers are competent in their field, understand common goals, invoke mutual respect and trust, respect physical workspaces, communicate constantly but work well independently, and understand the hierarchy of command yet feel free to consult, solicit, and assist in idea-making with their colleagues. The best collaborations speed the developmental process *and* allow interactive designers to tackle interactive projects beyond their own capabilities. If you find it necessary to work with other team members, keep in mind that consistent communication will keep everyone on the team up-to-date with any changes in the project. Furthermore, being aware of the diverse skill levels of everyone on the team as well as the available technology helps determine which ideas and plans are achievable on time and within the budget.

PROJECT CONTENT

Content is the subject matter, information, or media incorporated into the interactive document. Content can be gathered from many sources—**content experts** (specialists in a certain area, such as professors and consultants), literary materials, movies, videos, sound, animation, or dialogue with a colleague. This information is gathered, assessed, reworked, and integrated into an interactive document. Early in the design process, you should sit down with the client and compile a list of the content that is desirable for use in the document. Developing a content list will help you determine whether you can gather the content from existing materials or whether the content must be created specifically for the project.

A Few Words About Content and Copyrights

Generating a content list early in the project helps clarify copyright and usage issues. The content list serves as a checklist, showing everyone what content is available, where the content came from, and which pieces of content require copyright permissions (see Figure 2–11).

It is important to know where media originates and to under-

Content Checklist

Project: *Personalized Architectural Walkthroughs*

Cont. No.	Cont. Type	New	Format Status			Permission Status		Source	Comments
			Digital	Analog	to be Scanned	Yes	No		
276	Arched Window	X	x ACAD			X		SELF	
277	" Door	X	x ACAD			X		"	
278	" Fireplace	X	x ACAD			X		"	
279	Fireplace Rock Texture	X	X			X		SIERRA	SIERRA DEMO IN Photoshop
280	CREEK PHOTO from North East	X			X		Verbal X	JOHN	TO BE TAKEN in B/W & COLOR
281	MATLOCK ST. VIEW South on ROAD	X			X		Verbal X	John	PHOTO B/W & COLOR
282	Instrumental "Bsop"	X		X			Verbal X	Lori Walther	Lori has the music on tape, needs to be digitized
283	BACKGROUND MUSIC (THE MARCH)	X			X		Verbal X	Lori "	" " "

Figure 2-11 A sample content list.

stand the legal and ethical importance of obtaining permission rights in this digital age. Access to digital data has made it increasingly easy to "acquire" graphics, video, sound, and animation. Everyone involved with the project must know that simply "acquiring" content can infringe on copyrights. Creating interactive documents is enough of a challenge without the additional problem of a copyright infringement lawsuit.

Even content used in an earlier project may need to be relicensed for use in another project. In some cases, content is licensed per use, and additional usage in another document may require that extra fees be paid to the artist or copyright holder. Some copyright holders may ask for a significant fee in order to gain the right to use the piece. Other copyright holders may be extremely hard to find. Be forewarned, if you are using a lot of copyrighted content, it pays to start the permissions search early. It takes time to write, phone, fax, and e-mail copyright holders to negotiate for permissions. And just because you are on a deadline does not mean that they will respond to your request quickly. The sooner you start the process of obtaining copyright permissions, the sooner you can determine whether to reuse existing content or whether it would be more cost-effective to create new content.

NOTE
The earlier copyright permissions are secured, the less likely it is that critical content will have to be pulled in the last stages of creating the interactive document.

ADDITIONAL RESOURCES
Multimedia Law Handbook, Diane Brinson and Mark Radcliffe, Ladera Press, 1994, Menlo Park, CA. Discusses legal issues for the multimedia producer and includes sample legal contracts.

Reusing Content

Many interactive projects use a certain amount of existing content. In many cases, the client can provide an archive of information that can be reused in a new project. Existing content may be photographs, illustrations, videotapes, training literature, product development data, slides, text from an annual report, cassettes from interviews, or other stored data.

Inventorying existing content allows you to assess the quality and usability of the information. Some of this information may

require reworking, data verification, or conversion into a digital format in order to use it in your document. Original copies of artwork might be damaged, requiring redrawing for use. Statistical information may no longer be current or relevant. Existing digital data may be of such poor image resolution or sound quality as to require recreation.

Looking over the existing content helps determine if additional steps must be taken to adapt the content to use in a new project. Some information may be salvageable from older formats, but only if touched up by a professional. Poor sound quality from an audio tape might require the services of a practiced sound technician. Damaged animation film stills may need to be redrawn by an artist. Existing digital data may need to be converted to a more current format by a skilled computer expert. Identifying the quality of the existing content will help you decide whether it is of good enough quality to use or whether you will have to create entirely new content.

New Content

If the decision is made to create new content for your project, you will have to thoroughly research the content topic. Beyond the normal research channels of surveying magazines, books, and online sources, some designers choose to hire a content expert.

Content experts are individuals who have specialized knowledge about a particular subject. Content experts can range from professionals to individuals with extensive life experience. A good content expert will be able to research data, supply text, provide clear descriptions, introduce you to other experts, and offer you advice that assists in the accurate presentation of information. Although the content expert cannot make the decision on what sort of content goes into your project, their advice is often useful in helping you decide what media (such as video, text, or graphics) would best convey the message.

Once you have decided what sort of content and media will go into the project, you will have to either create the new content yourself or work with someone else who is creating the content. In either case, the sooner you identify what content is already available and what content still needs to be created, the sooner you can move on to establishing clear goals and visualizing your project through flowcharts and storyboards.

Tip: No matter what the content, scan or record it at the highest quality you can afford and save it in a digital archive. Technology comes and goes, but good content can be reused in the future.

ESTABLISHING GOALS AND VISUALIZING YOUR PROJECT

An important part of planning and visualizing your project is establishing realistic goals. Realistic goals will help you set up a workable timeline and guide you through the visualization of your project through flowcharts and storyboards.

Once you have a set of goals established, they can be used to determine the extent and functionality of the interactivity, to influence the stylistic look of your document, and to guide decisions on what hardware and software are appropriate to create the interactive document. The following list is a series of goals developed for the electronic book *The Cat & The Mouse*, along with a description of each goal's effect on the project.

The goal

❏ Produce a simple electronic book with narration, animation, and vocabulary definitions appropriate for a six- to ten-year-old audience.

Its effects on the final document

❏ The decision was made to produce a simple multimedia document with limited interactivity.
❏ Certain screens offer the child a choice of reading the text onscreen or, by toggling a button, having a narrator read the text (the narrator's voice serving as a pronunciation guide to new words). Some screens also include limited animation that supports and elaborates on the story line. Other screens have segments of text containing hot spots that, when clicked, open up a small text box defining the vocabulary word (see Figure 2–12).

The goal

❏ Offer an English or Spanish language version of the document.

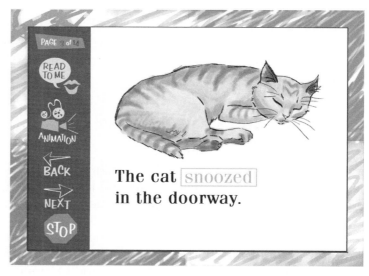

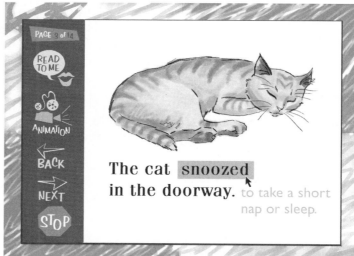

Figure 2-12 Screen from *The Cat & The Mouse*. The box around the word *snoozed* in the top image indicates that this word is a hypertext link. When the user clicks on the link, a short vocabulary definition appears.

Its effects on the final document

❑ On the opening screen, the child has the option of continuing the story line in English or Spanish. An additional advantage to letting the child select the playback language is that the child can experience the story in one language, then the other, and by comparison learn a few words of a different language.

The goal

❑ Allow children with vision disabilities to select a large-type version of the interactive document.

Its effects on the final document

❑ Type, images, and icons were enlarged to maximize readability for children with vision disabilities. As a result of the enlarged type and images, the large-type version contains approximately twice as many screens as the small-type version.

The goal

❑ Use simple illustrations and interactive controls to convey a fun, contemporary, and peaceful look.

Its effects on the final document

❑ The designer drew playful illustrations and interactive controls, using color to contribute to the fun, youthful look.

The goal

❑ Distribute the piece in both Windows and Macintosh compatible formats.

Its effects on the final document

❑ The interactive designer chose to use Macromedia Director as the authoring program and an Apple PowerMac as the developmental platform. Macromedia Director allows easy cross-platform porting (transference) of interactive documents, while providing a good selection of built-in, preprogrammed functions. Since the document uses very simple and limited interactivity, very little programming was required. This simplicity streamlined the whole production process and bypassed the need to hire a programmer. With little programming involved, alpha and beta version testing went smoothly, with few glitches discovered in the document. The biggest problem was a slight color shift as the document was taken cross-platform, and that problem was corrected by creating a cross-platform custom palette.

❑ The interactive document will be released in CD–ROM format, as many children have access to a CD–ROM player in the family computer and in educational facilities.

Timelines

Stated goals greatly assist in the creation of a realistic timeline. A **timeline diagram** is usually a paper document showing what will be completed when and by whom. Creating a timeline diagram helps set realistic time frames for the development of each task of the interactive document (see Figure 2–13). Setting feasible deadlines throughout the process will alleviate procrastination and avoid a buildup of critical tasks before the deadline. Breaking the project into a series of tasks helps determine who will be responsible for those tasks and whether those individuals can complete the work without being overloaded. It is crucial when developing a timeline to realistically assess personnel skill levels, as it may be necessary to hire and train additional support staff to complete the project on time.

Setting realistic work schedules also may constrain or open up the amount of content and even how interactivity functions within the project. Projects with a far-off deadline and large budgets have more leeway to build highly detailed, experimental documents. Projects with a very short timeline are developed under much tighter restraints. The tighter the deadline, the more streamlined the content, and the more simplified the interactivity.

Figure 2-13 This timeline from *Personalized Architectural Walkthroughs* breaks down the project into a series of tasks. Where appropriate, team members are assigned to specific tasks and given start and end dates. The bars on the right show the length of time dedicated to each task. Determining a realistic timeline helps keep a project on track, with clear communication on *who* is responsible for *what* task by *when*.

Task	Who	Start	End	Jan	Feb	March	April	May	June
Initial Research	Curt, Sierra	1/4	1/6	4-6					
Wire-Frame Drawings	Curt	1/7	1/21	7-21					
Rendering of Drawings	Curt	1/18	2/10	▬▬▬	▬				
InterfaceArtwork	Sierra, Lisa	1/7	1/15	7-15					
Prototype With Limited Programming	Sierra	2/1	2/15		▬				
Initial Usability Testing		2/16	2/20		▬				
Programming	Curt, Sierra	2/21	3/28		▬	▬▬			
Alpha Testing		4/1	4/15				▬		
Revisions	Curt, Sierra	4/16	4/25				▬		
Beta Testing		4/27	5/15					▬	
Final Programming	Curt, Sierra	5/16	5/30					▬	
Golden Master		6/5	6/5						
Manufacturing		6/6	8/1						▬

Tip: Remember to calculate learning and training time into the total project timeline. It takes time to learn how to best use the hardware and software.

Flowcharts

Flowcharts are important tools to help you organize and plan your project. A flowchart is a simplified outline charting how content is accessed through all the levels of interactivity. The first flowchart may be a few rough lines in box format or a highly detailed, computer-generated diagram. As the project grows and goals are further defined, so should the flowchart change to reflect the evolution of the project.

Flowcharts are useful as planning tools to help organize major topics, information and interactivity links, as well as the structure and levels of interactivity. Creating a flowchart often initiates discussions between team members about the larger decisions of the project—what major topic categories are placed on the main menu, how many levels of interactivity are linked to each of those main menu items, and what information is higher in importance and therefore should be easier to access. Once on paper, a flowchart can be easily revisited and reworked to refine the organization of content and interactivity.

Content, ease of use, and resources are all important to consider when building a workable flowchart. Content should always drive the design, for content provides the underlying reason for the creation of the document. Any interactivity built into the document should enhance the clear communication of the content without "muddying the waters" with poor or overly complex layers of interactivity.

One way to enhance communication is to understand that the placement of information within the layers of interactivity affects how well the information communicates. The further down the information is buried—beneath screen after screen—the less likely the user will be to find it. Navigating through multiple layers of interactivity increases the potential of the user getting lost or losing interest. A good rule of thumb is to avoid creating more than three layers of interactivity for the user to "dig" through. The more layers of interactivity, the more likely a user will forget the placement of the current screen within the overall interactive

> A flowchart is a powerful resource for assisting the interactive designer to analyze information access, to visualize the various paths the user might take, and to help guard against dead ends in the interactive navigation.

structure. Ideally, a good flowchart will evolve into a clearly understandable interface with easy-to-use links to information, topics, and navigation controls.

Planning for the technological capabilities of the proposed audience is an important concern when developing the flowchart. The diagrammatic form of a flowchart for an audience with slower computers is often simpler and more linear than that of a project aimed at an audience with faster multimedia computers. The more interactive functions desired in the document, the more complex the flowchart. In some instances, the designer may need to include additional notes along with the flowchart to help explain the action taking place on some levels. The more detailed the flowchart, the more time and effort are required to work out the interactive functions.

The clearest and most useful flowcharts show every link of inter-activity from the time the user first opens the document to when he or she closes out of it. Every link within the flowchart represents a level of interactive control you will have to design and integrate into the project. All interactivity levels, content, and links should be presented in a clear and focused manner, providing a map for all involved in the production of the interactive document.

> Most interactive projects benefit from clarity of content, superior usability, and simplicity.

Interactive projects have the tendency to evolve throughout the whole process. Creating flowcharts and other organizational devices constructively channels this evolution. Every interactive project has need for a series of continually refined flowcharts, from the simplest slide-show document to the most complex game.

NOTE

A good flowchart often reveals flaws in the organization of content and proposed use of interactivity. The sooner potential problems or concerns are spotted, the earlier—and less expensive—problems are to correct. The further along in the design process the problem is discovered, the more time, money, and effort it will take to correct the problem.

FLOWCHART STRUCTURES. Three common ways to organize flowcharts are in hierarchical flowcharts, linear flowcharts, and hybrid flowcharts. A purely *hierarchical flowchart* shows every link in a branching structure, beginning with a main menu that separates into first major topics and then subtopics (see Figure 2–14). A purely *linear flowchart* shows a primarily one-way flow of information, similar to the classic linearity of film or video (see

Figure 2–15). A *hybrid flowchart* mixes hierarchical and linear structures together (see Figure 2–16). Hybrid flowcharts can be envisioned as a primarily hierarchical structure intermixed with

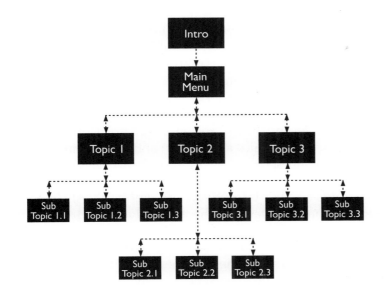

Figure 2-14 Diagram of the information flow in a hierarchical flowchart. Note the branching structure of the flowchart.

Figure 2-15 Diagram of the information flow in a simple linear flowchart.

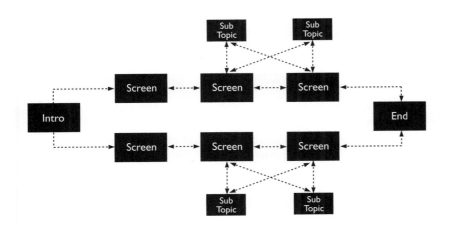

Figure 2-16 Diagram showing the flow of information in a hybrid flowchart. The flowchart presented here is only one possible variation of a hybrid flowchart.

a linear structure where content is difficult to interrupt without losing some of its meaning, as in the case of an interview or story.

Hierarchical structures offer many choices of control and levels of interactivity to the user but are frequently complex and expensive to produce. Linear structures offer less opportunities for interactivity but are often cheaper and faster to produce.

It is also possible to design with multiple tracks of linear information. Multiple tracks of information that play simultaneously within the same screen can support, enhance, and more fully explain the content. Figure 2–17 diagrams the multiple-tracks options available within the overall linear structure of *The Cat & The Mouse.* At certain times, the user can turn on and off the sound (the narrator's voice and music) and the animation (showing short animated sequences from the story). The vocal quality and intonation of the actors' voices speaking the cat and mouse's dialogue lends a richer impression and emotion to the story line, while the animation livens up the interactive experience.

Figure 2–18 shows the first rough flowchart drawn up for *The Cat & The Mouse.* Small icons representing sound, animation, and vocabulary choices record the designer's first thoughts on where and when these elements would become available for use. As you can see, the flow of the story is predominately linear, with the occasional addition of a secondary and tertiary track of information. This structure allowed the designers to keep the design simple yet accommodated the addition of animation and sound.

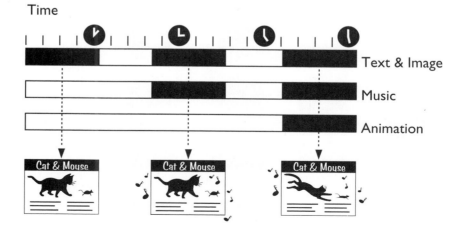

Figure 2-17 In this multiple-track diagram, time flows from left to right, and the user can turn on or off synchronous media tracks, choosing to play one, two, or all three tracks simultaneously.

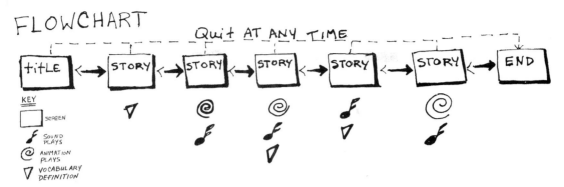

Figure 2-18 The first rough flowchart from *The Cat & The Mouse.*

Storyboards

As was briefly touched upon in Chapter 1, storyboards continue the organizational process of the flowchart, illustrating the relationships between content, interactivity, and links, and adding detail and breadth to the growing project. Like the flowchart, a storyboard grows and changes with the project. Figures 2–19 and 2–20 compare

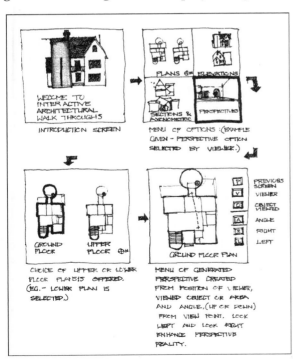

Figure 2-19 The first storyboard from *Personalized Architectural Walkthroughs.*

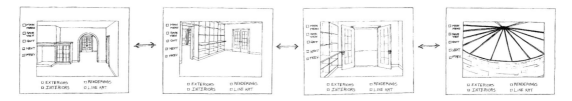

Figure 2-20 The second, more refined storyboard from *Personalized Architectural Walkthroughs*.

the initial storyboard for *Personalized Architectural Walkthroughs* with a later storyboard. Note the refinement of screen layout and interactive controls (controls such as buttons and links that let the user activate interactive functions). The generation of several storyboards continued the refinement of the information flow. The storyboard is extremely useful, as it allows the ongoing exploration of usability, navigation, and timing in an easily modified format.

Storyboards range in complexity and detail from quick rough sketches on paper to highly detailed computer renderings. A quick-and-dirty storyboard roughs out the flow of information within the interactive structure and the manner in which the user will access that information. Comprehensive storyboards show each image, action, and interactive control and illustrate how all the elements in the design (dialogue, sound, text, characters, and video sequences) connect together. Most storyboards fall into the middle range of details, with one or two interactive paths followed through the entire proposed document. Concentrating on developing a few paths in detail helps the designer focus on creating a clear presentation of content.

In detailing every significant screen and the set of actions possible within that interactive screen, the storyboard tells everyone involved with the project *what* the user will experience, *when* content will display, and *what* and *when* navigation or other tools will be available for the user. The storyboard does not require use of a final, polished screen layout, although interface designers often find the addition of notes about the treatment of graphics and other interface elements helpful to others working on the project. A detailed storyboard reveals information assisting in the development of a more realistic estimate of time, tasks, and project costs.

A storyboard is most useful when it details the links and types

of interactivity in a format that is easily refined as the interactive project evolves. A storyboard drawn on paper can be photocopied, cut apart, new images added, and thoroughly reworked to improve in the presentation of the information. Storyboards created on the computer are easily printed and undergo much the same process. In either case, the storyboard is a living, changing document that will undergo continual refinement through the design process right up to (in the worst case) the mastering stage.

Storyboards also serve as marketing tools, a tangible blueprint of the growing interactive project. For the design process to go smoothly, everyone involved with the project, including the client, must understand the relationship of the content to the interactivity. The storyboard explains this information to the client and the developmental team. On projects sponsored by an outside client, the storyboards should be reviewed and approved by the client. If any changes are requested, the storyboard will need to reflect those changes. Revising a project often means going back to the initial problem definition stages and reviewing content, regenerating flowcharts, and redrawing the storyboard. Once a working storyboard has been agreed upon, it is time to proceed with developing the initial prototypes.

INTERFACE DESIGN

In This Part:

Designing a working interface requires good artistic and strong technological skills. You will use both sides of your brain to create a communicative and navigable experience for the user. The content is meaningless until you learn how to structure the information on the screen so that it clearly conveys the message.

DESIGN FOR INTERACTION

OBJECTIVES

This chapter is where you start considering how to put together your interface. Chapters 1 and 2 covered how to build a strong base of information, content, personnel, and planning to help define the message of your interactive document. Chapter 3 helps you understand how to design a usable and functional navigation scheme with clear and understandable interactive controls.

Some of the objectives in this chapter include:

- To learn how to design a working navigation scheme
- To become familiar with the many different types of interactive controls in use in the industry
- To understand the many issues involved in creating unambiguous and engaging interactive controls
- To consider how you can make a user-friendly interface

NAVIGATION

ADDITIONAL RESOURCES

The Psychology of Everyday Things, Donald A. Norman, Doubleday, 1988, New York, NY. Norman discusses the basic principles of user-centered design by studying ordinary things.

About Face: The Essentials of User Interface Design, Alan Cooper, IDG Books, 1995. A good book about user expectations and the basics of interface design.

Moving through the levels of interactivity in a project requires a clear navigation scheme. **Navigation** is the process by which a user explores all the levels of interactivity, moving forward, backward, and through the content and interface screens. Users navigate through the project by clicking on interactive controls such as buttons, imagemaps, and hypertext, while clues such as spe-

cial colors, backgrounds, or interface sounds help orient them to where they are at within the levels of interactivity. A good navigational scheme will leave the user with little question about where they are in the document and where they can go from there. On the other hand, trying to navigate through a poorly arranged interface searching for information is like looking for a needle in a haystack. Without knowing where you are at, or how the current screen relates to other topics, it is difficult to find the right information.

Questions to Ask When Evaluating Your Navigational Scheme

❏ Are all icons and imagemaps clear and understandable?
❏ Do all the interface controls look like they relate stylistically to each other? Do they look like they are part of an overall system?
❏ Do the interface controls function consistently throughout the document?
❏ How easy or hard is it to navigate back to the main menu or home page?
❏ Can the user quit at any time?

 Interactive Design Principle

Design a clear navigation system that allows the user to understand where they are at within the system at all times.

A critical step in creating and implementing a good navigational scheme is the thoughtful analysis of where information will fall within the overall interactive structure. The sooner you start to think about how the user will move around within the project the better. The best time to really think about your navigational scheme is when you are developing flowcharts. Keep in mind, though, that flowcharts are the initial step of your design and that, as you work on the project, your design will naturally evolve. It is not unusual to continue to refine the navigation scheme well into the storyboard stage and beyond.

How Does the Flowchart Translate into Navigation Pathways?

A well-developed flowchart is the map that will help you design your navigational scheme. This map will help you shape the strongest and most direct access to any two points in the lev-

els of interactivity. Translation of a flowchart into a working navigation scheme, however, often takes some work and revision. Since flowcharts are living documents that grow and change along with the project, remember the items in the following list when reviewing your flowchart.

❑ Every link shown on the flowchart depicts a navigation pathway you will have to design.

❑ Every link requires a corresponding interactive control the user will activate to either take them to a different screen or bring additional information to the current screen.

❑ You will have to design interactive controls that fit stylistically and conceptually with the content, and that do not take up too much **screen real estate** (the available space onscreen).

❑ You will have to flesh out the implied navigation links. Flowcharts usually depict direct access to information between interactive levels. As the project evolves, however, you may discover the need to create additional access routes to help clarify and organize information. This means you will have to rework the flowchart and add more links to your document.

❑ You will have to look for opportunities to simplify the access to the information. One of the main tasks of an interactive designer is to make sure that users can take the most direct path between any two points in a document. Ask yourself as you review the flowchart, "Is this the simplest and easiest way to access this information?" At times you may decide that the navigation scheme developed in the flowchart is too complex and must be streamlined for better access.

❑ You will have to decide whether it is better (depending on the circumstances) to take the user to a new screen or bring the new information to the current screen (see Figure 3–1).

①

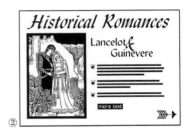
②

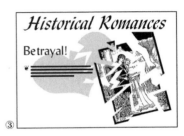
③

Figure 3-1 The above figure shows three different screens. Screen 1 and screen 2 share many visual elements (headlines, picture, and arrow); therefore, new text from screen 2 fits easily within screen 1. However, the content of screen 3 would not fit easily into the layout of screen 1 without reworking the layout design. Consequently, it is easiest to send the user to screen 3, then back.

Good Navigation Design

A good navigation design will clarify the content and interactive structure, enhance the document's usability, and accommodate the user's needs.

Good navigation design clarifies the content and interactive structure by:

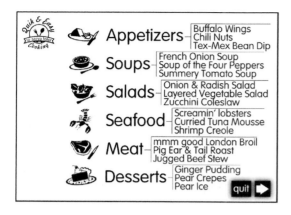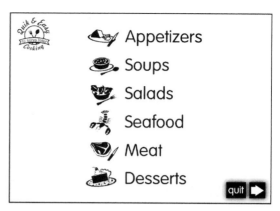

Figure 3-2 Two examples of a main menu design. The screen on the right presents simple, straightforward choices, while the screen on the left is cluttered with both main topic choices and subtopic choices.

❏ Quickly orienting the user in the first screens to what can be seen, done, and learned from the product.

❏ Establishing which pieces of content are more important than other pieces of content by their relative positions within the levels of interactivity. In general, the less important the information, the deeper it is placed within the levels of interactivity. For instance, a good navigation design will place all the major topics where they are accessible on a main menu. A poor navigation design might mix main topics and secondary topics on the main menu (see Figure 3–2).

❏ Letting the user know where they are at in the document at all times.

❏ Letting the user know where they can go from where they are at.

Good navigation design helps the user understand the functions and enhances the usability of the interface by:

❏ Connecting any two points in the content with the shortest possible paths.

❏ Avoiding the use of multiple or redundant paths to the same information from the same place (see Figure 3–3).

❏ Using easily recognizable images and icons as interactive controls.

❏ Using interactive controls that are simple and straightforward and that react consistently.

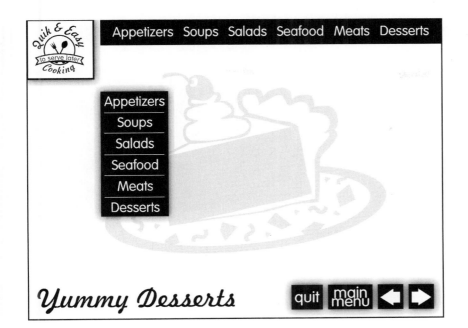

Figure 3-3 This screen offers two different ways to get at the same topic information—the menus listed across the top and the control bar floating in the left side of the screen. Duplicating interactive controls in this way is confusing to the user and requires unnecessary design effort.

Good navigation design will accommodate the user's needs by:

❏ Always providing a way for the user to return to the main menu or the home page.
❏ Letting the user go back to any point.
❏ Always providing a way for the user to exit the program.

ORIENTING THE USER TO THE INTERFACE

Convincing users to interact with your document in part depends on orienting them quickly to the document's content, navigation scheme, and interactive controls. These first screens are often your only chance to show the user what they can expect to see and do in the document. Orienting the user in the first screens of your project is critical because, unlike a book, users cannot pick up the document, flip through the pages, scan the table of contents, or look at the index to get a sense of what information the project holds.

Splash Screens, Main Menus, and Home Pages

In multimedia documents, the first screens the user will

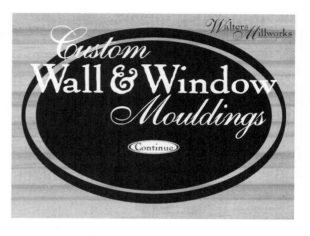

Figure 3-4 A simple splash screen design. Splash screens do not have to be complicated, but they do need to reflect the style and overall feeling of the rest of the design.

Figure 3-5 The splash screen from *Custom Wall & Window Mouldings*.

encounter are the splash screen and the main menu screen. In online documents, the initial screen is called the home page. First impressions count, and the impression the user forms from looking at these first screens contributes to their decision to continue to explore the document or to quit out of it.

A **splash screen** is the initial screen that a user sees (after any installation screens) and serves much the same function as the cover of book (see Figures 3–4 and 3–5). The splash screen, like the cover of a book, conveys an impression of what the rest of the document will look like, and sometimes introduces the user to the first interactive control. In multimedia projects, the screen that follows the splash screen contains the main menu. The **main menu** screen introduces the user to a summary of the contents of the document, much like a table of contents in a book (see Figure 3–6). The main menu also firmly establishes the look and function of the navigation controls, so it is important to make this screen as attractive and easy to understand as possible (see Figure 3–7). If the user continues to interact with the document, the user will return over and over to this screen, so it pays to spend some time designing it. And finally, in online documents, the **home page** often combines the functions of both the splash screen and the main menu (see Figure 3–8).

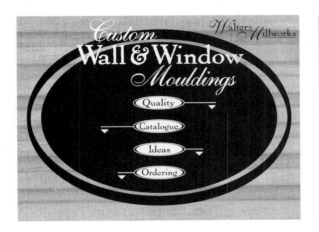

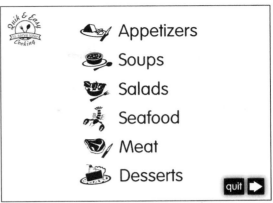

Figure 3-6 A main menu screen. The main menu contains a listing of the major topics found in the interactive document.

Figure 3-7 This main menu firmly sets up the major topics and stylistic look of the rest of the document in a simple, easy-to-understand design.

A good strategy in orienting the user to the potential of the document is to provide the user with enough images and text information to encourage them to use the document, but not to barrage them with so much information that they get sidetracked, confused, or overloaded.

Figure 3-8 A web home page.

What Goes on a Main Menu Screen?

Since the main menu is the gateway to the content, the user will come back to it over and over again when traveling through the document. Here is a short list to start you thinking about what should and should not go on a main menu.

Common items on a main menu screen:

❏ The title of the interactive document
❏ Topic category titles and interactive controls that are functional and let you access information topics
❏ A control for accessing user help
❏ An exit button

Things that should not go on the main menu screen:

❏ Lists of credits
❏ Installation information
❏ Preferences set-ups
❏ Product registration.
❏ Subtopic category titles
❏ A mug shot of the multimedia designer. (You think I'm kidding, but I've seen it done!)

METAPHORS

Once the user decides to move forward in the document, they will need easy-to-understand and easy-to-use interactive controls. One way of building easy-to-use interactive controls is to use a metaphorical approach. A **metaphor** refers to an experience, location, object, or tool using the more familiar terms of another experience, location, object, or tool. For instance, Windows and Mac computers use the metaphor of the "Desktop" with folders, trash cans, recycling bins, and stickies as a quick way to understand the structure of the whole system.

Using metaphors has become a popular convention in interactive design to help orient the user to the computer environment. For example, the Internet contains "chat rooms" where people electronically converse, electronic "mailboxes" receive e-mail, and design-

> The best metaphors refer to familiar real-world experiences, locations, objects, and tools.

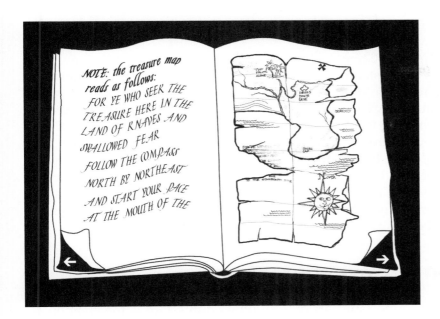

Figure 3-9 This interface uses the metaphor of an open book to help the user navigate through the interactive document.

ers build web "pages." Other commonly used metaphors are books and maps, such as the screen depicted in Figure 3–9 where users can toggle arrows to flip the page forward or backward or refer to the map to help them navigate through the interactive document.

Metaphors work best if they are easily understood by the audience, relate to your topic, and are not taken too far. A good way to test whether a metaphor is easy to understand is to ask other people if the metaphor helps them understand what to do. If you have to explain the metaphor, then it does not work (see Figure 3–10).

When working with metaphors in your interfaces, however, it is best not to take the metaphor too literally. Taking a metaphor too far can quickly become irritating. For example, imagine how much of a nuisance it would be if every time you wanted to send e-mail to someone you had to first click a "place in envelope" button and then click a "lick a stamp" button!

Figure 3-10 When encountering the icon on the left in an interactive document, would you understand what it meant? Now look at the icon on the right. Would you be able to interpret that the arrow pointing to the left means "forward" while arrow pointing to the right means "backward"?

THREE CLICK RULE

Users will find the document much easier to navigate through if they understand where they are at within the layers of interactivity. You should never bury information or desired functions more than three clicks away from the first click. For example, if a user is attempting to "print" a document, they should not have to "click" through three or more screens to access the desired function.

Moving backward or forward through more than three screens increases the chance that the user will lose track of where they are at within the document. If your project uses a hierarchical or hybrid navigational scheme, you should be on guard against embedding information too deep within the structures.

 Interactive Design Principle

Do not bury the user in too many levels of interactivity.

INTERACTIVE CONTROLS

An important part of designing an interface is the creation of clear and unmistakable interactive controls. **Interactive controls** such as hyperlinks, hypertext, buttons, imagemaps and hot spots add functionality to the interface and are a prominent feature of your navigation scheme. It is important to remember that, in many documents, the controls are the only way that users can activate interactive features.

Because interactive controls are employed throughout a project, you should design them to dovetail with the concept, style, and tone of the document. If the overall style of your document is factual and businesslike, such as a training presentation, the interactive controls can bolster that style with a straightforward, serious approach. If the overall tone of the document is playful and humorous, interactive controls with an entertaining twist to them are a good fit. Interactive controls provide a good opportunity to reinforce the seriousness or playfulness of the document.

As was mentioned earlier, there are a number of different types of interactive controls. The following information highlights a few of the most common types and explains more about the importance of consistent use of controls in your document. While looking over this information, you may want to keep in mind that interactive controls are a vital part of your navigation scheme and can make or break the design in terms of whether a user can find their way consistently through a document. So the design of interactive controls is critical to the success or failure of your project.

NOTE
How can you teach someone what a symbol or interactive control means in your document? Users learn how to recognize the meaning of symbols and interactive controls in a number of ways, including:

❏ *by example,* when someone teaches them the meaning;
❏ *by analogy,* when the new symbol or control is similar enough to another concept that they can make assumptions about the meaning;
❏ *through context cues,* such as a symbol paired with text like "search," "help," or "credits"; and
❏ *through exploration,* when clicking on a symbol or control always initiates the same interactive function, for example, "quit."

Hypertext

Hypertext is specifically a word, phrase, or paragraph that, when clicked, links to another piece of content in the document. This piece of content can be on another page or screen, or can appear on the current screen (see Figure 3–11). Because hypertext links are easy to build, easy to maintain, and appear quickly onscreen, online designs such as web pages depend heavily on hypertext links.

Buttons

Buttons are one of the most widely used interactive controls. Interactive designers depend heavily on buttons because they are so familiar to us through many different technological devices. When you push a button, for instance, whether it is on your radio or on your computer screen, you expect something to happen.

> A good button is an unambiguous one.

There are a lot of different kinds of buttons, as shown in Figure 3–12. As you can see from the figure, buttons do not always have to look like the button on a VCR tape deck. Instead, buttons are often a mixture of icons and typography.

Some kinds of buttons are called **multi-state buttons** because, when clicked, they display a second visual image or even a short animated sequence. Multi-state buttons can be further divided into highlight buttons, rollover buttons, and animated buttons. A **highlight button** simply "highlights" when the user clicks on it,

Figure 3-11 This figure shows a home page with a linked web page. When the user clicks on the "Planning Your Garden" hypertext link in the top image, the link takes the user to the web page shown in the bottom image.

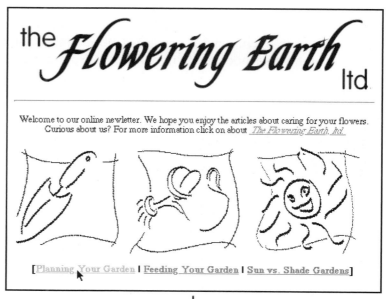

as shown in Figure 3–13. This highlighting effect serves to tell the user that their click has been acknowledged by the computer and that some action has been initiated.

Like highlight buttons, **rollover buttons** provide needed feedback to the user. Rollover buttons are also used to identify interactive controls and to deliberately attract the user's attention (see Figure 3–14). A rollover button will typically display a second image when the user's pointer "rolls over" the hot spot occupied by the rollover button. (A **hot spot** is an area of the screen that is currently designated as active. A hot spot can have buttons or graphics parked on it.) Figure 3–15 uses dotted lines to show the

hot spot areas around the images on this screen interface. Hot spots allow the user to clue in on what is clickable and what is not. For instance, if the user moves the pointer around onscreen looking for something to do, a rollover button that changes its display will help the user understand that it is a clickable interactive control.

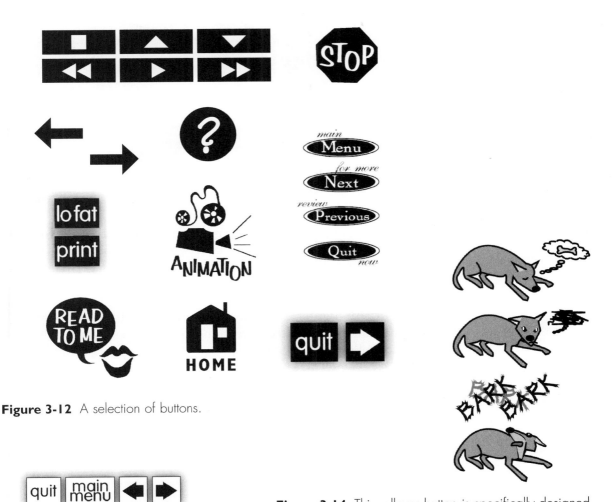

Figure 3-12 A selection of buttons.

Figure 3-13 The highlight state (top image) and the normal state (bottom image) of a group of buttons.

Figure 3-14 This rollover button is specifically designed to attract the user's attention and to provide an element of humor in the document (to see how the dog is placed within the rest of the screen, see Figure 3–26). When the user's pointer rolls over the image of the sleeping dog (top), the pointer "wakes" the dog up, spoiling his culinary dream (middle). The third state of the rollover button is the dog barking at the pointer (bottom).

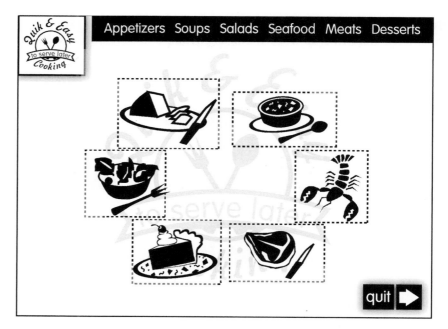

Figure 3-15 The dotted lines reveal the edges of the hot spots.

The third kind of multi-state button is an **animated button.** An animated button displays a short animated sequence either before or after the user clicks on it. For example, an animated button can be programmed to display its animation sequence after a period of inactivity (that is, a short period of time that has passed without any pointer movements or clicks). Or, like a rollover button, the animated button can change out images when the user's pointer rolls over it (see Figure 3–16). In this case, the primary difference between an animated button and a rollover button is that

Figure 3-16 This "magic" carpet from Figure 3–26 normally lies flat and inert on the screen (top), but when the user's pointer rolls over it, it briefly cycles through two other states (middle and bottom).

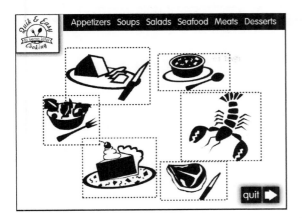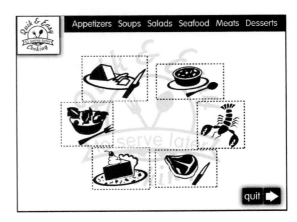

Figure 3-17 The screen on the left depicts a poor hot spot arrangement. The screen on the right shows essentially the same layout, but with minor modifications that result in a better hot spot arrangement.

the animated button rapidly shows three or more images, while a rollover button typically shows only two (the normal resting image and the rollover image). Another way an animated button commonly displays is to initiate a short animated sequence after the user clicks the button.

Although it is possible to use all of these different kinds of buttons together on one screen, keep in mind that multi-state buttons should not be placed too close together. Many times a multi-state button occupies a designated hot spot area larger than its actual resting image. (This is true because the second or third button image may be slightly larger or in a different position than the original resting image.) There should be enough room between the buttons that the user does not activate the alternative states of both buttons with the pointer or have difficulty selecting one button without also selecting the other one. Figure 3–17 depicts two hot spot arrangements. The screen on the left demonstrates a poor hot spot layout, because when the user clicks on the "salad" hot spot, he or she may inadvertently activate the "desserts" hot spot. The screen on the right shows the same basic arrangement, but with the images small enough to avoid any problems caused by overlapping hot spots.

Imagemaps

A graphic that is clickable and links to other information in the document is called an **imagemap.** Typically, imagemaps are used

Figure 3-18 Note the imagemaps used in this web page. The image of the spade represents "Planning Your Garden," the image of the watering can represents "Feeding Your Garden," while the image of the sun stands for "Sun vs. Shade Gardens." These images are diverse enough in content to be understandable imagemaps. In contrast, look at the imagemaps used in Figure 3–19.

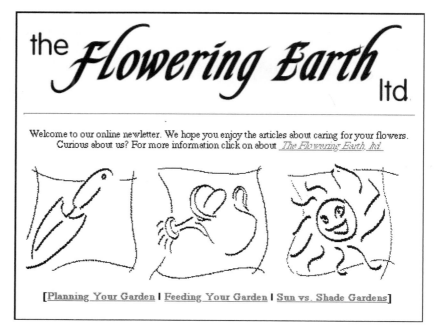

on the main menu or home page in a document. If skillfully chosen, these images are useful in quickly representing content categories (after all, a picture is worth a thousand words) (see Figure 3–18). If poorly chosen, they can add an element of confusion to

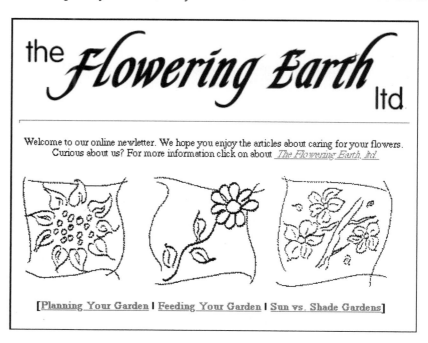

Figure 3-19 These imagemaps are difficult to understand. The images do not provide enough information to adequately inform the user about their functions.

the interface (see Figure 3–19). Furthermore, since imagemaps can consist of any kind of graphic, or graphic and type combination, the style of the graphic you choose for your imagemap should fit with the tone and impression of your document.

Menus

Menus are a familiar interface control to virtually anyone working on a personal computer. They can be a simple text listing of functions or a more complex mix of text and graphics.

The most common type of menu is a pulldown menu, such as that shown in Figure 3–20. A *pulldown menu* is a list of choices available under a single heading on a menu bar that, when clicked, displays its listings. Clicking and holding on the File menu in Windows or Mac computers, for example, manifests a pulldown menu with a list of common operating commands such as Save and Open. Another useful menu type is a popup menu. A *popup menu* typically manifests in two stages (see Figure 3-21). The first stage usually shows onscreen as the default option used by the program. The second stage appears when the user clicks and holds on the menu, revealing additional choices. Once the user moves the pointer down the list and selects a new option, the menu listing disappears, showing only the newly selected option. Popup menus are extremely useful in preference screens.

The advantages of popup menus are that they consume less screen real estate and accommodate long lists of options. They also offer a standard of comparison to the user. For instance, if the user goes through a game preference screen and customizes the intensity of the game play, the previous choice will display in the popup menu until it is changed again. This way, if the user saves a game file and reopens the file a few days later to play the game, he or she can consult the preferences file to check the intensity level of the previous game.

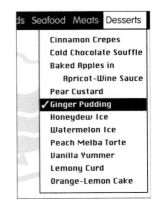

Figure 3-20 A simple pulldown menu.

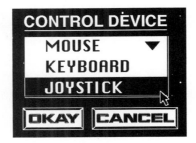

Figure 3-21 A popup menu from a game preferences screen.

Keep Controls Consistent

Good controls that react consistently clarify the navigation scheme and add functionality to the interface. When interactive controls react predictably, users can learn the navigation scheme quickly and easily. For example, users quickly determine that an arrow pointing right means "next" after having clicked on it several times with the result that the next screen displays. Conversely, if the user clicks on the arrow a second time and it freezes the machine or jumps to the credits screen, some confusion might ensue about the arrow's function (see Figure 3–22). In some cases, inconsistent controls may make the user inclined to quit entirely out of the document.

◉ **Interactive Design Principle**

Design interactive controls that react consistently.

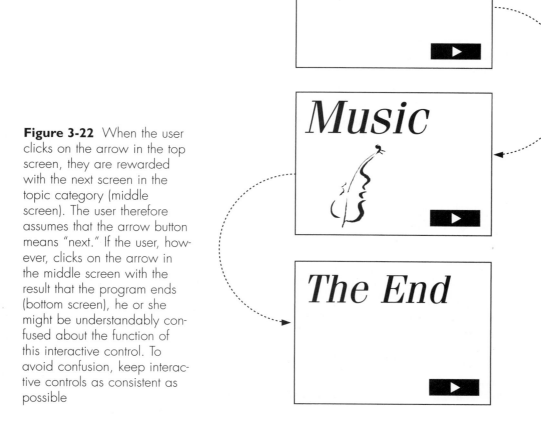

Figure 3-22 When the user clicks on the arrow in the top screen, they are rewarded with the next screen in the topic category (middle screen). The user therefore assumes that the arrow button means "next." If the user, however, clicks on the arrow in the middle screen with the result that the program ends (bottom screen), he or she might be understandably confused about the function of this interactive control. To avoid confusion, keep interactive controls as consistent as possible

USABILITY AND FUNCTIONALITY

Usability refers to how easy an interface design is to understand and use. A user-friendly document will let the user read or play any content at will; it will have unambiguous interactive controls and a clear and understandable navigational scheme. *Functionality* is how well (and reliably) the interactive controls and media perform on the target platform. Making sure your interface is user-friendly and performs flawlessly on the target platform is a critical goal.

How do you create a user-friendly interface? Well, first you have to understand some of the audience's basic abilities and needs. For instance, if most of the potential users understand that a mouse can be employed to click and drag on an object, you can build interactive controls such as pulldown menus to take advantage of that ability.

Another way to build a user-friendly interface is to accommodate special input devices and device-specific options. This often means programming into the document the ability for the audience to select the input device of their preference (a trackball mouse, joystick, stylus, and so on). You should further build in options for the user to customize their chosen input device—for example, if the user wishes to use a joystick (typical in many games), the user may wish to select which button will be the firing button (perhaps to accommodate the preferences of right versus left handers).

Other ways to build effective, friendly, and highly usable interfaces include the following:

❑ Let the user undo any action or try an activity more than once (see Figure 3–23).
❑ Do not crowd too much information into the screen real estate.
❑ Make interface controls as intuitive as possible.

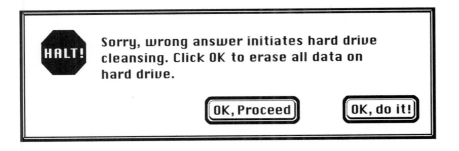

Figure 3-23 An example of a very unforgiving interface. How would you like to input the wrong answer into an interactive document and receive this dialogue box as a reward?

❏ Provide audio and/or visual feedback.
❏ Give the user control.

Placement of Interactive Controls Within the Screen Real Estate

A sure way to slow down a user and to frustrate them is to spread interactive controls to all corners of the screen real estate. Placing heavily used interactive controls on opposite sides of the screen may balance the layout and look good, but their placement means the user will have to make a lot of extra wrist and arm movements to access them. It is much easier for the user (and less encouraging to the formation of carpal tunnel syndrome) to group related interactive controls together (see Figure 3–24).

One way to determine if interactive controls belong together is to analyze if they are global interactive controls or local interactive controls. A **global interactive control** is a control that is accessible over and over again within the majority of the interface—for instance, "forward," "backward," and "main menu." The user will access these controls multiple times during the interactive session, so the best ergonomic placement of these controls is to group them together in a predictable, consistent spot onscreen.

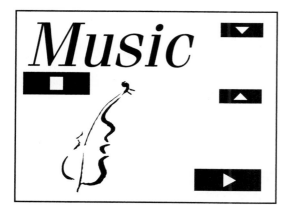
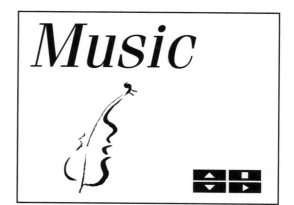

Figure 3-24 The screen on the left depicts an ergonomically incorrect user interface. In order for the user to access these controls, they will have to roll their pointer all over the screen. The screen on the right, while essentially the same layout, conveniently groups the interactive controls together in a much ergonomic layout.

Figure 3-25 A convenient grouping of global interactive controls (quit, main menu, back, and next) and local interactive controls (lo fat and print).

Figure 3-26 Screen from the experimental and playful multimedia project "Playtime Pad." When the user rolls their pointer over the sleeping dog, he wakes up and barks at the user's pointer (see Figure 3–14 for the whole dog sequence).

The placement of a local interactive control, on the other hand, is a little more forgiving. A **local interactive control** is a control that occurs infrequently or only in association with certain topics or media. The option of playing an animated sequence, for example, might occur only during certain topic categories; consequently, the interactive control would appear only when the animation is accessible. These local interactive controls theoretically can be placed anywhere onscreen, but if a number of them are available at one time, it makes sense to group them together whenever possible. This grouping of controls helps streamline the overall interactive process (see Figure 3–25).

There may be times, however, when you want the user to cover a lot of territory. In Figure 3–26, for instance, the whole screen shows a playroom to be explored. In this instance, the screen (and the controls onscreen) are deliberately set up in such a way as to invite exploration and discovery. In this example, the designer wanted the user to move the pointer around onscreen in order to search for interactive possibilities. When the pointer moves over elements onscreen (such as the dog, the TV, and the carpet), some of them move, inviting the user to click on them.

Grouping Navigation Controls

By the time you place all the navigation controls onscreen the screen can look pretty cluttered. One way to clean up the screen real estate and clarify the interface is to group control functions together in navigation bars, pulldown menus, or control panels.

❏ A **navigation bar** is used to group together frequently used global interactive controls (like "quit" and "next" buttons). Navigation bars can be a simple text list or a combination of text and graphics (see Figure 3–27). A navagation bar should be placed within a designated area onscreen where the user can consistently find it.

❏ A **pulldown menu** is a good option for longer lists of controls, like the one shown in Figure 3–28. The disadvantage of pulldown menus is that they take up a lot of screen territory when active. They disappear from the screen, however, after a choice is made.

❏ **Control panels** are similar to navigation bars in that they can hold global interactive controls or local interactive controls in a condensed strip of icons (see Figures 3–29 and 3–30).

Figure 3-27 Two states of the navigation bar from "Playtime Pad." The image on the left shows the inactive state of the navigation bar. The image on the right shows the bar's active state. The user can access the navigation bar by clicking and dragging on the drawer of the TV table.

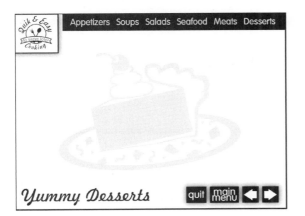
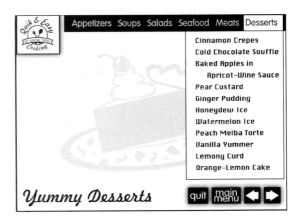

Figure 3-28 Two views of the same screen. The screen on the left is the base screen without any pulldown menus active. The screen on the right shows how much room the pulldown menu occupies on the screen.

Figure 3-29 A control panel with global interactive controls.

Figure 3-30 A control panel with local interactive controls.

Transparency

One of the ways to gauge a good interface and navigational design is the degree to which it goes unnoticed. The better the interface design, the more intuitive—and therefore, more transparent—the design appears. If a user has to puzzle out how to navigate their way through the content or if the interface is unfamiliar and counterintuitive, they may not understand the message of the project. And, just like any other communication medium, the message should drive the interactive project.

Building intuitive interactive controls depends on creating straightforward icons, buttons, and imagemaps (and any other type of interactive control you can think of) with comprehensible

● **Interactive Design Principle**

Design interactive controls that the user can grasp intuitively.

Figure 3-31 An example of a difficult-to-understand dialogue box.

text. Icons, buttons, and imagemaps should be easily recognizable and their functions clear and consistent no matter where they appear in the document. The text used with any interactive control should relate to its function, and descriptive text appearing in menus and dialogue boxes should avoid programming jargon understandable only to specialists (see Figure 3–31).

Furthermore, you should avoid duplication of interactive controls onscreen that do essentially the same thing. An interface that uses both clickable imagemaps and text-based buttons to perform the same actions is clearly redundant and may unintentionally confuse the user. At the very minimum, this arrangement wastes users' time, as they may be apt to try every interactive control onscreen. Imagine the potential for growth of user irritation when multiple buttons send them back to the same content and screen.

Provide Clues

It is important to provide clues onscreen to inform the user about what is clickable as well as to provide feedback to the user. Clues may range from rollover buttons that light up when the pointer rolls over them (informing the user they have interactive possibilities) to buttons that perform a brief animated sequence when clicked (telling the user that the command has been acknowledged).

People like to know when they are using an interactive document that the program is working properly and is responsive to their commands. Feedback clues provide this reassurance to them. Using multi-state buttons (such as rollover and highlight buttons) is an excellent way to show feedback, as they display a different image when the user clicks on them. Not all feedback clues need to be visual; for instance, a viable feedback clue might be as subtle as a low "click" noise when the user clicks on a button.

Building clues into the interface can also help the user understand which controls and content are most important in the inter-

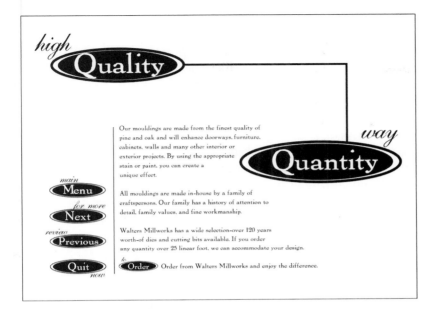

Figure 3-32 The global interactive controls in this screen—"menu, next, previous, quit"—are larger than the local interactive control "order." The difference in size reflects the relative importance of the controls; the global interactive controls are more important and, therefore, are bigger.

face. The most important information can be made more prominent through size, color, animation, or sound. A global interactive control, for example, could be larger than commands that show up only once or twice in the document (see Figure 3–32). An important piece of content might be in color, while other less important pieces of content are presented in gray tones. An animated narrator or character might pop up onscreen to advise the user to choose a particular control. All of these methods can be used to direct the user's attention to important controls and available content.

Give the User Control

Users anticipate that they will be able to do whatever they want to do in an interface. This includes skipping over sections they have seen and going back to revisit sections as many times as they want. Users also expect to be able to correct any mistakes they make. If they inadvertently type a wrong letter or word, they expect to be able to reselect that letter or word and retype it. Creating user-friendly and ergonomic interactive controls (as well as an interface) involves giving the user as much control over their situation as possible.

Users rightfully expect to be able to leave screens that do not interest them instantly. Therefore, the user should be able to skip

 Interactive Design Principle

Let the user have as much control over the interface as possible.

Interactive Design Principle

Be forgiving of user error.

Interactive Design Principle

Let the user end the interactive experience at any time.

or stop all media that appears onscreen, whether it is a text field, video clip, or animation. Imagine accessing a screen where a video immediately starts to play. Suppose you have seen that video once before in your exploration of the document. How would you feel if you were not given the ability to stop or skip the sequence and, instead, the only way to exit that screen was by watching the video play on and on and on until it ended? Would you be annoyed?

Users also expect to be able to quit an interface at any time. Since the quit command is a global interactive function, users should have simple and straightforward access to this control at all times. What many interactive designers have discovered, however, is that the quit command is the last opportunity to communicate a parting message to the user. In many cases, clicking the exit button leads to an exit splash screen. This splash screen may briefly show credits or other product offerings, or it may ask any number of questions intended to give the user the opportunity to change their mind and reenter the program. When an exit splash screen is used, care should be exerted to not be too obnoxious about trapping the user in screen after screen of information (see Figure 3–33). If the user has to

Thank You

*For using our cookbook
we hope you enjoyed it . . .*

*Please feel free to try our other
great cookbook*

Southwest Meals • Texas Style

Click any key to continue

Figure 3-33 This exit screen advertises a product but also lets the user easily exit the document.

jump through hoops just to quit the program you can be virtually assured that they will permanently leave the program.

LESS IS MORE

Designing a highly usable interface also involves determining just how much functionality the document needs to convey the message. Since interactive documents have limited screen real estate in which to fit content and interactive controls, you need to decide how many options the user can access at one time. Each option takes up screen real estate, and the more options onscreen at one time, the more cluttered and confusing the interface becomes. Too many options detract from the experience as surely as having just the right number and kind of options enhances the experience.

One of the primary goals of an interactive designer is to build the simplest and most direct path between any two points in the document. This means simplifying how many levels of interactivity are between those two points as well as providing clear and unambiguous interactive controls that take the user there. Determining how to present the most information in the clearest possible way begins way back at the flowchart stage, and often continues all the way through usability and functionality testing.

Interactive Design Principle

Keep the design simple.

WORKING ON
THE SCREEN

OBJECTIVES

- To understand the effect resolution and screen dimensions have on your design
- To comprehend the use of anti-aliasing techniques
- To become familiar with the use of windows and panels in interactive documents
- To consider using grid structures and visual hierarchy in defining a multiple-screen layout
- To become familiar with the basics of color onscreen

RESOLUTION

Interactive documents are designed to display on computer monitors; therefore, the amount of detail in the images they display is limited by the screen's resolution. The term **resolution** refers to the number of dots per inch (or pixels per inch) displayed by a monitor or an image. The higher the resolution, the smoother and more detailed an image appears (see Figure 4–1). Computer screens display images onscreen via **pixels** (short for picture elements), tiny squares showing a single color, as can be seen in Figure 4–2. It is by looking at the entire image that the colors seem to blend together. Typically, Mac computer screens have a resolution of 72 pixels per linear inch, while Windows computer screens show about 96 ppi (pixels per inch).

Dots Per Inch (DPI) Versus Pixels Per Inch (PPI)

When is it appropriate to use the term *dpi* versus *ppi?* Readers who are familiar with laser printers and traditional printing processes in the print media world are accustomed to the term *dots per inch* (dpi). Many interactive designers also use this term, since many of them work with print media or have had teachers

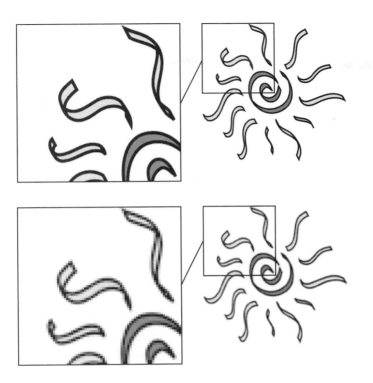

◉ Interactive Design Principle

The resolution of images in your inter-active document should match the resolution of the audience's display monitors

Figure 4-1 These figures show the same image at 300 pixels per inch resolution (top) and 72 pixels per inch resolution (bottom).

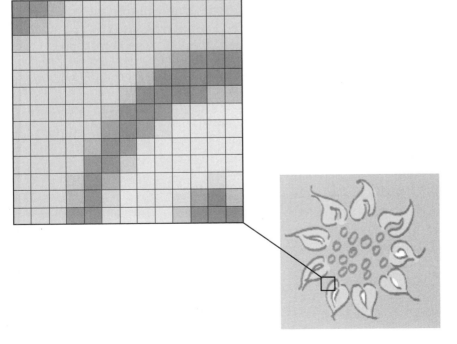

Figure 4-2 A section of this flower has been enlarged to reveal the pixels making up the image onscreen. Each one of the squares in the enlarged detail is an indi-vidual pixel.

who were familiar with print media.

An image, when printed to paper, will print out in a series of dots per inch. These dots are reduced or enlarged by laser printers to simulate varying intensities of lightness and darkness. An image seen onscreen, however, is always shown via a square pixel. The size of a pixel never changes, only the color within it. So, to be strictly factual, an image intended to be seen onscreen should be referred to using the term *pixels per inch* (ppi), while an image intended for print media should be referred to using the term *dpi*. This book follows that style, as interactive media is definitely *not* print media. The term *dpi*, however, is widely used and understandable by both print designers and interactive designers.

Since the computer screen has a fixed number of pixels available to display images, you should try to keep your image resolutions small to accommodate the number of pixels per inch available on your audience's monitors. 72 ppi is widely accepted as the standard, as it is a good, workable display resolution for Mac and Windows monitors. 72 ppi images have enough detail to display nicely on both platforms, and these images save in small file sizes. (The smaller the file size of an image, the faster it will download to the screen). Images with a resolution that is higher than 72 ppi will map to a one-to-one proportion to the screen resolution. Figure 4–3 demonstrates this effect.

Two graphics have been created for comparison purposes. One

Figure 4-3 The graphic on the left is at 72 ppi resolution, while the graphic on the right is at 144 ppi resolution. Displayed on the same 72 ppi monitor screen, the 144 ppi graphic will display at 2" in size.

graphic is 72 ppi square, while the other is 144 ppi square. When the 72 ppi image maps onto a Mac monitor, it displays at 1″. The 144 ppi image, on the other hand, enlarges to twice as big, or 2″ in size. As a further comparison, the 72 ppi image displayed on a Windows monitor will show up slightly smaller than 1″. As you can see, high resolution images used in online or multimedia projects will dramatically enlarge, consequently disturbing your screen design. Images with extremely high resolutions will render the design virtually useless.

SCREEN DIMENSIONS

When designing your interactive project, one factor to take into consideration is the most prevalent size of monitor used by your target audience. Many users (especially those individuals using school computer labs to "cruise" the Internet) access interactive designs using 13″ to 15″ color monitors. This is the result of economics, since smaller monitors are more affordable than 17″ to 21″ monitors. As the cost of large monitors goes down, the number of users viewing interactive designs on those monitors will rise. In the meantime, to accommodate the large group of users viewing documents on a small monitor, it makes sense to restrict the total size of your screen layout to fit within the 640 × 480 pixel dimensions of those 13″ to 15″ monitors (see Figure 4–4). If you know that most of your audience will have a larger monitor, however, you may want to go ahead and design for a monitor of that size.

Figure 4-4 Standard screen dimensions (in pixels).

> **NOTE**
> A pixel dimension of 640 × 480 is considered the standard screen resolution for full-frame video.

Another trend to watch (in terms of helping you to decide what the screen dimensions of the project should be) is the growing availability of television-based web access devices such as WebTV. WebTV is a combination of hardware and software that lets users interact with the Internet through their television. WebTV screens have a default screen dimension of 544 × 376 pixels. (Compare this to Netscape Navigator's default screen dimension of 490 × 337 pixels.) These dimensions are smaller than 640 × 480 in part because a portion of the screen holds icons, com-

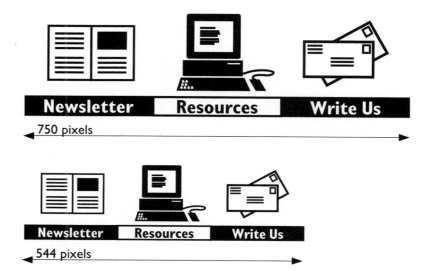

Figure 4-5 Images larger than WebTV's default screen size will shrink to fit into the space.

mands, and scroll bars.

If WebTV becomes a widely used standard, clearly you will have to take this pixel dimension into consideration when designing online documents.

> **NOTE**
> Web pages designed wider than WebTV's default window size will shrink to fit into the 544 pixels available (see Figure 4–5).

How Is Your Interface Design Influenced by Low Screen Resolution?

Designing for low screen resolutions demands thoughtful consideration of what typefaces and kinds of images will look best onscreen. Here is a list of some of the most common ways that low screen resolution influences your interface design.

 Aliased images and text have jagged edges that affect how good the images look onscreen and the legibility of the typefaces onscreen (see Figure 4–6). You will have to choose typefaces carefully, testing them in sample documents to preview their legibility onscreen.

Figure 4-6 The type on the left shows the effect of low resolution on the graceful curves of the typeface. The type on the right shows that same typeface at the higher resolutions allowable by print media.

Figure 4-7 This figure shows how pixelated the edges of a 72 ppi image become when enlarged.

❏ To avoid jagged, stairstepped aliased edges, some images can be anti-aliased, a technique that "smoothes" out edges and makes them look more natural. Not all images, however, can be anti-aliased, so you will have to learn when and when not to use this technique. (More information about anti-aliasing is provided later in this chapter.)

❏ Low resolution images cannot display fine details. Therefore, avoid images with a lot of fine details.

❏ Images absolutely necessary to the design will have to be dramatically enlarged to show the details.

❏ You will learn to avoid enlarging small, low-resolution images, as the larger the image is stretched, the more jagged the edges appear (see Figure 4–7).

ALIASED VERSUS ANTI-ALIASED OBJECTS

Images onscreen are made up of square pixels; therefore, the edges of images tend to look square and stairstepped. These jagged edges are called **aliased** edges.

One way to avoid the "jaggies" on edges is to apply a technique called anti-aliasing to the image. **Anti-aliasing** creates pixels in between the foreground and background colors that blend the two colors and smooth out the jagged, stairstepped edges on an object (see Figure 4–8). The technique also makes the image appear to have more resolution than it actually does.

Anti-aliasing is most useful when the image stays paired with one background. If you anti-alias an object and then move the object onto a new background (especially one that is lighter or darker or a different color), the anti-aliased edge will not match with the new background and a clear "halo" will appear (see Figure 4–9). This halo effect is also known as an anti-alias artifact.

If the image will be used in several places on a variety of differ-

Figure 4-8 The top left image is an aliased image. Note the jagged, stairstepped look of the edges of the form. The top right image has been anti-aliased, showing the method's characteristic rim around the edges of the form. These pixels form a smooth transition between the foreground and background colors

Figure 4-9 An example of anti-aliased type that has been placed over a background other than its original background. Note the halo effect around the edges of the letter forms

ent backgrounds, it may be best to avoid anti-aliasing the edges. If an aliased edge is completely unacceptable, however, you will have to create a custom anti-aliased image for every background.

BACKGROUNDS

When designing an interactive document, one of the quickest ways to help establish a stylistic look and feel is to add a background image. Since this background image may be used over and over again within the document, picking one that fits stylistically with other visual elements *and* ties in with the content is critical.

No matter what image you choose for your background, it is important to make sure that the background is light enough that it does not interfere with the readability of other images layered over it. For example, a background that is too intense or has many changes of color makes it difficult to read type layered over it (see Figure 4–10).

Because background images often stay onscreen while other images change out over the top of them, it is a good idea to save the background as an independent image. In fact, you may end up creating several different versions of the background, especially if at times the background must have anti-aliased images matched up with it. Additionally, since there may be many different kinds of images placed over the top of the background, saving alternative versions of the background allows you to minutely adjust color and contrast to enhance legibility.

Backgrounds in Online Documents

Two major factors to keep in mind while selecting a background for use in an online document are file size and color. In general, the larger the image, the larger the file size, and consequently the slower the image will download over the Internet. What you should avoid, at this point in the technology, is using full-screen images as backgrounds in online documents. Full-screen images, especially if there are any other pictures, icons, or graphics present, take a significant amount of time to download. How long the image takes to download depends on the speed of the user's modem and the connection lines involved.

Standard copper wire telephone lines are slower than other

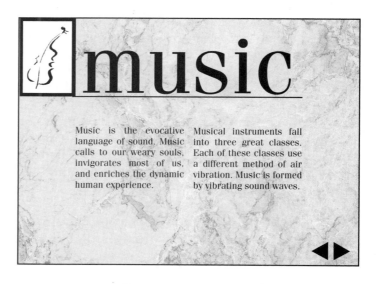

Figure 4-10 These two screens use the same background, but at different intensities. Note how much easier it is to read the text on the lighter background in the upper screen than it is to read the text crossing the more intense background in the lower screen.

digital transmission lines like ISDN. Since many users access the Internet using standard copper telephone wires, they may become frustrated at the download speed of a large background graphic and interrupt the download, and probably move on to another site. Some users may even disable image loading entirely and view your web page as a text only document. There are a couple of options to use in creating backgrounds for online documents that will help to avoid this situation.

COLORPLATE

An example of a simple background choice.

 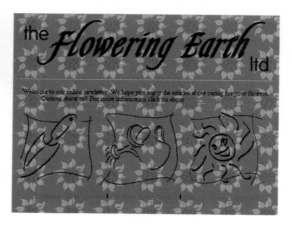

 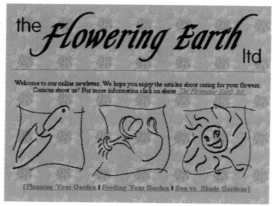

 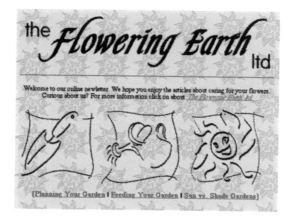

COLORPLATE 2

This figure shows how subtle variations in an image tiled into the background of an online document can affect the readability of the interface. Pay particular attention to the readability of the small type in all three home pages.

COLORPLATE 3

This vibrant color combination conveys an impression of energy.

COLORPLATE 4

Blue color combinations can be soothing.

COLORPLATE 5

Bright colors convey an impression of energy, while lighter colors seem more subdued.

COLORPLATE 6

The images on the left are easily read when displayed on a color monitor. However, when the same images are displayed on a grayscale monitor, it becomes clear that the top image suffers from a lack of contrast.

COLORPLATE 7

Not all color combinations are as easily readable on a grayscale monitor.

COLORPLATE 8

Several different type and background color combinations. While all are readable, some combinations are more difficult to read (second and third rectangles from the top).

Lorem Ipsem dolor con secteteur elit, adipsicing sed ali quam erat volaput. Sunt ut labore in velit esse dolore.

Lorem Ipsem dolor con secteteur elit, adipsicing sed ali quam erat volaput. Sunt ut labore in velit esse dolore.

Lorem Ipsem dolor con secteteur elit, adipsicing sed ali quam erat volaput. Sunt ut labore in velit esse dolore.

Lorem Ipsem dolor con secteteur elit, adipsicing sed ali quam erat volaput. Sunt ut labore in velit esse dolore.

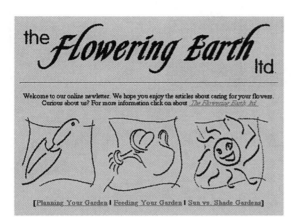

Three possible ways an online document could be viewed by different users. The top image shows a standard, default browser setting. The middle and bottom images depict what happens to the legibility of the small type when the user customizes the background color settings in the browser preferences.

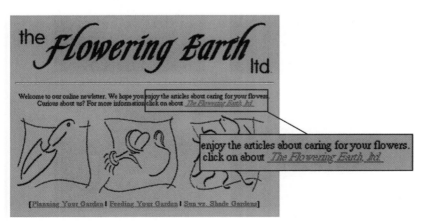

COLORPLATE 10

This RGB scale shows how three different color intensities of red, green, and blue combine to form different colors. Each color scale contains 256 colors; therefore, a standard computer will allow you to mix colors using 256 x 256 x 256 possible combinations.

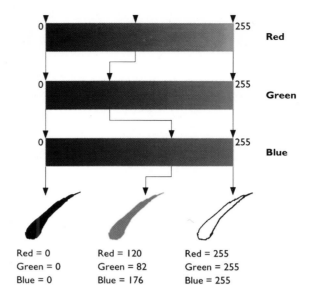

0	255	Red
0	255	Green
0	255	Blue

Red = 0
Green = 0
Blue = 0

Red = 120
Green = 82
Blue = 176

Red = 255
Green = 255
Blue = 255

COLORPLATE 11

Image "a" shows the original 8-bit image. At 8-bit quality, this image will work very well in a multimedia project; however, in the interest of speeding download times in an online document, you might want to consider using a lower bit-depth. The lower the bit-depth, the smaller the file and the faster it will download.

Image "b" has been indexed (reduced) to 7-bit color, image "c" to 6-bit color, image "d" to 5-bit color, image "e" to 4-bit color, and image "f" to 3-bit color.

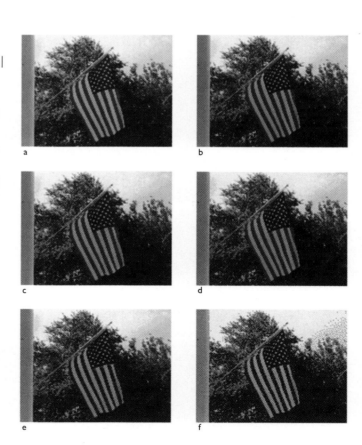

a

b

c

d

e

f

COLORPLATE 12

The top image shows the original 8-bit image, with a detail showing the pixel quality of the image. The bottom image has been indexed into a 7-bit image. The enlarged detail of the bottom image shows how the program moved and altered pixel colors to simulate the original colors with a more limited color palette.

COLORPLATE 13

The parrot indexed using the "pattern dither" option. Notice the weird burlap-like texture of the image.

COLORPLATE 14

This image was indexed using the "diffusion dither" option. Diffusion dithering tends to look more natural than pattern dithering.

COLORPLATE 15

An example of an image indexed without choosing a dither option. Notice how the colors have banded.

▨ COLORPLATE 16

The top image was created using a standard 256 color palette. When this image is displayed online (bottom image) using the default 216 Web palette, it tends to dither badly.

▨ COLORPLATE 17

Image "a" is shown with its custom color palette (top right). When image "c" loads onto the screen with its own custom palette (bottom), image a will remap to conform to the new custom color palette, as shown in image "b".

The simplest option is to designate a single background color for your online document, like that shown in Colorplate 1. The downside to this solution is that the color you see on your screen may not be the color the user sees. Mac and Windows monitors display colors slightly differently, as do different browsers. **Browsers** are computer programs such as Netscape Navigator and Internet Explorer that are used to view online documents. Browsers read and interpret the computer language used to build each document. There are a number of online programming languages available, of which **HTML** (HyperText Markup Language) is perhaps the best known. Not all browsers interpret color exactly the same way. Therefore, to avoid any possible color problems, it is best to keep the color light so that any text onscreen is readable, no matter how the background color displays on the user's monitor.

Another option is to create a small image and "tile" it in the background of the document. Many browsers support the option to tile (repeat over and over) an image. If you have spent any time online, you probably have already seen tiled backgrounds that range from subtle to appalling. A word of warning: if the original tile image is colorful or busy, it will quickly become obnoxious once it is tiled over and over again onto the screen, as can be seen by the three examples of background tiles in Colorplate 2. The best way to avoid this possibility is to pick a subtle pattern and color and to be aware that different platforms, monitors, and browsers will display your design in a slightly different way than the way it appears on your computer screen. If possible, try to view your online document on several different browsers to catch any problems.

WINDOWS AND PANELS

At times you may want to use, or the client may insist that you use, a background image that resists all your best efforts to integrate it with other elements onscreen. In this situation, windows and panels are useful visual devices that can help you layer elements onscreen in a more readable way.

A *window* is any area of the screen designated to hold motion media (such as video and animation). Most people initially think of a window as being a rectangular shape similar to a standard video window. Many authoring programs, however, offer the opportunity to use custom shapes to hold media. Figure 4–11

Figure 4-11 Windows can be placed anywhere on the screen and as a wide variety of custom shapes. This particular screen uses the metaphor of a TV screen as a window to hold content.

shows a custom window shape. A **panel** is any shape placed beneath other elements and media such as type or photos to separate them from the background. Figure 4–12 shows how a panel can be used to enhance the legibility of type crossing a busy background image. Panels can be rectangular, circular, oblong, or a custom shape, and they range from nearly transparent to fully opaque. In the print world, a panel would be called a screen.

Good Reasons to Use Windows and Panels Onscreen

❏ They can draw attention to important elements and add extra emphasis to content.

❏ You can use them to help establish a unified look in your document. Using the same style, color, and size of panel throughout the document establishes a consistent visual style.

❏ Windows and panels can help the viewer figure out relationships between items. A series of related topic screens, for example, could all use the same color panel.

❏ They can point to certain areas of the screen as being reserved for displaying specific kinds of content.

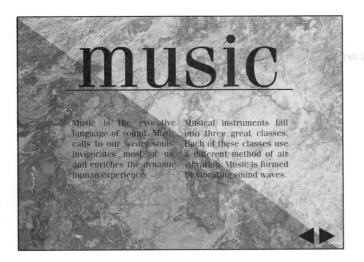

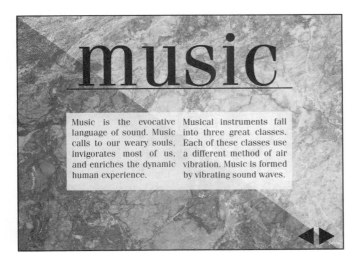

Figure 4-12 The small type in the top interface is nearly impossible to read as it crosses over a very busy background texture. The bottom interface shows how a panel can be strategically placed behind the type and in front of the background to enhance the legibility of the text.

❏ Windows and panels help define a grid structure within the screen layout and can balance other elements onscreen.
❏ Windows and panels help to fill empty space so other elements do not appear to float onscreen (see Figure 4–13).
❏ They can be used to enhance the legibility of media and typography layered over a busy background.

Figure 4-13 The top screen image in this figure shows the text layered over the original background. The intensity of the background in the top image makes it difficult for the user to see the type and interactive controls. Panels placed strategically on the screen (middle) greatly improve the legibility of the type and interactive controls as well as anchoring the images in place. The bottom image shows how additional content can be placed into the panels

LAYOUT

Layout is the part of interface design that is focused primarily on making everything onscreen balanced, aesthetically pleasing and easy to read. Layout involves arranging all of the type, images, media, and interactive controls on the computer in a visually pleasing and functional manner.

Layout is concerned not only with individual screens, but with all of the screens in the document. Since it is common for screens to change out either as a whole or in parts (as content is added

> Good layout design encourages easy scanning.

or taken away from the screen), you can guess how complicated the task of forming a functional layout can become.

There are countless ways to arrange elements onscreen. How you place elements on multiple screens depends a great deal on your audience, the message, the different kinds of media you have available (such as text, graphics, video, and so on), and what content must be emphasized to best get the message across. As you design your interface, keep in mind that while you want your interface to have a sense of dynamic energy, you do not want it to look cluttered and confusing. Try to avoid using too many special effects or media elements at one time. Simplicity is often best.

Many layout conventions useful in print media can be applied effectively to interactive designs, since so many people in the audience are familiar from early childhood with these print conventions. People encounter print conventions every day in newspapers, magazines, posters, brochures, and books. Therefore, it makes sense to let people bring their real-world familiarity with print to the computer screen as much as possible. Not all print conventions apply directly to interactive documents, but a good layout onscreen, like a good layout on paper, has a clear visual hierarchy, a unified look and feel, and a balanced composition.

LAYOUT AND VISUAL HIERARCHY

When developing a layout, you should ask yourself, "What is the message? Which pieces of content are critical to communicating the message clearly?" By asking these questions, you begin to define which text and images should be emphasized in the screen layouts. Defining which items of content are critical in conveying the message helps you to arrange the content into a visual hierarchy within the screen layout. **Visual hierarchy** is the arrangement of elements according to importance and emphasis. Typically, this involves emphasizing certain elements in order to influence the user to look at and interact with a certain item first, another item second, yet another item third, and so on. Figure 4–14 shows two variations of a simple screen design, one with and one without a clearly defined visual hierarchy. Browsing through an interactive document without a visual hierarchy is analogous to listening to three different radio stations playing at full volume; it becomes confusing and irritating.

In shaping a strong visual hierarchy system, it helps to understand how individuals from Western cultures determine the

Figure 4-14 The screen on the left shows a layout lacking visual hierarchy. All the type is the same size, making it difficult to determine what is the most important information on the screen. In contrast, the screen on the right has a clearly defined visual hierarchy, helping the reader to determine which information should be read first, second, and third.

importance of information in a layout. In general, people from Western cultures will:

❑ Quickly scan from upper left to bottom right to get an overview of the entire screen image. This is a learned response developed from reading text from left to right in Western print media such as books and magazines (see Figure 4–15);

❑ Tend to look at larger items first and smaller items last (see Figure 4–16);

❑ Be attracted to brighter colors first, but also look at colors that contrast with or are different from other colors;

❑ Interpret items placed above other items as more important than items placed below;

❑ Look at items that appear to be "heavier" first;

❑ Assume arrows or elements pointing to the right mean "forward" while arrows or elements pointing to the left mean "backwards";

❑ Look at moving elements before looking at static elements;

❑ Assume items that make sounds are more important than items that do not make sounds; and

❑ Tend to look at moving images of another human (such as a videotaped personal interview) before moving on to other elements.

Figure 4-15 This figure shows the typical visual path a reader from Western cultures will use to quickly scan over a screen.

Lancelot & Guinevere

Historical Romances

Figure 4-16 Viewers tend to be attracted to larger items first.

Techniques to Draw Attention to a Visual Focal Point

The following list contains some of the visual techniques you can use to emphasize the focal point in your visual hierarchy. Keep in mind, however, that in order to create a strong visual hierarchy, you need to consider the placement of all the elements onscreen, their conceptual and visual relationship to one another, and design factors such as color, size, visual weight, and, in motion media, how long the clip will play and what other elements must be synchronized to play with it (for example, sound). Once you have selected an item you wish to establish as the primary focal point in the visual hierarchy, you can try some of the following techniques, but remember that these visual techniques should be tailored to the needs of your project.

❏ Make it the biggest.
❏ Make it the brightest.
❏ Enclose the item in a different shape than that of the other content onscreen.
❏ Make the item a different shape than that of the other content onscreen.
❏ Add a border to the shape around it.

❏ Change the color of the item to make it a different color than other items onscreen (try contrasting it with other items).
❏ Isolate it from other items onscreen.
❏ Add a special effect to it (for example, add a texture).
❏ Make it bright if everything else is dull, or vice versa.
❏ Make it sharp if everything else is out of focus.
❏ Position the item so all of the other elements lead to or point toward it.
❏ Animate it (for example, make it blink or change colors, apply a rolling texture to it, or create a looping image animation).
❏ Use another animated element to call attention to the item.

DESIGN A UNIFIED INTERFACE

In order for an interface to look unified, all of the elements and screens must look like they belong together. Unity is a critical factor in designing a working interface, as a unified interface helps the user see the document as a coherent work instead of an assortment of unrelated screens. A unified interface design will be more memorable, easier to use, and communicate more clearly than a chaotic, unorganized interface design.

To achieve a unified interface, elements onscreen should have a similar visual style, be properly aligned, and be organized into a consistent visual hierarchy system. The following passages cover several visual devices that can help you shape a unified interface design.

Visual Style

When you create a common visual style between elements on the screen, you establish a visual connection between those elements, which strengthens the overall layout. There are many ways to achieve a unified visual style. Choosing similar colors, shapes, line weights, typography, photographs, and illustration styles is a common visual solution used to help create a unified visual style. Having one artist create all of the images is another. Repeating a certain element—whether a line, icon, or some other visual image—throughout the screens also helps unify the layout. Figure 4–17 shows how the consistent use of lines, typography, images, and placement can shape a unified series of screens.

NOTE

The most natural elements to repeat throughout the interface are global interactive controls such as "next," "previous," "main menu," and "quit." Since these controls are present on multiple screens, they provide the perfect opportunity to begin to set up a unified visual style.

Sometimes, getting images to work together onscreen is as simple as altering image colors or finding the right background. Other times, you may have to use other visual techniques such as shadows, size, placement, silhouetted images, and custom edges to establish a unified look. As an example, a few images have been chosen to be integrated into a screen design. Figure 4–18 shows the original images selected. As you can see, the images are in three different visual styles, yet related by subject matter (cars). Note that while the three images of cars vary in style—one is a photograph and two are in different illustration styles—they have a common element: the grills of all three cars are pointed toward the viewer. Figures 4–19 and 4–20 show variations on how these different visual elements could be used to establish a unified visual style.

Figure 4-17 This series of screens appears unified due to the consistent use of type, image, placement of interactive controls, and illustration style.

Figure 4-18 The original four images used in Figures 4–19 and 4–20.

Alignment

There are two major visual alignment issues at work within interactive documents—alignment and registration. Good **alignment** in a screen layout generally means the viewer can draw

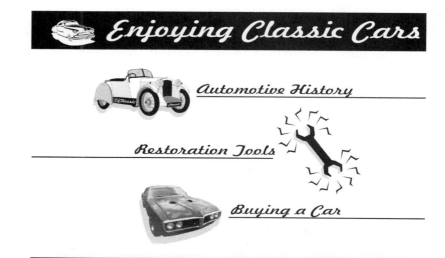

Figure 4-19 In creating this figure, the author used a variety of visual techniques, including vignetting the photographic image of the car, adding a dropped shadow to the images, and reversing the illustration of the car in the title block from black to white to match the illustration with the white type in the title block.

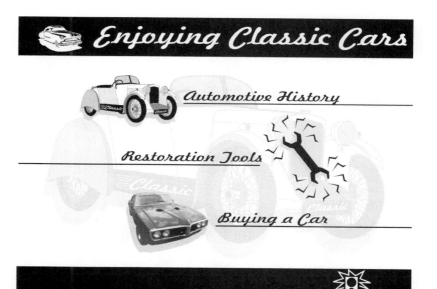

Figure 4-20 In this figure, the author used all of the techniques from Figure 4–19 *and* repeated one of the illustrations as a background image. Adding the background image helped anchor the other visual elements on the screen.

Figure 4-21 Drawing a series of dashed lines through this sequence of screens clearly shows the underlying alignment between elements on individual screens and between screens.

visual connections between the edges or axes of type, images, lines, shapes, and any other elements onscreen (see Figure 4–21). The easiest way to achieve alignment is to plan a grid structure. Planning a grid subdivides the screen into fixed horizontal and vertical divisions and sets up an organized framework for placing space, type, interactive controls, and visual elements onscreen. A solid grid design can help you establish a layout plan for multiple screens. (The grid is examined in depth later in this chapter.)

The other visual alignment issue you will have to deal with when aligning elements across multiple screens is making sure those elements are in proper registration. Elements in **registration** are aligned down to the exact pixel. For example, if one screen has a "main menu" button placed exactly 25 pixels in from the left edge and 244 pixels down from the top edge, then that element will be properly registered on the next screen if it is placed in exactly the same pixel position. If the element varies even one pixel, the button will appear to jump slightly as the new screen pops into place over the old screen.

Balance

Interactive documents are dynamic, undergo constant change, and combine many different elements onscreen. Elements can appear and disappear on a single screen, videos and animation play onscreen, or whole screens transition into new screens. All of this activity makes the task of achieving a balanced composition difficult.

Why is it necessary to achieve a balanced composition in the first place? Because people feel comfortable with a balanced interface design. And the more comfortable a person is with a design, the more likely they will stay to explore it further. When a layout is balanced, the user feels as if the screen design is more unified and harmonious (see Figure 4–22).

Figure 4-22 The image on the left is unbalanced, as the majority of the visual weight is on the left side of the image. The image on the right has a more balanced distribution of visual weight.

Visual Weight
Visual Weight

Figure 4-23 Note how bold and prominent the bottom type is in comparison to the same size type (but in a regular weight) on top. The heavy visual weight of the bottom type will draw the viewer's eyes faster than the less prominent type on top.

A **balanced design** is one in which the visual weight of elements appears to be equally dispersed throughout the design. *Visual weight* is the illusion of physical weight of an object onscreen. For example, a headline set in **bold** type will have more visual weight than the same size headline set in regular type, as can be seen in Figure 4–23. In general, there are two ways of achieving a balanced design: you can make a symmetrical design or an asymmetrical design.

A *symmetrical* design is created simply by drawing an imaginary vertical axis down the center of your screen and arranging identical or similar elements so they are equally distributed on either side of that axis. Symmetrical designs often appear formal. An *asymmetrical* design is the arrangement of unequal weight elements onscreen. Asymmetrical designs tend to be dynamic. Creating an asymmetrical design is more challenging, as each individual element needs to be considered and weighed against every other individual element onscreen.

Whether you choose to design a symmetrical or asymmetrical layout, you will need to consider the visual weight, color, size, and alignment of all elements onscreen.

Flow

A layout with a good *flow* will visually lead the user from one element to another element on the screen. Keep in mind as you arrange elements onscreen that Western audiences are conditioned from reading text to scan their eyes from left to right.

Flow also refers to how smoothly screens transition into one another. A **transition** is a movement from one element or screen to another element or screen, and is usually accomplished via

using cuts, wipes, or dissolves (many authoring programs have a wide selection of preprogrammed transition effects readily available). For an example of a simple transition, see Figure 4–24. Transitions that are sloppy or abrupt, or the use of too many different kinds of transitions in one document, can appear inappropriate or even jarring.

The Grid

Good layout takes lots of planning. When you think about the fact that an interactive project usually has multiple screens with many different kinds of images and media, the task can seem overwhelming. If you approach your screen layout design with a basic grid structure, however, your task will become more manageable.

A **grid** is a system of guidelines, usually a series of horizontal or vertical lines, that divide the screen format and provide a way to consistently align elements in your layout. Figure 4–25 shows the underlying grid lines in a simple interface. The horizontal and vertical lines of grids ordinarily do not show up in the prototype or final product, as they are usually deleted from the document files after the screen layouts are completed.

In most screen layouts, a grid is a two-dimensional system for aligning elements onscreen and across multiple screens. In virtual reality and 3D animation, grids extend into three dimensions and are useful in organizing and ordering the 3D space. (Imagine the view of a city with crisscrossing streets. The streets are a grid system). Figure 4–26 shows the 3D grid structure used in the construction of an experimental virtual reality environment.

When you have many elements (such as type, images, video, animation, and so on) to organize and place in a unified layout design, grid structures are a good way to organize them. This is especially true when you are trying to maintain clarity, legibility, unity, balance, visual hierarchy, and a smooth flow of information across multiple screens. Grids can have as many or as few guide-

Figure 4-24 An example of a simple fade-to-black transition. Starting with the top image, a fade-to-black transition gradually becomes darker and darker until the whole image is obscured

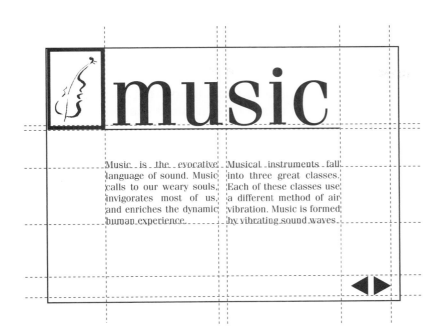

Music is the evocative language of sound. Music calls to our weary souls, invigorates most of us, and enriches the dynamic human experience.

Musical instruments fall into three great classes. Each of these classes use a different method of air vibration. Music is formed by vibrating sound waves.

Figure 4-25 Dashed lines drawn through this screen show the underlying grid structure that helps provide order for the overall layout design.

lines in them as you find necessary for aligning elements in your project. Grids, even the simplest ones that consist of only a few imaginary guidelines onscreen, underlie the elements onscreen

Figure 4-26 These two images reveal the underlying 3D grid structure used to help construct the avenues of this experimental virtual reality city. The left image shows the environment as it is normally seen. The right image shows the line structure of its streets and buildings. *(Courtesy Curt Fain.)*

and help establish a unified look either on a single screen or across multiple screens.

One point to keep in mind is that a grid structure is not intended to place your creativity in a straightjacket. The lines in the grid are *guidelines,* and there will be times that the placement of unique combinations of media in your document will demand that you break or alter the grid. Therefore, a good grid design is also a flexible grid design.

COLOR

Color plays an important part in the creation of interactive documents. Color evokes emotional responses, enhances stylistic unity, and can add or detract from the readability of the interactive document.

Color is a complex subject about which whole books have been written. It is beyond the scope of this book to go into scientific detail about color. Instead, the following pages summarize information about what is color, how color affects our emotions, and color palettes. Understanding more about color will help you shape more effective interactive documents.

ADDITIONAL RESOURCE
The Color Mac, Marc D. Miller and Randy Zaucha, Hayden,1992, Carmel, IN. A well-rounded discussion about color on the computer.

What Is Color?

Color is light energy in the form of waves and particles that is interpreted by the human eye as mixtures of red, green, and blue. The frequency of the lightwave determines the color that is perceived. High-frequency lightwaves register in the human eye as red. As the frequencies decrease, the eye sees orange, yellow, green, blue, indigo, and finally, violet. Lightwave frequencies higher than the red range are infrared energies; lightwave frequencies lower than the violet range are ultraviolet rays, X rays, and gamma rays.

The differences in the frequency of the lightwaves are interpreted in the retinas of your eyes. The retinas contain two types of light-sensitive cells: rods and cones. Rods perceive the

strength, value, and brightness of a lightwave, while the cones perceive the frequency of the wavelengths as red, green, and blue (RGB) colors. There are three types of cones, and each type perceives predominantly red, green, or blue wavelengths—although each cone is not sensitive exclusively to one color but can also distinguish limited amounts of the other two colors. This ability to read small amounts of other colors helps the brain interpret mixes of RGB as in-between colors, such as magenta, purple, and brown. Light reaching the rods and cones triggers an electrical signal that is sent to the brain, which processes the signal as colors in the visual spectrum.

The Psychological Impact of Color

Different colors can influence our emotions. The exact reason why colors are associated with different moods is debatable, and the associations made are influenced by individual preferences and cultural biases. Whether or not you are conscious of it, color influences your behavior. The psychological impact of color is an inexact science, but color does have a powerful impact. As a test of this, imagine trying to read a bright orange paragraph of text on a fire-engine red background. Would you find reading this text difficult or even disturbing?

Using color in a sophisticated, knowledgeable way can enhance the appearance and legibility of your interactive document. Using color poorly can produce an emotional effect on the user that can range from mildly disturbing to the color equivalent of fingernails grating on a slate blackboard.

Exciting, dynamic colors such as orange and red are considered warm or hot, perhaps because of a psychological link with fire. Bright oranges and reds convey an impression of excitement, passion, liveliness, and quickness, as can be seen in Colorplate 3. Orange hues influence individuals to eat more quickly—a reason fast-food restaurants use a lot of orange in their interiors (such as seat cushions, tabletops, and trash containers). Yellows and reds are also associated with speed and danger and are widely used in traffic lights as warnings to slow and stop. Dark reds are associated with the color of blood and suggest passion.

Cool colors such as blue and violet are interpreted as serene and soothing (see Colorplate 4) and can convey an impression of cold and shade. This feeling of coolness may arise from the association of blue with bodies of water. Darker shades of blue and

violet are often interpreted as moody. Greens imply vigor and growth and are considered nurturing. White is widely used in hospitals, as it suggests purity and cleanliness.

Bright colors seem more exciting and active, while softer, lighter colors seem more soothing and passive. (Individuals in search of romance commonly turn down the lights to create a sense of security and comfort.) Designers can imply a sense of energy by using bright color combinations such as green, purple, and pink (see Colorplate 5).

Certain color combinations are associated with events, historical periods, and certain nationalities and cultures. Red and green are associated with the bright cheer of Christmas. Faded rose, blue, tans, and yellows suggest aged, antique materials. Red, white, and blue bring all-American images to mind such as mom, apple pie, and the symbolism of the flag.

When making an interactive document, especially one intended for cross-cultural or cross-nationality distribution, the meaning of colors in individual cultures and nations should be studied. Seeking the advice of a graphic designer or an artist from the target culture or nationality can reveal color choices that communicate something different than intended. As is true with so many aspects of creating an interactive document, research and knowledge is vital to the formulation of a working interactive document.

COLOR METHODS

Computer monitors project lightwaves to depict colors. Most monitors emit beams of red, green, and blue (RGB) electrons onto a layer of fluorescent phosphor that coats a glass screen. It is the mix of RGB electrons on the phosphor that causes the screen to glow, creating visible colors. The RGB beams are focused and fire in triples. Each triple beam projects onto a singular pixel. The RGB beams are so focused that they appear to your eyes as one color.

Additive Color

When the monitor uses projected RGB light to create colors, it is using the additive color method (see Figure 4–27). The additive color method starts with an absence of all color, which results in black. Equal proportions of the RGB beams result in white.

Varying intensities and proportions of RGB lightwaves create the *gamut* (the full range of colors) available onscreen.

Subtractive Color

As a comparison to the additive color method, the print media industry uses the subtractive color method. In the additive color method, white is achieved by using the full intensity of projected RGB light. The subtractive color method achieves white by the complete absence of the colors cyan, magenta, and yellow (CMY). Mixing the full intensity of the CMY pigments produces a dark color that is almost black (see Figure 4–28). To achieve a true black, black (K) pigment is added. This CMYK color combination is widely used to achieve a range of color on paper.

COLOR MONITORS VERSUS GRAYSCALE MONITORS

Most color monitors can easily display at least 256 colors, and many can display thousands and even millions of colors. As the technology advances, so, too, do color display capabilities.

At this point in time, however, there is a wide range of monitors

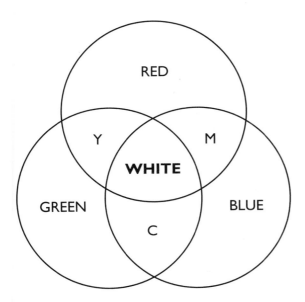

Figure 4-27 The additive color method.

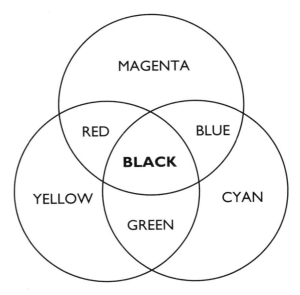

Figure 4-28 The subtractive color method.

in use with differing capabilities, and it is difficult to completely predict how many colors your audience's computer monitor will be able to display. Furthermore, not all monitors currently in use can even project colors. A *grayscale monitor,* for instance, projects light in varying intensities to create gray shades. Common uses for grayscale monitors are in small handheld games, portable laptop computers, and full-size computer screens.

Since there is a bit of uncertainty about how many colors your audience's equipment will be able to display, the best way to ensure your document will read well on all monitors is to plan for 256 colors. If you build in enough contrast between text, images, and backgrounds, 256-color documents will display decently on both color and grayscale monitors.

USING HIGH CONTRAST IN YOUR INTERACTIVE DOCUMENT

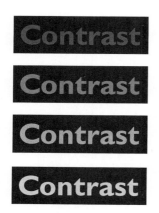

Figure 4-29 An example of different levels of contrast.

Since your interactive document could potentially be displayed on either a color or a grayscale monitor, it pays to make sure all images and text in your document can be clearly read on a wide variety of monitors. As a word of warning, documents with low contrast between text, images, and background can become almost unreadable on a grayscale monitor (see Colorplates 6 and 7). On the other hand, adding contrast to the text, images, and background in your document will improve its legibility whether it is displayed on a grayscale monitor or a color monitor (see Figure 4–29).

NOTE
One way to check whether your document has enough contrast in it is to periodically view it in grayscale. This is easily accomplished by changing the default software setting of a color monitor from "color" to "gray." This helps you identify and correct any potential contrast problems early.

It is important to make sure there is plenty of contrast between text and background colors, as text can be tiring to read onscreen. Small amounts of text can be easily read in light type on a black or dark background, while longer passages of text work better with dark type on a light background. Maximizing contrast is more critical when using long passages of small type; in this

instance, perhaps the best color mixes are black or dark blue text on a white or cream background. The least legible type and background combinations are orange on blue, red on blue, green on orange, and yellow on orange, as is depicted in Colorplate 8.

Another important reason to design with high-contrast images arises from the capabilities of the browser programs used to view online documents. There are literally dozens of different browsers available across three major platforms (PC, Macintosh, and UNIX). Depending on the capabilities and limitations of the browser and the document, the browser will either display the document's coded design settings, employ its own built-in defaults, or display the information with the user's chosen settings. With all of these possible combinations of dozens of browsers and millions of individual users, there are almost endless variations in the manner in which your online document will appear on the user's screen.

ADDITIONAL RESOURCES

Coloring Web Graphics, Lynda Weinman and Bruce Heavin, New Riders Publishing, 1996. A good resource to consult when designing color combinations for the web.

If the user stays with the fairly standard built-in browser settings of small black text on a light background, the page may be, quite frankly, boring but readable. If the user decides to change the basic settings to a personalized preference, there is no predicting how readable the document will be. Colorplate 9 shows three possible ways an online document could be viewed. Again, your best option to ensure that your document will be readable is to use high contrast between your text, images, and backgrounds.

> **NOTE:**
> Reading black text on a white screen, while legible and common, actually can cause eye strain because the user is looking right into a bright light source (the monitor). A less eye-straining combination is black text on a light yellow background.

COLOR DEPTH

The amount of colors a computer can display is called *color depth,* which is measured in bits. Many computers can display 8-

bit, 16-bit, or 24–bit color; with 32-, 36-, 48-, and 64–bit color used by a few higher-end computers. Many stock computers can display 8-bit color information (which translates into 256 colors). A computer that displays 16-bit color information can show you 65,536 colors (256 × 256). Instead of showing the mixtures of just two colors, like red and green, a computer with 16-bit color capability distributes the amount of color information available across the red, green, and blue colors (see Colorplate 10). A computer with 24–bit color capability has enough processing power to display all 256 intensity levels of RGB color at one time (256 × 256 × 256 = 16,777,216 intensity levels of color).

Because many stock computers only read 8-bits (256 colors) or 16-bits (65,536 colors), using 24–bit or higher color graphics in interactive documents is largely unnecessary and takes up a tremendous amount of data space. Furthermore, in online documents, 24–bit or higher color graphics take an extremely long time to download. Reducing the color depth to an 8-bit palette ensures that most users' computers will be able to more quickly read the image. Colorplate 11 graphically shows how an 8-bit color image looks when reduced in bit-depth. The smaller the bit depth, the faster the image will download, but at the cost of a loss of image quality.

REDUCING BIT-DEPTH AND DITHERING AN IMAGE

The process of reducing the bit-depth of an image is called **indexing.** When an image containing millions or thousands of colors is indexed down to 256 colors, a certain amount of color loss is inevitable.

Fortunately, image-processing programs (like Adobe Photoshop or Equilibrium Debabelizer) offer several options by which the color of images may be optimized. One option is to pick between several different color palettes or create a customized color palette (palettes are explained more thoroughly in the next section). Another option is to use a special indexing method called dithering to simulate as many of the original colors as possible (see Colorplate 12).

Dithering is the mixing of pixels with available colors to simulate the missing colors. For instance, red and blue dots juxtaposed in an image would simulate a purple color. Dithering can also create a smoother, more natural-looking gradation between

colors by mixing pixels in-between adjacent colors. Images indexed without using the dithering method can have abrupt divisions between colors and values.

Most image-processing programs let you choose between several options to dither an image. In Adobe Photoshop, for example, you can pick between "pattern dither" and "diffusion dither." The pattern dither option tends to result in an easily seen, coarse, gridlike pattern of colors (see Colorplate 13). In most cases, diffusion dither (see Colorplate 14) is the preferred choice, as it results in a more natural-looking image, if slightly grainy due to the juxtaposed dots of color. In comparison, an undithered image often has unnatural and distinct bands of color (see Colorplate 15).

COLOR PALETTE OPTIONS

When you reduce the bit-depth of an image, it is possible to choose between several different color palette options. Not all color palettes display the same on different computers or online browsers. An image set to the Mac system palette, for example, will have a tendency to look darker when displayed on a Windows computer.

When the computer displays RGB colors onscreen, it accesses a program's or an image's color palette to tell it which colors to project. Simply put, a **color palette** is the collection of colors available to a program or system. Palettes work because the collection of 256 RGB colors is stored in a standard format—a 16 × 16 square grid called a "color look-up table" (CLUT) (see Figure 4–30). Each of the 256 squares has an unique numerical address from 0 to 255, allowing the computer to reference the grid by the numerical address. This is an important point to remember, as this numerical addressing system is part of the reason why image-processing programs allow you the option of making custom palettes.

NOTE
To complicate the issue of color, most of the major online browsers can read only 216 colors. If your online document contains a color beyond that 216-color palette, the browser will attempt to compensate by dithering (combining different color pixels together to simulate the missing color) (see Colorplate 16).

Figure 4-30 A "color look-up table."

Dithered images online can look rough, while images that exclusively use colors from the 216-color palette have a smoother look.

One way to get around this problem is to use a browser-safe color palette. This color palette is accessible (for free!) from Adobe for use with their image-processing program Photoshop. To download this color palette for Windows, go to ftp://ftp.adobe.com/pub/adobe/photoshop/win/3.x/web216w.zip
and for Macs, go to
ftp://ftp.adobe.com/pub/adobe/photoshop/mac/3.x/web216m.sit

System Palettes

Both Windows and Macintosh have standardized 256-color palettes available for use. On the Windows platform, this palette is called the *default palette,* while on the Mac it is called the *system palette.* These palettes have been carefully constructed to handle a variety of images, using the widest range of colors possible within the 256 squares.

Because the Windows and Mac palettes differ in their color distribution, sometimes the way a color image displays on one platform will be different than how it displays on the other platform. Therefore, if the interactive document is intended for release on both platforms, you might want to use a cross-platform palette.

Cross-platform Palettes

While the Windows and the Mac systems both use 256-color palettes, the colors used in these palettes are not all the same. The Windows default palette requires that the first ten and the last ten colors in the palette be in a specific arrangement. Macs only require that white be in the first square and black be in the last square in the palette.

Since the Windows platform has more stringent color requirements than the Mac platform, an interactive document that displays on both platforms should use a *cross-platform palette*. Fortunately, many authoring programs (like Macromedia Director and Authorware) and image-manipulation programs allow you to choose the palette assigned to the images and document, and thereby configure your file to better play across platforms.

Custom Palettes

While most images display fairly decently using the default palette, there are some images that display better with a customized palette. A **custom palette** is a specially created palette with 256 color choices tailored to enhance the display of the image. Making a custom palette is achieved by selecting what is called an "adaptive palette" in PhotoShop and Equilibrium DeBabelizer. This custom palette is created and saved with the image, so whenever the image appears, the computer loads that palette to display it.

Both image "a" and image "c" in Colorplate 17 are examples of images using custom palettes (the palettes to the right of image "a" and to the left of image "b"). Notice how the custom palette for image "a"has a wider range of reds, oranges, and warm yellows than that for image "c". Since image "a" consists mostly of warm tones, the blues and greens are unnecessary and have been replaced with a larger range of reds and oranges.

Custom palettes work the best when there is only one image onscreen at a time. Problems arise, however, when there is more

than one image with a custom palette onscreen at a time. In this situation, the computer is forced to choose and display only one palette, since using two 256-color palettes at one time exceeds the 8-bit display capabilities of the computer. The computer will use the custom palette for the active image (often the one on top) and apply it to any other images onscreen. As soon as another image becomes active, the computer will apply its palette to any other image onscreen. As you might imagine, this can result in some pretty unusual color effects. Image "b" in Colorplate 17 displays how an image can be affected by the color palette of a different image.

Managing Palettes

To avoid unpleasant color transitions between palettes, you should try to keep the total number of palettes used in the document to a minimum. When an interactive document has several palettes available for use, the switch from one palette to another can also result in a brief flash when the colors change. This *palette flashing* happens during the moment of transition because the new set of colors displaces the existing set of colors in the CLUT (color look-up table) grid. Any images onscreen at that moment will reflect that changeover by remapping the new colors from the grid onto the image, before reconfiguring to better color selections in the CLUT grid.

When it is necessary to load a new palette, one way to avoid palette flashing is to find a common color or colors used in the same location in the grids of the two palettes. Two color locations that are common to all palettes are those of white and black (in square 0 and 255). Macintosh palettes use white in squares 0 and black in square 255, while Windows reverses these positions. Some authoring programs like Macromedia Director allow a controlled fade of the colors in the image's palette, leaving all white or all black. Then the color palette from the next image can be faded up to full intensity. This fading of some of the colors in the palettes allows for a smooth transition without flashing.

There are some instances in which palette flashing actually can be used in an interactive document to simulate a limited sort of animation. For more information about "color cycling," see the section on animation in Chapter 6.

RESOURCE MEDIA

In This Part:

Interactive documents utilize an incredible variety of resource media to communicate the message. Every time you use digital media in your document, you will have to deal with issues *and* concerns unique to that media *and* to interactive design. Although each media is undeniably complex, it is heartening to know that you do not have to be a specialist or hold a degree in any one of them to create successful interactive designs. The more you work with these media (and read about them), the better will be your mastery of the whole interactive subject.

While a thorough discussion of each one of these media could occupy whole books (and has, in some instances), this part of *The Principles of Interactive Design* will familiarize you with useful terms and concepts necessary to an interactive designer.

TYPOGRAPHY AND GRAPHICS

OBJECTIVES

- To gain a better understanding of the special issues and concerns of reading text onscreen
- To gain a better understanding of typography onscreen
- To learn industry-standard type terminology
- To become familiar with sources of text and graphics
- To become familiar with the different types of graphics used in interactive documents
- To gain a basic understanding of using images onscreen

TYPOGRAPHY

ADDITIONAL RESOURCES

Expressive Typography, Kimberly Elam, Van Nostrand Reinhold, 1990. A wonderful book with many visual examples of creative and expressive typography.

Photoshop Type Magic, David Lai and Greg Simsic, Hayden Books, 1995. An instructive and visual book that explains in a step-by-step manner how to create interesting type effects in Photoshop.

Text on the screen adds expressiveness and style to an interactive document along with meaning. Text details information and brings to life abstract concepts difficult or impossible to convey with imagery. Text is always content, whether it is intended to be read or to serve as a decorative visual element. Using text is also one of the quickest and easiest ways to communicate large amounts of information.

Although text is quick to make, it takes effort to write readable copy and to design attractive and visually expressive type. Good text is easy to read, informative, and adds visual style to the interactive document. If type onscreen is hard to read, continues for screen after screen, or clashes with the visual style of the rest of the elements, it can potentially turn the user away

from the document.

One way to create good text is to understand the basics of typography. *Typography* is the art of designing type that is legible, expressive, and engaging. Designing good typography depends on choosing the right typeface, size, weight, spacing, color, and layout to convey the message. In addition to dealing with these traditional issues of good typographic design, you should be aware of resolution, anti-aliasing, contrast, text fields, and file format issues. Understanding and working with all these issues will help you shape more readable text onscreen.

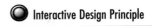

Interactive Design Principle

Type should be concise, legible, and should contribute to the overall look and style of the interface.

BASIC TERMINOLOGY

Typography has a long history and an established terminology. While type on the computer is generated via electronic and digital means, most of the basic typography terms originated in the days when type was cast in metal. Many of these terms are widely used today, including the following:

Typeface: a set of characters (letters, numerals, and symbols) with similar design features (see Figure 5–1). Some computer programs use the word *fonts* interchangeably with the word *typeface.*

Point size: the height of a letterform, traditionally measured in points. There are 72 points to an inch. The smaller the point size, the smaller the type (see Figure 5–2). Smaller point sizes are dif-

abcdefghijklmnopqrstuvwxyz
ABCDEFGHIJKLMNOPQRSTUVWXYZ
1234567890 $.,;:!?&-/()""''

Figure 5-1 An example of a typeface.

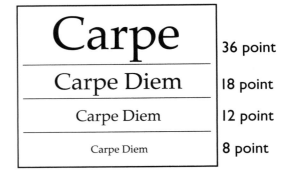

Figure 5-2 Type point sizes.

Gill Sans Regular

Gill Sans Bold

Gill Sans Extra Bold

Figure 5-3 A popular typeface (Gill Sans) shown in three of its weights.

Carpe Diem

C a r p e D i e m

Carpe Diem

Figure 5-4 Three examples of letterspacing. The type on top is at normal letterspacing. The type in the middle is shown with wide letterspacing, while the type at the bottom uses a very tight letterspacing.

Lorem Ipsem doming eu nam liber tempor facer possim omnis eligent. Vel illum dol consequat duis autem. Adipsicing elit, sed diam lorem ipsum dolor sit id quod.

Lorem Ipsem doming eu nam liber

tempor facer possim omnis eligent.

Vel illum dol consequat duis autem.

Adipsicing elit, sed diam lorem ipsum

Figure 5-5 An example of regular leading (top) and wide leading (bottom). Leading that is too wide can impair legibility.

ficult to read onscreen, for reasons explained later in this section.

Weight: the thickness of the strokes that make up a letterform. The thicker the strokes, the bolder the letterform. Common weights are regular, bold, and ultra bold (see Figure 5–3). Thin, delicate type is generally not as easy to read onscreen as regular or bold type.

Spacing: the space between letters, words, or vertical lines of type. Spacing encompasses letterspacing, word spacing, and leading. **Letterspacing** is the space between individual letterforms (see Figure 5–4). **Word spacing** is the space between words. **Leading** is the vertical space between lines of type (see Figure 5–5). Letterspacing, word spacing, and leading are all factors that influence the readability and the expressiveness of the type. Type spaced too closely or too far apart can be difficult to read onscreen.

ADDITIONAL RESOURCES

Notes on Graphic Design and Visual Communication, Greg Berryman, William Kaufmann, Inc., 1984, Los Altos, CA. A very good resource for basic rules of typography and layout.

TYPE CATEGORIES

While there are literally tens of thousands of typefaces, most typefaces have similarities in form that allow for their placement into broad type categories, including:

❏ roman,
❏ sans serif,
❏ square serif (also known as Egyptian),
❏ script, and
❏ decorative (also known as occasional or novelty typefaces).

Figure 5–6 shows examples of typefaces from each type category.

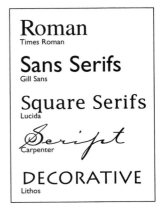

Figure 5-6 The different categories of type.

Roman

The roman typeface style originated with Roman stonemasons who, with iron chisels, cut the letterforms into stone. The ends of the incised lines were often ragged, requiring the stonemason to make a short cut at the ends of the incised lines to clean up the letter stroke. This extra cut was called a **serif** (see Figure 5–7). Roman typefaces typically have thick and thin variations in their letter strokes, and serifs range from moderately to extremely pointed.

Roman typefaces are commonly used in body copy, as they are considered easy to read. However, because of low screen resolutions, and the thick and thin strokes within the letterforms, serif typefaces can be difficult to read onscreen if they are too small. (The thin strokes in the letterforms are often too delicate to adequately render onscreen due to low screen resolutions.)

Sans Serif

Sans serif means "without serifs" (see Figure 5–8), Sans serif typefaces have a modern appearance and feel and can be very easy

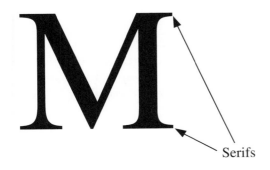

Serifs

Figure 5-7 The serifs on a letterform are the little wings that extend off the ends of letter strokes.

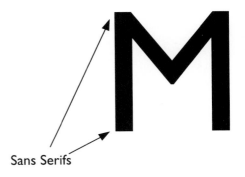

Sans Serifs

Figure 5-8 A sans serif letter.

to read. They hold together well at small sizes and are generally a good choice for headline copy, body text, and interactive controls.

Square Serif

In these typefaces, the serifs at the end of the letter strokes appear to end in blocks or slabs. Square serif typefaces work best in headlines or display type. When set in smaller type sizes, square serifs tend to make text fields onscreen appear dense and black.

Script

Script typefaces can convey the feeling of handwritten designs. Some script typefaces can be hard to read, especially in blocks of text that are all capital letters. Furthermore, the delicate letter strokes of some script typefaces make them hard to read at smaller sizes. They are best used sparingly and for headlines.

Decorative

When a typeface design is hard to categorize, by default it is dropped into the decorative category. There are no particular design limits for this category. Many of these typefaces can be extremely difficult to read and are best used for display or headline copy instead of body text. The advantage of using decorative typefaces is that they can quickly establish a mood, time period, or style.

> **NOTE**
> When trying to decide which typefaces work best onscreen (and with each other), it is a good idea to try them out in a full-size sample screen layout. A good question to ask yourself (and anyone to whom you show the sample layout) might be, "Is the type hard to read?" If the answer is yes, consider using a different typeface.

GETTING TEXT INTO YOUR DOCUMENT

Normally, there are three main options for obtaining text for your interactive document. If your project is a revision of an exist-

ing print or motion media piece—such as a brochure, newsletter, or video—you may be able to reuse existing copy. This text can be typed manually or scanned using OCR (optical character recognition) software. To get text for an entirely new project, the text will have to be written and edited specifically for the project. And finally, the third way to get text into your document is to let the user input information.

New Text

Writing or editing new text may require the services of a professional copywriter. A good copywriter can breathe life into words by phrasing concepts in interesting and unique ways. The copywriter, however, should be aware of the limited screen real estate dedicated to text. Text written for an interactive document benefits from conciseness. As an additional advantage, writing new text circumvents the need to obtain copyright permissions.

Reusing Existing Text

Reusing existing text may require the services of a professional typist or someone willing to carefully edit OCR-scanned text. While many scanners include OCR software, unfortunately, these scanning programs have a tendency to "misread" letterforms; as an example, a lowercase "e" may become an "o." For long lengths of text, however, scanning may be a viable option, as long as someone is available to copyedit the text to identify and correct any OCR scanning problems.

User Input

Interactive documents requesting user input are more demanding to design and program. On the design side, you must consider how much screen real estate is necessary to accommodate user input. For instance, a web page may ask for the user to "fill in the blank" with their name, title, and address—all in a limited amount of space (see Figure 5–9). Questions you should ask while designing a web page that requests user input might be, "What happens when the user has a long last name that does not fit in the 'name' line? Or an unusually long street address? What happens if the user decides to write a poem in the space instead of their address? Can the user retype information if they discov-

For Sale/Want to Buy

All Postings must have first and last name, city, state and
Email of contact person to be posted.

◉ For Sale ○ Want To Buy

Contact Person

First Name : []

Last Name : []

Address : [Optional]

City : [] State: [TX] Zip Code: [] - []

Country : [USA]

Figure 5-9 User input form in a web page. *(Courtesy Dimitrius Samudio.)*

er a spelling error?" A good design with sound programming will easily accommodate long answers, let users retype their information, and may even reject irrelevant answers.

Furthermore, in some situations, it may be desirable to program pull-down menu choices or point-and-click lists designed to limit the user's choices to predetermined responses. This option, however, can rapidly become an irritation to users if the lists are incomplete (see Figure 5–10).

Ultimately, whether text is typed, scanned, or input by the user, text adds functionality to your document. Text can be searched, placed in mathematical tables, and indexed. Many authoring programs include the ability to run *search engines* (a program that lets users search for key words or phrases and build indexes) in your document. These search engines increase the usefulness of your program by letting the user find information at will.

Users may avoid even the most information-packed database if the text is hard to read or use. Your ongoing challenge, as an interactive designer, is to shape readable, stylish, and usable typography for the screen.

State:
- Alabama
- Arkansas
- California
- Conneticut
- Delaware
- Georgia
- Hawaii
- Illinois
- **Iowa**
- Kansas
- Michigan
- Minnesota
- Missouri
- Montana
- New Jersey
- Pennsylvania
- Texas
- Utah
- Wyoming

Figure 5-10 Incomplete lists can frustrate the user.

READING TYPE ONSCREEN

People see and read typography in their everyday lives in newspapers, books, movies, and other well-established commu-

Text on Paper versus Text Onscreen

	Paper	**Screen**
Typeface	As long as the typeface fits well with the style and tone of the project, just about any typeface will work (see Figure 5-11).	Just about all typefaces are readable at larger point sizes. Serif and sans serif typefaces with relatively even letter stroke thicknesses work well in large or small point sizes. Decorative, script, condensed, and expanded typefaces should be avoided for body copy or small type (see Figure 5-12).
Size	9, 10, and 11 point type are common sizes used in documents with lengthy amounts of body text.	Low screen resolutions make type below 12 points in size difficult to read.
Spacing	Extra tight and extra wide letterspacing, word spacing, and leading are commonly used in a wide variety of printed projects.	Too tight spacing makes the edges of anti-aliased type blur together. Even the edges of type with normal spacing can blur together at smaller point sizes. Too wide spacing consumes valuable screen real estate.
Weight	All weights of type are readable.	Very thin letter strokes are hard to read onscreen, except in very large sizes.
Color and contrast	Control over color is good, so designers can specify more subtle color combinations and still achieve legible type. In general, however, the higher the contrast, the easier the type is to read.	Color is difficult to control, as projects cross computer platforms and are displayed on a wide range of grayscale and color monitors. High contrast between type and background assists the legibility of type no matter what kind of computer and monitor the project is displayed on.
Flow	Writers try to achieve a smooth continuity in text.	The flow of text is even more critical in interactive documents because the text can be split up between multiple screens.

	Roman	Sans Serifs	Square Serifs
36 point	Lorem Ipsem	Lorem Ipsem	Lorem Ipsem
24 point	Lorem Ipsem dolor set.	Lorem Ipsem dolor set.	Lorem Ipsem
12 point	Lorem Ipsem dolor set. Capesum id moni valot eu feugiat mulla henderit vel illum nam libor soluta velit	Lorem Ipsem dolor set. Capesum id moni valot eu feugiat mulla henderit vel illum nam libor soluta velit	Lorem Ipsem dolor set. Capesum id moni valot eu feugiat mulla henderit vel illum
8 point	Lorem Ipsem dolor set. Capesum id moni valot eu feugiat mulla henderit vel illum nam libor soluta velit esse. Lorem Ipsem dolor set. Capesum id moni valot eu feugiat mulla henderit vel illum nam libor soluta velit esse. Lorem Ipsem dolor set. Capesum id moni valot eu feugiat mulla	Lorem Ipsem dolor set. Capesum id moni valot eu feugiat mulla henderit vel illum nam libor soluta velit esse. Lorem Ipsem dolor set. Capesum id moni valot eu feugiat mulla henderit vel illum nam libor soluta velit esse. Lorem Ipsem dolor set. Capesum id moni valot eu feugiat mulla	Lorem Ipsem dolor set. Capesum id moni valot eu feugiat mulla henderit vel illum nam libor soluta velit esse. Lorem Ipsem dolor set. Capesum id moni valot eu feugiat mulla henderit vel illum nam libor soluta velit esse.

	Script	Decorative
36 point	*Lorem Ipsem*	LOREM IPSEM
24 point	*Lorem Ipsem dolor*	LOREM IPSEM
12 point	*Lorem Ipsem dolor set Capesum id moni valot eu feugiat mulla henderit vel illum nam libor soluta velit*	LOREM IPSEM DOLOR SET. CAPESUM ID MONI VALOT EU FEUGIAT MULLA
8 point	*Lorem Ipsem dolor set Capesum id moni valot eu feugiat mulla henderit vel illum nam libor soluta velit esse Lorem Ipsem dolor set Capesum id moni valot eu feugiat mulla henderit vel illum nam libor soluta velit esse Lorem Ipsem dolor set Capesum id moni valot eu feugiat mulla henderit vel*	LOREM IPSEM DOLOR SET. CAPESUM ID MONI VALOT EU FEUGIAT MULLA HENDERIT VEL ILLUM NAM LIBOR SOLUTA VELIT ESSE. LOREM IPSEM DOLOR SET. CAPESUM ID MONI VALOT EU FEUGIAT MULLA

Figure 5-11 This chart shows the different categories of type at a variety of point sizes at print media quality. Notice how most of the type (except for the script category) remains extremely legible at each sizedown to as small as 8 points. Compare this chart with Figure 5-12.

Roman	Sans Serifs	Square Serifs
36 point Lorem Ipsem	Lorem Ipsem	Lorem Ipsem
24 point Lorem Ipsem dolor set.	Lorem Ipsem dolor set.	Lorem Ipsem
12 point Lorem Ipsem dolor set. Capesum id moni valot eu feugiat mulla henderit vel illum nam libor soluta velit	Lorem Ipsem dolor set. Capesum id moni valot eu feugiat mulla henderit vel illum nam libor soluta velit	Lorem Ipsem dolor set. Capesum id moni valot eu feugiat mulla henderit vel illum
8 point Lorem Ipsem dolor set. Capesum id moni valot eu feugiat mulla henderit vel illum nam libor soluta velit esse. Lorem Ipsem dolor set. Capesum id moni valot eu feugiat mulla henderit vel illum nam libor soluta velit esse. Lorem Ipsem dolor set. Capesum id moni valot eu feugiat mulla	Lorem Ipsem dolor set. Capesum id moni valot eu feugiat mulla henderit vel illum nam libor soluta velit esse. Lorem Ipsem dolor set. Capesum id moni valot eu feugiat mulla henderit vel illum nam libor soluta velit esse. Lorem Ipsem dolor set. Capesum id moni valot eu feugiat mulla	Lorem Ipsem dolor set. Capesum id moni valot eu feugiat mulla henderit vel illum nam libor soluta velit esse. Lorem Ipsem dolor set. Capesum id moni valot eu feugiat mulla henderit vel illum nam libor soluta velit esse.

Script	Decorative
36 point *Lorem Ipsem*	LOREM IPSEM
24 point *Lorem Ipsem dolor*	LOREM IPSEM
12 point *Lorem Ipsem dolor set Capesum id moni valot eu feugiat mulla henderit vel illum nam libor soluta velit*	LOREM IPSEM DOLOR SET. CAPESUM ID MONI VALOT EU FEUGIAT MULLA
8 point *Lorem Ipsem dolor set Capesum id moni valot eu feugiat mulla henderit vel illum nam libor soluta velit esse. Lorem Ipsem dolor set Capesum id moni valot eu feugiat mulla henderit vel*	LOREM IPSEM DOLOR SET. CAPESUM ID MONI VALOT EU FEUGIAT MULLA HENDERIT VEL ILLUM NAM LIBOR SOLUTA VELIT ESSE. LOREM IPSEM DOLOR SET. CAPESUM ID MONI VALOT EU FEUGIAT MULLA

Figure 5-12 For comparison purposes, the author has taken the chart in Figure 5–11 and converted it to 72 ppi (screen resolution), with anti-aliasing applied. Notice how difficult it is to read some of the 8 point text. Depending upon the typeface, 12 point type is about the smallest size that is readable onscreen.

nication forms. Individuals who view these media are used to the quality and sophistication of these communication forms and expect similar quality in interactive documents. Realistically, the resolutions available in other media are not yet achievable in interactive documents (approximately 2400 ppi for print media as opposed to the typical 72 to 96 ppi of computer screens). Design treatment and style, however, should be at a comparable level of sophistication.

Designing type that works well onscreen demands a good understanding of the traditions of effective typographic design *and* how to work with the strengths and weaknesses of interactivity. There are many factors involved with making type legible onscreen. These factors include careful consideration of typefaces, sizes, weights, color and contrast choices, when to anti-alias type, and where to place type in the screen layout. The next section discusses these issues in more detail.

Typeface Choices

Choosing the right typefaces for your project means selecting (from the thousands available) typefaces that are expressive, legible, and fit the overall tone and style of your project. Selecting a typeface to use in your document may at first produce some surprises, so it is best to view the typefaces onscreen for legibility. Many typefaces that are easily read on paper may not translate well onscreen.

NOTE

Italic type can add stress to words and phrases, but large areas of italicized type can be hard to read. It also tends to look jagged onscreen (see Figure 5–13).

A compass is a device which enables the direction of the poles to be found without observation of the heavens. Two principles are used in the construction of compasses: one depends upon the rotation of the earth on its axis, and the other on the earth's magnetic field. It has been known since very early times that a pivoted magnetic needle or other magnetized body will point in an approximately north and south direction.

Figure 5-13 Large areas of italic type are often difficult to read onscreen.

Size and Screen Resolution

Small type onscreen is notoriously hard to read, largely due to the low resolution capabilities of most monitors. On low resolution screens, small letters tend to lose definition and clarity. For instance, a 12 point lowercase letter, displayed on a 72 ppi monitor, may only have 5 or 6 vertical pixels available to display the letterform. An 8 point lowercase letter at the same resolution may have only 4 or 5 vertical pixels available to render all details of a letterform, including serifs and interior spaces (see Figure 5–14). At these low resolutions, letter strokes can appear to grow together; characters may be awkwardly spaced, with some letters compressed together while others have large gaps between them; and graceful curves in decorative fonts bitmap into a jagged, awkward mess. Eventually, as monitor resolutions improve, so should the legibility of smaller point sizes.

> **NOTE**
> A good rule of thumb is to use a larger point size onscreen than what might be used for similar bodies of text in a print project.

Optical Weight

Each typeface has its own optical weight that makes the typeface appear lighter or heavier. Typefaces with thick letter strokes appear heavier than typefaces with regular letter strokes. The advantage of using a bolder typeface is that the increased visual weight of the word adds emphasis. Typefaces with more visual

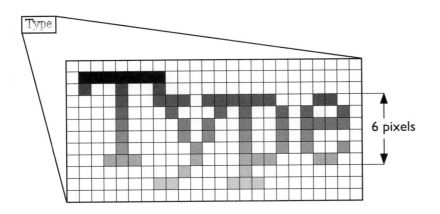

6 pixels

Figure 5-14 This figure shows a word at 12 point size, and enlarged to show the pixels available to the computer to display that size type. Notice that the lowercase e only has a total of 6 vertical pixels available to display all of the letterform's details.

A compass is a device which enables the direction of the poles to be found without observation of the heavens. Two principles are used in the construction of compasses: one depends on the rotation of the earth on its axis, and the other on the earth's magnetic field. It has been known since very early times that a pivoted magnetic needle or other magnetized body will point in an approximately north and south direction.

Figure 5-15 An example of bold type as seen onscreen.

weight also hold together better onscreen. The disadvantage to a very bold typeface is that setting line after line of text in the heavy weight tends to decrease readability (see Figure 5–15).

All uppercase letters can also appear darker than lowercase letters. Setting type in all UPPERCASE LETTERS ALSO TENDS TO CAUSE WORDS AND SENTENCES TO APPEAR TO VISUALLY SHOUT AT THE READER.

Spacing

Most interactive authoring programs can modify letterspacing, word spacing, and leading; however, these programs are often limited in scope. In situations where a special type effect is desired (for example, widely spaced type on a curve) designers often depend on the fine typographic controls available in drawing programs such as Adobe Illustrator (see Figure 5–16). Once

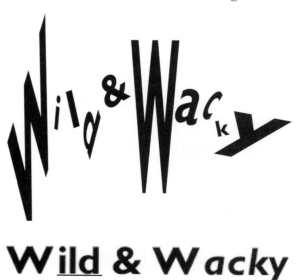

Figure 5-16 Two examples of how different type can look when made in a drawing program (top) and in an authoring program (bottom). You can quickly see the limitations of authoring programs to create typography.

the type is in the desired configuration, it can be converted to a bitmapped image and imported into the authoring program.

Readability problems can arise when letterforms and words in long passages of text are either too close or too far apart. Both tight and open spacing slows down the reader's recognition of letterforms, resulting in a slower reading speed. Too much spacing between letters, words, and leading in body text can also expand the amount of screen real estate a section of body text occupies, in some instances, so much so that the user has to flip across multiple screens to read the information.

While spacing letters and words too close or too far apart can cause legibility problems, judicious use of creative letter and word spacing can add positively to the look and style of the document. Creative spacing tends to work better in short passages of text, such as headlines, interactive buttons, or the credits.

Color and Contrast

Color and contrast can help establish a stylistic look or feeling in your document; they also can enhance or detract from readability. Dark colors in type imply somberness, quality, or dignity. Bright colors in type are visually exciting and convey a dynamic feeling to a screen interface, but when used extensively, they can easily tire the eyes. Middle-range colors (such as a medium blue) in type often suggest sophistication but, unless placed on a very dark or very light background, are difficult to read onscreen.

Using high contrast is a quick way to enhance readability. Just like in print, the higher the contrast between the background and the type, the more readable the type. It almost goes without saying that you should avoid similarly colored text and backgrounds. A red headline placed over an orange background, for example, would be both difficult to look at for any length of time (because of the eye-jarring color combination) and difficult to read (because of the lack of contrast).

Other possible problems arise from layering type over more than one image. If you must layer type over a very colorful background or over several different images, special treatment of the type (and/or the image) is necessary to enhance legibility. In this situation, lightening the section of the background behind the type (see Figure 5–17) or adding a typographic special effect such as a 3D drop shadow may dramatically improve legibility.

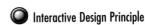 **Interactive Design Principle**

Use high contrast between text and backgrounds to increase legibility.

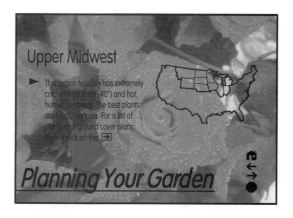

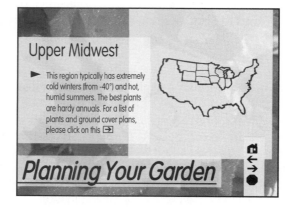

Figure 5-17 Type lay-
ered over a very busy (or
colorful) background
(top). You can improve
legibility by selectively
lightening sections of the
background (bottom).

Type Layout

Type should fit in stylistically with the rest of the screen ele-
ments. Headline type, text fields, and column widths should bal-
ance with images, interactive controls, and other screen elements.
Screen layouts loaded with lots of images but little descriptive
type may be interesting to view but lacking in detailed, exact
information. Screen layouts with lengthy bodies of text may com-
municate the precise, detailed meaning, but all-text screens may
not appeal visually to the user.

There will be times when you find it necessary to convey com-
plex information using a body of descriptive text. In this situa-
tion, you may want to consider using a text field.

Text Fields

A *text field* is an area onscreen designated to hold scrolling text (see Figure 5–18). Text fields are useful for holding large amounts of text. They are easily created within most authoring programs and can hold any amount of text. They also provide handy built-in control buttons or scroll bars that let the user go forward or backward through the information. The downside of text fields is that creating custom typography or formatting within the field is difficult, and the scroll bars and other built-in controls rarely coordinate with the rest of the look and style of the interface design. Furthermore, some users will not read large amounts of text onscreen.

An alternative to using a text field is to edit the text to contain only the most necessary information. Once you have done this, text that is moderate in length can be broken down into sections integrated into the screen design. As the user finishes reading a section of text, they can toggle an interactive control to advance the next section of type onto the screen (see Figure 5–19).

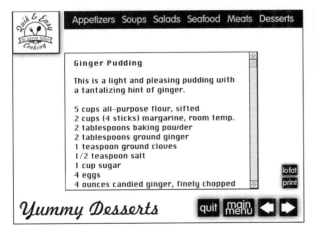

Figure 5-18 An example of a text field. While text fields are useful for holding large amounts of text, they also cover any background images that would otherwise contribute to the style of the screen.

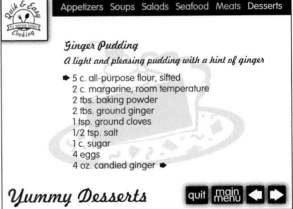

Figure 5-19 This screen shows how short sections of text can be placed onto the screen. When the user reaches the bottom of the recipe, they can toggle the small arrow to bring more information to the screen. The advantage of layering text on the screen is that it can be any typeface and format you choose, and that any background imagery you have placed onto the screen is clearly visible.

Tip: On 13″ to 15″ monitors, a page of Times Roman 12 point text contains approximately 250 to 275 words. If you want to limit the number of screens of text, try to keep the word count in this range.

FONT FILE CONSIDERATIONS

In order for the user's computer to display a font in your inter-active document properly, the user's computer must have the same font installed. In an ideal world, every designer and user would have the same fonts installed on their computers, so what you see on your screen would be the same as what the user sees on theirs. Since there are thousands of digital fonts available in a variety of file formats, this ideal world seems unlikely.

You have a number of options to consider when using type in an interactive document. You can ship the font files along with the product, select a standard font present on most computers, convert your document to a portable document format (PDF), or convert the type to a bitmapped image.

If you are creating a multimedia project, it is a relatively easy matter to include the font files used in the document along with the product. This entails securing a license from the font manu-facturer to release the file on disk, along with documentation instructing the user on how to install the font files in the comput-er. The success of this option depends on the user actually com-pleting this action before attempting to run your document.

Once the files are installed onto the user's computer, text in the document will display onscreen with the correct format, point size, spacing, and any other typographic specifications. Text that draws upon a font file loaded on the computer also can be edited (if the display program permits) and, therefore, can be considered live "editable" text. Editable text is a necessity in multimedia pro-jects that allow the user access to databases where the user might add, alter, or delete information.

If it is financially detrimental to secure a license to distribute a certain font file, or if you are working with an online document, you may want to consider picking a font that comes loaded on Windows and Macs. Both Windows and Macs, for example, include Times Roman as a default font choice, and Times Roman

is also the default font used by many browsers. Using a standard font increases the chance that what the user sees onscreen is what you intended them to see, although there are no guarantees. (Some users detest these preloaded fonts and deliberately strip them from their computer operating systems.) Using a standard font is also complicated by the fact that many browsers allow users to choose what font the browser will use to display documents (see Figure 5–20).

 Mariner's Compass

A compass is a device which enables the direction of the poles to be found without observation of the heavens. Two principles are used in the construction of compasses: one depends upon the rotation of the earth on its axis, and the other on the earth's magnetic field. It has been known since very early times that a pivoted magnetic needle or other magnetized body will point in an approximately north and south direction.

On seafaring vessels the compass is mounted in a pedestal called a binnacle. Most binnacles are provided with a lamp for nighttime illumination. On the bowl is a verticle black mark called the lubbers line. The compass is mounted in such a way that a line drawn through the pivot and lubber's line is parallel to the keel of the ship. When the point on the card meets the lubber's line, the ship's magnetic course is easily determined.

Aircraft compasses are called a periodic compass and the earth inductor compass. During World War II a pole-proof compass called a gyro flux gate compass, which is called the most important compass development in 2,000 years.

 Mariner's Compass

A compass is a device which enables the direction of the poles to be found without observation of the heavens. Two principles are used in the construction of compasses: one depends upon the rotation of the earth on its axis, and the other on the earth's magnetic field. It has been known since very early times that a pivoted magnetic needle or other magnetized body will point in an approximately north and south direction.

On seafaring vessels the compass is mounted in a pedestal called a binnacle. Most binnacles are provided with a lamp for nighttime illumination. On the bowl is a verticle black mark called the lubbers line. The compass is mounted in such a way that a line drawn through the pivot and lubber's line is parallel to the keel of the ship. When the point on the card meets the lubber's line, the ship's magnetic course is easily

Figure 5-20 The top image shows a web page displayed in Netscape Navigator's standard browser default font, Times Roman. The bottom image shows the same web page after the default font has been changed in the browser preferences. You have very little control over which font the user will select as the default display font, but if you stick with the standard Times Roman, your web page will be readable by the large group of users who do not take the time to change this aspect of the preferences.

NOTE

The default proportional font used by many browsers is Times Roman, while the default monospace typeface for forms and input boxes is usually 10 point Courier. Internet Explorer uses 14 point Times Roman, while Netscape Navigator uses 12 point Times Roman.

This lack of predictability is a common problem in displaying type properly online. Many designers choose to try to circumvent this problem by converting their designs to a portable document format PDF file. One advantage of using a PDF file is that it preserves all of your original text layout and type specifications. Online PDF documents can also include hyperlinks. A major disadvantage to using the format is that the end users must have Adobe Acrobat Reader installed on their machines in order for the file to read properly. Luckily, Adobe generously distributes this software free of charge, and it is possible to provide a link from your document to the Adobe web site.

NOTE

For more information about PDF files and Adobe Acrobat, visit the Adobe web site at http://www.adobe.com.

For those products that cannot use a PDF file, or if you are concerned that the user will not take the time to download the software to read the format, you may want to consider converting your type to a bitmapped graphic. Converting type to a bitmapped graphic has the advantage of "freezing" the type into the precise typeface, size, weight, spacing, and color that you created. Unfortunately, once type is converted to a bitmapped image, the computer can no longer recognize individual letterforms. Therefore, the text can no longer be edited or searched via key words.

NOTE

Type created in a drawing program such as Adobe Illustrator can be easily converted to a bitmapped (raster) image by opening the file in Adobe Photoshop.

Bitmapped type also takes up a lot of file space. A headline that references font files in the operating system, for example, might take up approximately 3 K of memory. The same headline type, when saved as a bitmapped graphic, might occupy 70 K of mem-

Figure 5-21 Interlaced graphics appear onscreen in "chunks," and progressively refine.

ory. A single full screen of RGB color bitmapped graphic type can use around 900 K.

Multiple full screens of color bitmapped type not only consume tremendous amounts of data space, but also can cause significant download problems for online documents. It is a cruel fact of life that the larger the graphic, the longer it takes to download across the web. If the download time is too slow, some users will inevitably stop the download and move on to another web site. Therefore, it is a good idea to limit the use of bitmapped graphic type.

Tip: One way to make the user's wait seem shorter when a web page graphic is downloading is to use interlaced images. An interlaced image will first appear as a whole, albeit very rough, bitmap (see Figure 5-21) and progressively refine to full resolution. The noninterlaced alternative is to have the full resolution image draw line by line downward from the top of the image.

Deciding on a Type Format

Deciding which type format to use in your document depends on a number of factors. The following list shows some of the

advantages and disadvantages of each option.

Editable text (font files loaded in the user's computer)
Advantages
❏ Since the letters and words are stored as a series of codes, they can be edited, searched, and modified.
❏ Editable text can be placed in text fields.
❏ Editable text takes up very little data space.

Disadvantages
❏ The end user must have the complete font files installed on their computer or else the text will not display right.

Type converted to a portable document format (PDF)
Advantages
❏ You can make the type any typeface, style, and format you want.
❏ PDFs takes up very little data space.

Disadvantages:
❏ The end user must have the proper software loaded or else the PDF document will not display properly.

Bitmapped image type
Advantages
❏ Because type is an image, you can apply special effects to the type in an imaging program. For example, you could apply special textures or colors into the type.
❏ The type can be anti-aliased.
❏ You can make the type any typeface, style, and format you want.
❏ It will always look right on the user's computer.

Disadvantages
❏ The bitmapped image takes up a lot of disk space.
❏ Large bitmap files take longer to load onto the screen.
❏ Bitmapped type cannot be moved or edited.

ANTI-ALIASING TYPE

Bitmapped text is made up of a series of pixels. Since pixels are square, the edges of text and objects appear jagged or stair-

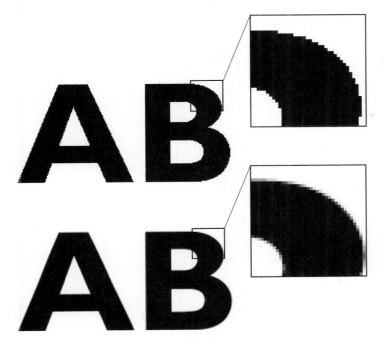

Figure 5-22 The top group of letters show the jagged edges of aliased type. The bottom group of letters show the same type, only with anti-aliasing applied. Notice how the edges of the B show a rim of blended pixels that are halfway between the foreground and the background colors.

stepped. This jagged effect is most apparent on curves or in thin letter strokes. Fortunately, these jagged edges are easily softened by anti-aliasing the edges (see Figure 5–22). As was explained in Chapter 4, anti-aliasing is the technique of slightly blending the colors in the edges of an object with the colors in the background. By anti-aliasing the edges of objects, the eye perceives a less artificial and more natural edge.

Text created in the computer is easy to anti-alias, as many image-processing programs and authoring programs have built-in anti-aliasing capabilities. Unfortunately, once text is anti-aliased, in order to retain the anti-aliased format when it plays, the programs convert the text to a bitmap. The disadvantage of bitmapped type is that it is no longer "editable" type.

Importing anti-aliased type into your interactive document can improve the look of the type, but also imposes a few problems of its own. Anti-aliasing small body copy can blur the edges of type to the extent that letterforms tend to "merge." One way to enhance legibility is to add letterspacing between letterforms; however, the interior spaces in the letterforms also tend to blur. Small anti-aliased letters with interior spaces like D, F, R, and P may lose def-

Anti-alaising type blurs the edges of the letterforms. At large sizes, this effect does not impair legibility. At small point sizes, however, the edges of type can seem to blur together, making the text hard to read.

Anti-alaising type blurs the edges of the letterforms. At large sizes, this effect does not impair legibility. At small point sizes, however, the edges of type can seem to blur together, making the text hard to read.

Figure 5-23 Text at 12 point size (top) and 8 point size (bottom) shows how difficult it can be to read small anti-aliased text.

Figure 5-24 A detail of the blurring that occurs within and between anti-aliased letter-forms at a small point size.

inition, blurring into a blob (see Figures 5–23 and 5–24). In general, anti-aliasing type tends to work best in larger type such as titles.

Another problem with anti-aliasing text or images is that the technique is safe to use only when the background behind the anti-aliased object remains constant. If the background changes behind the anti-aliased type, you will be able to clearly see the anti-aliased edges of the type, unless you create a new version of the type that matches the background.

BALANCING DESIGN TIME AND EFFORT

When working with type onscreen, you have to balance design time and effort against potential gains. Ideally, type in interactive documents should have similar levels of sophistication and style as that of the print world, but limitations in budget, timelines, and personnel can affect how much effort goes into any one aspect of the project. Examined in that light, it may be reasonable to create beautiful, attractive, legible headlines with anti-alias techniques and leave body text as editable, searchable text.

Overall, when working with type in your document, you should strive for attractive, easy-to-read type mixed in with a well-planned balance of backgrounds, graphics, animation, and other screen elements to enhance the usability and legibility of the inter-

face. Good type design, no matter the medium, can help engage the user's interest and keep them looking at your message.

GRAPHICS

Visual elements such as photographs, illustrations, charts, maps, and icons are familiar elements and are often the keystones of interactive documents. The images you choose help create a mood, establish a visual style, and convey complex information.

Graphs, charts, and diagrams are good for putting across complex and detailed information, while photographs and illustrations are better at implying a feeling or style. Many individuals find statistical or numerical information easier to understand when placed into a graph or chart form. Photographs convey a sense of realism. Artistically treated photographs and some illustrations can imply a mood or impression. Choosing good graphics helps put across a lot of information in a small, compact space.

Photographs

Photographs are often the mainstay of interactive documents, as they are relatively easy to obtain and to scan, and they add a sense of realism to a document (see Figure 5–25). Photos can range in

Figure 5-25 This black and white photograph of a door adds a melancholy impression to this screen design. *(Courtesy Lori Walther.)*

Figure 5-26 An example of different filters (available in many image-processing programs) applied to a photograph.

style, from moody landscapes, to sensitively lighted intimate portraits, to gritty photojournalistic live-action shots and more.

Photos can be powerful visual images evoking strong emotional responses in the viewer. This strong emotional response can be partially attributed to the fact that viewers are used to seeing photographs in magazines, books, and newspapers. Because of this, photographs have a sense of photojournalistic realism that many individuals accept without question.

Photographs are easily transferred into the computer. Traditional and digital cameras are widely available and commonly used. Film taken with a traditional camera must to be developed and printed, and the resulting photos scanned. Photos taken with a digital camera can be directly transferred to a computer hard drive.

Once loaded onto a computer, photos can be imported directly into your authoring program (if they are saved in a format recognizable to your authoring program), or special effects can be applied to them in an image-processing program. Most image-processing programs let you apply a variety of enhancements to the photographs, including color correction, adjustment of the resolution, and experimentation with special effects such as emboss or blur filters (see Figure 5–26).

One factor to take into consideration is that photos with many details will not render well on low resolution computer screens. For instance, a starting lineup shot of a high school football team, when displayed at 72 ppi, would lose most of the detail of the players' facial features. Less detailed photos usually hold up better when displayed at the lower resolutions of monitors. When it is necessary to show detailed information, illustrations are often a better choice.

Illustrations

Illustrations can be diagrams, charts, maps, cartoons, or drawings. They are particularly useful for showing complex, detailed information that is difficult to show in other ways. An illustration, for instance, can easily show the splitting of an atom, a process particularly troublesome to record photographically.

Illustrations can be humorous, serious, decorative (see Figure 5–27), or strictly factual. Whatever the style of the illustration, a well-designed illustration can quickly put across information as well as adding style, emphasis, and interest to your document.

THE

THE EQUINE IN ART
IN PAPER, PLASTER, AND WOOD

Figure 5-27 This illustration of a carousel horse adds visual interest to this simple screen design. *(Courtesy Lori Walther.)*

Graphs, Charts, and Diagrams

Graphs, charts, and diagrams work best when they are well designed and stripped to just the essential data. Excess decoration or data is often confusing or even misleading to the user. A good graph, chart, or diagram will clearly state all relevant measurements and parameters. Legends will be prominently displayed and correlate accurately to visual and numerical information.

Graphs and charts are widely used to represent numerical data. Bar graphs and pie charts are two common forms (see Figure 5–28). Diagrams usually contain data, text, and a visual element such as a photograph or an illustration (see Figure 5–29). Diagrams are useful for pointing out detail in existing images. An illustration of the inside of a computer box, for instance, can be made more meaningful with labels pointing out the logic board, RAM chips, and power-supply assembly.

Maps

Maps are a commonly used visual element in interactive docu-

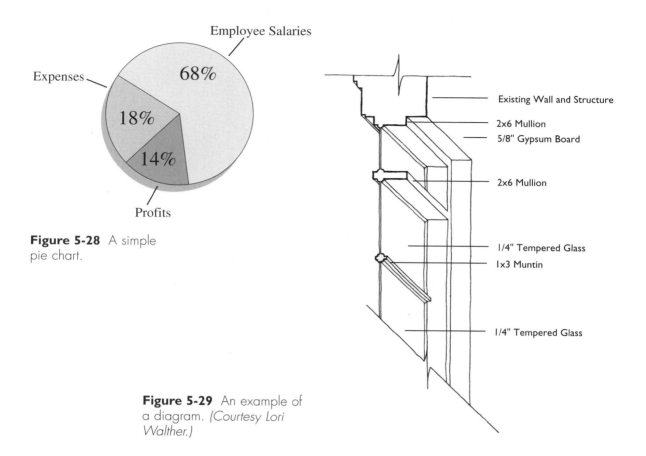

Figure 5-28 A simple pie chart.

Figure 5-29 An example of a diagram. *(Courtesy Lori Walther.)*

ments, but they can be easily misinterpreted if poorly or inadequately labeled. Imagine trying to figure out distances on a map with none of the measurements labeled, or trying to navigate your way through an interactive game with the east, west, and south placed randomly at the top of the map every time it appears onscreen (see Figure 5–30).

Screen resolution limits the amount of detail it is possible to show in maps, so you may have to simplify some details. A road map of Chicago, for instance, shown in its entirety on a 15″ monitor, cannot possibly depict all of the streets in the city. A viable alternative in this case would be to simplify the map and provide a zoom function so the user could selectively enlarge portions of the map.

Figure 5-30 This screen shows the image of a treasure map on the book page. Would you find it confusing if, every-time you "paged" back to this screen, the orientation of the map would change?

Icons

Icons in interactive documents have come to mean any symbol or picture that is "clickable" (see Figure 5–31). An icon is a simple symbol or picture that represents another thing. For instance, a symbol of an arrow has commonly come to mean "forward" or "backward" in interactive documents, depending on whether it points to the right or the left. Once you establish an icon in your document, it should always stand for the same thing. If you use an arrow pointing to the right to indicate "go to next screen," that icon, when clicked, should perform the same function through-out the whole document.

ADDITIONAL RESOURCES

Dictionary of Symbols, Carl G. Liungman, ABC-CLIO, 1991. A col-lection of symbols created by humans over approximately the last 20,000 years. The book covers an amazing variety of symbols about a wide variety of topics and is a useful reference to consult when trying to develop a new symbol.

Icons should be easily recognized by users. Testing whether an icon is easily recognized often means showing the icon to a group

Figure 5-31 A few examples of simple icons.

of potential users. A good icon needs no explanation; if the icon must be constantly explained, then it should be redesigned. Another characteristic of a good icon is that it can be enlarged or reduced and still remain legible.

Another consideration in designing good icons depends on the culture of your audience. If the proposed audience is cross-cultural or international, the icon should be easily recognized by individuals from all of the proposed audiences. Airport icons are a good example of icons that are widely used throughout the world and roughly interpreted as meaning essentially the same thing.

> **Tip:** It is sometimes difficult to design an easy-to-understand icon for every link in your document. Coming up with a recognizable graphic for links such as "stop," "next," and "search" is much easier than developing a graphic for "cigar distributor's monthly report." If an icon is hard for the user to quickly interpret, consider using a combination of text with the graphic or even using text alone.

SOURCES OF GRAPHICS

There are many sources for obtaining graphics. You can reuse existing graphics; commission work from professional photographers, illustrators, and graphic designers; use clip media from clip art and clip photo CD–ROMs; or create images yourself. Whatever the source, the graphics you choose should fit with other screen elements, work well compositionally, and convey the information or desired impression to the user.

Capturing Images

Graphics are usually either created in drawing or image-processing programs or scanned into a digital format from existing drawings, photographs, or other images. If your graphic is generated in the computer, it is fairly simple to control the resolution and format of the data files. On the other hand, capturing images with a scanner requires familiarity with a number of issues. The following paragraphs discuss some of the issues that should be addressed when scanning your images.

SCAN IMAGES AT A HIGH RESOLUTION AND SAVE A HIGH RESOLUTION VERSION. One of the best things you can do to improve the overall image quality is to scan your images at a resolution at least twice as high as the one you will need onscreen. Since most multimedia and online projects will be displayed on standard monitors at about 72 ppi, a good rule of thumb is to scan your image at about 150 ppi. However, this works best when you intend on using the graphic at about the correct size (100%). If you intend to enlarge the image, you should scan your image at a higher resolution. For instance, an illustration to be used three times larger should be scanned at about 450 ppi (3 × 150 = 450). Later, you can correctly size the image and then reduce it to approximately 72 ppi (a standard display resolution for monitors).

Some individuals recommend scanning images at screen resolution, and are vehemently against scanning images at a higher resolution. Their argument is that the larger images take up unnecessary storage space, and since the computer only displays 72 ppi, the extra image information is unnecessary. If storage space is a critical issue, this is a pragmatic approach to keeping your hard drive lean. If storage space is not an issue, however, or you have a good backup system for archiving files (the author uses a Compact Disc writer, purchased for under $600, to back up all files) scanning your images at a high resolution is recommended for the following reasons:

1. Scanning images at a high resolution provides greater long-term flexibility. Computer technology is constantly improving, and so will the display resolutions of monitors. Saving a version of a high resolution file will eliminate the need to rescan an image for use in a future version of your document that will be viewed on a high resolution display system.

2. High resolution images can be reused in other media, such as printed materials advertising your product. 72 dpi resolution images printed on paper tend to look crude next to the standard 266 dpi (or higher) resolutions used in a printed image.

3. If you later choose to slightly enlarge an image in the interface, you can go back to the original high resolution file, size the image, then resave it at 72 ppi to use in the authoring program.

4. Reducing the image later to a lower resolution helps to "clean up" unwanted dust specks in the image.

Figure 5-32 This figure shows the results of increasing the resolution in an image. The top image is the original; the image on the bottom shows the image after the resolution has been increased by a factor of 2. Increasing the resolution in an image commonly results in pixel-blurring.

REDUCE RESOLUTION IN THE IMAGE USED IN THE INTERACTIVE PROJECT. While it is recommended that you scan and save images at a high resolution (for greater long-term flexibility), *it is absolutely critical that you reduce the size of your image before placing it in your interactive project.* Since most monitors only display around 72 ppi (that is, 72 available pixels per linear inch), the image should be reduced to that resolution. If your image has higher resolution, the monitor will enlarge the image. For instance, an image that is saved at 150 ppi has more than twice the number of pixels to display; consequently, in order to display all of this information, the monitor must enlarge the image. A 72 ppi image, in contrast, will show at actual size because of the one-to-one mapping display of the image pixels into the monitor's pixels.

AVOID IMAGE DEGRADATION. One technique to rigorously avoid is to take an existing image file and increase the resolution. Increasing the resolution in an image makes the image appear to blur. This degradation of the image occurs because boosting the image's resolution means the computer has to add information to the image file. It adds the information by averaging the values of neighboring pixels, creating new pixels based on those values, and then inserting (interpolating) the new pixels in between them (see Figure 5–32). It is a much better idea to start with a high resolution file, because you can always lower the resolution later if needed. Scan high, save low.

Another quick way to severely degrade the quality of an image is to take a small image and enlarge it in the authoring program. For instance, taking a 72 ppi image saved at 1" × 1" and stretching it in the authoring program to the full 13" screen dimensions will distort your image and make gigantic bitmapped edges appear. If the image needs to be large, it should be scanned and saved with enough resolution that it can be stretched without much distortion.

INTEGRATING IMAGES INTO THE INTERFACE

You may want to intergrate all sorts of images into your interface, including scanned photographs, special-effects photographs, cartoons, charts, illustrations, 3D computer-generated renderings, and so on. The source and type of the images are not as important as how you integrate them into the interface. Whatever the image,

it should not only communicate content, but also look good both individually and with other elements onscreen.

Standalone Versus Layered Images

Interactive documents are dynamic, and images onscreen are constantly changing. The contents of an entire screen can change, like when a user flips to the next "page" or screen in an electronic book. At other times, only certain individual images or elements change, like when titles fade onto the screen over other images.

Graphics can be used either as standalone images or as layered images. Standalone images can begin as an individual picture like a photograph or a scanned piece of artwork (see Figure 5–33). Standalone images such as photographs are easy to place and move around onscreen. Layered images are individual elements that are designed to work together as part of a larger interface (see Figure 5–34). Using layered images adds flexibility and enhances the control you have over the interface. With layered images you can easily move individual images around onscreen, reuse them in other screens, or apply interactive functions to the image.

Since layered images are saved as individual graphics, they are easily transferred to other projects and used over and over again. A series of electronic children's books, for instance, might deliberately reuse characters and images to set up a trademark style as well as thriftily get the most out of their labor investment.

Use Images as Interactive Elements

Using images as interactive controls adds visual interest to the layout and is a good way to provide feedback to the user. Images are commonly used in imagemaps and multi-state buttons, which clue the user in to interactive possibilities. If an image has interactive potential, for instance, it might highlight or briefly animate when the user rolls the pointer over it (see Figure 5–35). In this way, images can add visual interest to the screen *and* enhance functionality.

DO'S AND DON'TS WITH IMAGES

Now that you are more familiar with what you can do with

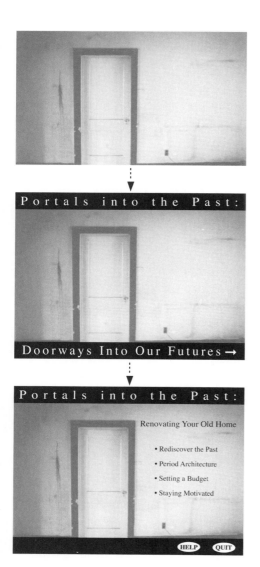

Figure 5-34 Layered images are easy to reuse in other screen designs. They can also later have an interactive function assigned to them (such as reused as a button). Layered images offer maximum flexibility in design.

Figure 5-33 Standalone images such as this door (top) are easily used in several screens (middle, bottom). Standalone images are easy to place and move around, but if you want to use only a portion of the image, you will have to create a custom image in an image-processing program. (*Courtesy Lori Walther.*)

Figure 5-35 An example of an image that "highlights" when the user's pointer rolls over it, letting the user know the image has an interactive function assigned to it. (*Courtesy Leslie Nelson.*)

images, here is a list of do's and don'ts to serve as a quick reminder.

1. *Do use standard display resolution.* Currently, this is around 72 ppi for Macs and 96 ppi for Windows computers. As technology improves, so too will display resolution, but for now, most stock computers display 72 to 96 ppi.

2. *Do work with layered images.* Using layered images offers maximum flexibility and control over the visual layout. Layered images also can be reused throughout your project to help establish a unified visual style.

3. *Do use aliased images in layered elements.* Remember, anti-aliasing creates a color transition between the foreground color and the background color. If your image is intended to function as a layered element, you should not use anti-aliasing, as that transition of color will be easily visible. An aliased image can be easily placed on a wide variety of backgrounds.

4. *Do use anti-aliased images in standalone images.* Use anti-aliased edges if (a) your image is part of a standalone image you created on the computer, such as an illustration; (b) the image will not be moving across the screen; or (c) the screen will not be changing behind the image. If one of these conditions exists, you can enhance the look of the image by anti-aliasing the edges.

5. *Do remember the capabilities of the user's equipment.* Don't make images that are so big (in terms of file size) that playback speed is adversely affected. Also keep in mind that most stock computers can currently display only 8-bit color files. Therefore, placing 24-bit color files in your document is unnecessary and, in fact, can dramatically slow down playback speeds.

6. *Don't think good images will mask poor interface and programming design.* While it is true that great images will enhance a design, even the best images can not save a product that is riddled with programming flaws.

7. *Don't take a small image and stretch it to fill a whole background.* Doing so will cause the image to horribly degrade and show gigantic bitmapped edges.

8. *Don't overload your screens with too many images.* Too much of a good thing can overload both the user and their equipment (such as when there are so many layered images the computer has to struggle to load them). This is a particular problem in online design where it takes time to download every image. Often simplicity is best.

9. *Don't unify your images to the point that they look all the same.* The goal is consistency, not to make everything look identical.

10. *Don't make every image flash, buzz, beep, whir, rotate, flash, change color, or otherwise move onscreen.* This is similar to number 8, but is placed here as a reminder that often simplicity is best.

Overall, working with images can be difficult but rewarding. Good graphics can tie the elements of your interface together and help you establish a unique style and character to your project.

TIME-BASED MEDIA: ANIMATION, VIDEO, SOUND, AND VIRTUAL REALITY

OBJECTIVES

- To gain a better understanding of the unique issues and concerns of integrating time-based media (media that plays over time) into your interactive documents
- To comprehend the difference between analog and digital time-based media
- To become familiar with a selection of the basic terminology of animation, video, sound, and virtual reality
- To learn about sources of video
- To learn about sources of sound
- To learn a selection of basic principles of designing for virtual reality

ANIMATION

Animation is a rapid sequence of images that, played back quickly enough, give the illusion of continuous motion. Animation is widely used in interactive documents, and it is often the best way to present concepts that are difficult to understand or capture on video. For instance, the designer of a CD–ROM about volcanoes might hire an animator to create a sequence showing how fissures in the earth's core allow molten magma to seep into underground tunnels in a volcano. In this situation, it is both dangerous and difficult to obtain photographic images of the volcanic process; it is much easier to create and present the process in animation form.

Animation is represented by two main branches: 2D and 3D animation. 2D animation is an evolution from the traditional animator's art of drawing flat images frame by frame, while 3D animation lets the animator create and present modeled objects and scenes within the computer's digital space (see Figure 6–1). 2D animation tends to look more "flat" than 3D animation, and has a tendency to look more stylized and cartoonish (see Figure 6–2). 3D animation, on the other hand, can appear more realistic (see Figure 6–3).

Figure 6-1 This 3D animated sequence of a bouncing ball was completely generated in the computer's digital space.

Figure 6-2 This animation sequence depicts the flat look characteristic of 2D animation.

ADDITIONAL RESOURCES

Principles of Three-Dimensional Computer Animation, Michael O'Rourke, W.W. Norton & Company, 1995. An information-intensive book that covers the techniques and principles of 3D computer animation without talking about specific software packages.

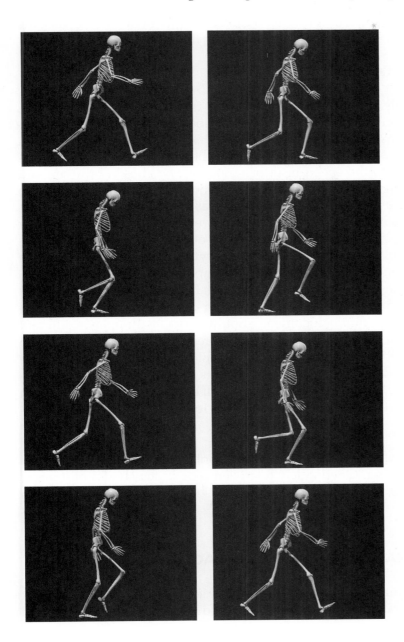

Figure 6-3 This 3D animation sequence, created in Fractal Design Corporation's excellent figure modeling program, Poser 2, shows a very realistically modeled image of a walking human skeleton.

ANIMATION IN INTERACTIVE DOCUMENTS

Animation can be integrated into almost all interactive formats—games, presentations, kiosks, electronic books and magazines, and online web pages. Rotating logos, animated imagemaps, flip book images, shifting textures, and many other animated elements onscreen can add excitement and enhance the fluid interactive look and feel of the document.

Online Concerns

While animation integrates easily into multimedia documents, it is more difficult to add to online documents. Online technological limitations affect the playback speed of animation. Technological limitations include the capabilities of the user's computer, the speed of user's modem, the chosen browser, and the plug-ins supported by that browser (plug-ins are used to enhance multimedia features, such as sound playback).

Online documents have to play well not only on older, slower computers but also on newer, state-of-the-art, faster multimedia-capable computers, and on everything in between. Online "surfers" hook into the web with computers ranging from 486 DOS machines to ultracurrent multi-megahertz graphics-, video-, and sound-capable multimedia computers. To further complicate matters, the online document should work with many different browsers, which have widely different animation interpretation capabilities. As a result of these technical problems, animation has not fared as well in online documents as it has in multimedia documents. Undoubtedly, animation will become more widespread in online documents as the technology to support it advances.

> **Tip:** Downloading movies and animation online can be very time consuming. Offering low resolution clips or thumbnails of frames lets the user choose whether to play the full resolution clip or not.

ANIMATION IN THE INTERFACE

Animation in the interface can range from full-screen complex 3D work "dropped in" like video, to limited motion in type and

interactive controls. Animating the screen can add impact to your interactive document by:

❏ highlighting important information by focusing attention to the animated element;

❏ leading the user through a sequential presentation of information. Lines of type can fade in or out of the screen, important elements can animate while less important elements remain static, floating arrows can indicate critical information while a narrator's voice describes important points;

❏ informing the user of available interactive functions by switching out one image for another when the pointer "rolls over" hot spots;

❏ adding "oomph" to the document. For example, animated elements in an child's storybook enliven an impression of silliness, playfulness, and fun;

❏ explaining complex information that may be difficult or impossible to capture on video. A sequence describing the shifting of continental land masses over millions of years is clearly impossible to capture on film, and therefore, being able to animate the process may be the only choice to visually show it; and

❏ enticing the user to try an interactive control. Some interactive documents are preprogrammed to animate selected screen elements if a certain period of inactivity has passed without any keyboard or mouse clicks, thereby attracting the user's attention.

There are many other ways to creatively use the power of animation in your document. A good animator can animate almost any concept. However, animation thrown onscreen without a firm concept behind its use is an attractive, but expensive, luxury. And no matter how exciting or visually appealing the animation, it cannot hide basic functionality problems in the interface.

COMMON ANIMATION EFFECTS

There are many ways to add animation to an interactive document. Listed in this section are some common animation special effects, including animated interactive controls, color cycling, loops, flip books, sprite animation, rolling textures, filter animation, transitions, morphing, warping, and dropped-in animation.

These special effects are discussed here because they are useful additions to an animator's basic creative techniques.

Animated Interactive Controls

Animated interactive controls can add excitement to the interactive document, provide necessary feedback to the user, and suggest a viewing order of the information. Adding motion and color to buttons, type, and imagemaps is a relatively easy way to achieve visual impact.

Hot Spot

Two common effects are buttons that display highlight states and "rollover" states. Highlight and rollover states are activated by the user rolling the pointer over the hot spot of the interactive control. A **hot spot** is an area in the interface that has a current interactive function assigned to it, for example, a button or an imagemap. Hot spots that use a highlight state usually switch to a second color as the user rolls the pointer across them, then change back after the pointer leaves the perimeter of the hot spot (see Figure 6–4). Hot spots that use rollover states can change colors, textures, and form, or can display a short loop animation—just what the rollover state displays is really limited only by the animator's imagination.

Figure 6-4 A simple hot spot that changes color when the user's pointer crosses over the boundaries of its space.

Animating hot spots onscreen also helps tell the user what is clickable. If a user knows that a button will do something or lead them to another (and maybe very interesting) screen, they may be inclined to explore the interface further. This natural human curiosity can be used to help suggest a viewing order to the user. For instance, if on a particular screen, it is fairly important that the user click on a topic imagemap, then you can assign an animated loop to that imagemap while other imagemaps onscreen stay static. A moving imagemap has a higher possibility of being noticed and selected first than does a static imagemap. Once the user returns to that screen, the next most important imagemap may become animated, suggesting to the user that it should be clicked next.

Loops

Loops are short animated segments that repeat a specified number of times (see Figure 6–5). Loops are effectively used in online documents, usually represented by the "spinning logo." The disadvantage of loops in online documents is that if the loop is very

Figure 6-5 The basic images used in a simple animated loop. *(Courtesy Leslie Nelson.)*

long, it prolongs the download time. Many designers, however, feel that loops add excitement to the screen design.

Color Cycling

A limited form of animation can be achieved by using palette flashing. Palette flashing happens when the computer transitions between displaying one color palette to another. Normally, this effect causes unsightly and unpredictable color changes in the image; however, this effect can be used in a controlled manner. To provide the illusion of movement, two or more nearly identical palettes can be created with a few colors changed in certain squares. As those palettes are loaded onto the screen, the images referencing those palettes will undergo palette flashing. This controlled palette flashing is called *color cycling*. As can be seen in Figure 6–6, the changes of the placement of values of pixels can suggest movement.

Rolling Textures

A rolling texture contains a sequence of slightly different texture images that, when applied to an element onscreen (such as a background or type), lends a subtle sensation of movement to the

Figure 6-6 This image of arrows uses a palette of three colors. Notice that the palette was duplicated several times, and the color distribution (here shown in black and grays) within the duplicates was changed. By doing this, every time the image of the arrow encounters one of these palettes, the image will remap to the altered palette. If the palettes are swapped out quickly enough, the arrows will appear to animate.

Figure 6-7 An example of rolling textures within type.

interface (see Figure 6–7). Rolling textures can add visual excitement to the document and entice the user to look at that element.

Rolling texture maps can also be applied to 3D surfaces to add a sense of texture and movement to the environment (see Figure 6–8).

Figure 6-8 Textures applied to a 3D object. *(Courtesy Lori Walther.)*

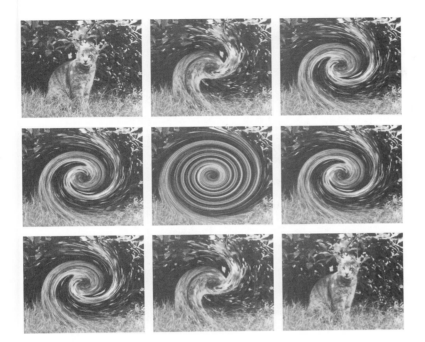

Figure 6-9 A "twirl" filter was incrementally applied to this photograph. By rapidly changing out these images on screen, the image appears to animate.

Filter Animation

An incredibly simple and effective technique to add animation to your file is to gradually apply filters from an image-processing program to your images (see Figure 6–9). Depending on the selected filter, the results can be subtle or dramatic.

Transitions as Animation

Fades, dissolves, wipes, and other transition effects are quick ways to simulate animation in screen elements. Transitions can be applied to the whole screen or to individual elements within that screen.

A good transition is subtle and rarely catches the user's attention; bad transitions are quickly apparent. For instance, overuse of a flamboyant transition effect such as "checkerboards" can rapidly annoy the user.

Most authoring programs have a decent selection of transition effects available—from wipes to venetian blinds (see Figure 6–10). Simple dissolves and fades are subtle and can be used over and over again unobtrusively to link topics screens together.

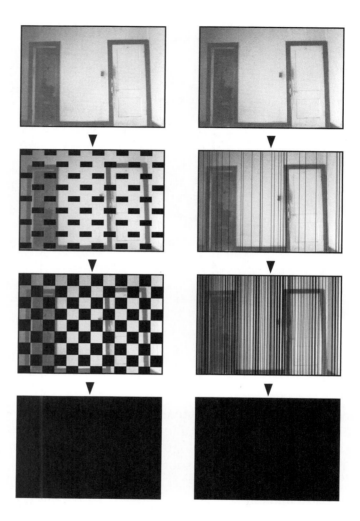

Figure 6-10 These two sequences show two different transition effects—"checkerboards" and "random stripes."

Morphing and Warping

Morphing is the gradual merging of one image into another (see Figure 6–11), while **warping** is the controlled distortion of an image (see Figure 6–12). The basic technique of morphing an image involves the selection of a sequence of points in two pictures (for instance, defining the edges of the chin in both pictures). The program then creates the in-between steps.

Many animation programs allow you to easily warp an image by placing a sequence of control points around an image (usually a rectangular box) and pushing the image around by moving

Figure 6-11 The image of the smiling bug (a) has been morphed into the image of the frowning bug (d). Images b and c show two in-between images generated by the morphing process.

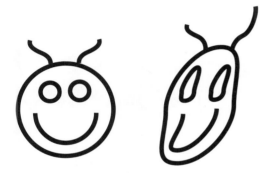

Figure 6-12 The original image (a) and the warped image (b).

the points. To record this animation, you would have to periodically save the image, then have the animation program replay the sequence of frames to show the warping of the image.

Rendered Animation

Rendered animation is animation that is too complex for the authoring program to play back in real time. Figure 6–13 shows an example of a rendered image. Rendered animation is added to the interface in the same manner as video clips.

VIDEO

Video, like animation, has the ability to show powerful and attention-grabbing moving images in the interactive document. A rich and complex communication medium, video can bring

> Video is an art form and a highly technological endeavor.

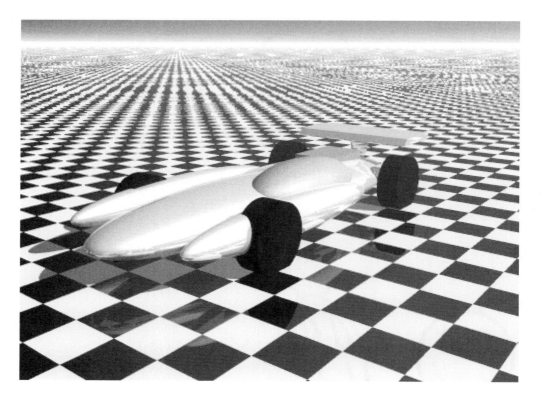

Figure 6-13 A still from a rendered animation sequence.

onscreen reports, action scenes, celebrity interviews, and more into your interactive document. Video integrated effectively into the project adds a sense of dynamic energy to your document; video that plays slowly, runs too long, or has little purpose except to function as "eye candy" can detract from the interactive experience.

ADDITIONAL RESOURCES

The Low Budget Video Bible, Cliff Roth, Desktop Video Systems. A great source for tips on how to shoot, edit, and produce video on a tight budget.

Desktop Video World, IDG Communications Publishing, Peterborough, NH. The magazine covers professional and semi-professional tools.

DV, Active Media, Inc., San Francisco, CA. This magazine concentrates on digital video and multimedia production.

Video is both an art form and a highly technological undertaking, and can be one of the most expensive mediums to produce for a multimedia project. To create professional-level, engaging video requires video professionals, specialized video and audio equipment, and studio facilities. If your goals are more modest, the availability of video camcorders (both analog and digital), computer video cards, and video editing programs make shooting simple video footage for your project a viable option. Be aware, however, that video is widely used in the television and movie industry and, therefore, audiences are accustomed to high-quality video.

Why Use Video?

Video adds enhanced depth of information to an interactive document because images in motion can:

❏ show information quickly, easily, and concisely in a way that text or still images might not. For instance, showing a ten-second short video sequence of two dancers boot-scooting to the Texas Two-Step would be much more effective than a text step-by-step description of the dancers' body movements, foot positions, and enthusiasm;

❏ add a sense of realism to your document by, for example, depicting historical or contemporary nonfiction events;

❏ function as an artistic statement;

❏ teach concepts too dangerous or expensive for users to experience personally;

❏ show places, persons, animals, or events that most individuals would never have the opportunity to view (like snow leopards in their high mountain habitat in Asia); and

❏ add celebrity and on-the-spot interviews, bringing real-life experiences to the document.

SOURCES OF VIDEO

Generally, interactive designers have three major alternatives when searching for video to use in their interactive documents: repurpose existing motion media such as film and video clips, hire a professional production team to shoot new video, or take on the project themselves, using desktop video tools. Each alternative has its plusses and minuses, and unique issues that must be dealt with.

Reusing Existing Motion Media

Searching for existing motion media involves looking at a variety of different sources. Sometimes the client will have existing film or video footage stored in archives. This archived footage can be digitized and reused in the interactive document. Other good sources to search for existing motion media are museums, historical societies, college and public libraries, and research foundations.

When a suitable clip of material has been located, it often must be edited to fit into the format and concept of the new interactive project. Motion media shot for movie release, for example, will have a significantly different sense of tempo and pacing (that is, longer) than the short, fast-paced video shot for interactive projects. In this case, the motion media footage will require rigorous editing to condense segments into short, self-contained video segments suitable for interactivity.

Hire a Professional Video Production Team

Complicated projects with little archive material available may require the services of trained professionals. As stated earlier, video is a tremendously complicated medium that demands the videographer be as much accomplished artist as expert technician. Creating professional-level video is a highly choreographed series of tasks often best addressed by a professional video production team comprised of directors, stage managers, videographers, actors, and editors.

When collaborating with a production team, it is the responsibility of the interactive designer to make sure everyone on the team understands the special requirements of video shot for interactivity. Users expect to be able to interrupt long motion media sequences in mid-play;, therefore, video shot for interactiv-

ity often works best when shot and edited into short, self-contained, modular sequences. This is dramatically different from traditional video, which can go on uninterrupted for a long length of time. Educating the production team to these special requirements early in the process dramatically improves the chances of shooting good, usable video.

After a sample portion of video has been shot, the interactive designer will put together a video prototype. The video prototype is used to quickly test how effectively the video style, length, and story sequences work in the interactive document, as well as to discover any technical limitations. Viewing the video onscreen may affect how lighting, camera work, props, and actors are used in the final version of video shot for the project.

Interactive Designer as Videographer

There may be times when there is no other option but to shoot the video yourself. Making good video is a complex task, and this option works best when the needed video is short and simple. To succeed at this venture, you should have access to a video camera (analog or digital) and have available video desktop tools such as video cards and video editing programs. And, of course, you need to know how to work with actors, lights, and props to create a good composition.

If your primary aim is to develop a quick prototype of a video sequence, you might want to shoot a rough video sequence using an inexpensive video camcorder attached to your computer. In the last several years a growing assortment of digital video camcorders have been introduced into the market. A trip to a large electronics store will most likely reveal an ever-changing selection suitable for quick video. (It seems like every few months a new and improved analog and digital camera product appears on the shelf, as imaging technology is undergoing tremendous change). Figure 6–14 shows a rough video sequence the author shot with an inexpensive digital video camcorder hooked directly into a video card on a PowerMac. The video was then dropped into a quick-and-dirty prototype to test the technology (see Figure 6–15).

Sound quality is also important for good video. Most cameras include built-in microphones, but unfortunately, they do not always record the highest-quality sound. A better choice is to buy, borrow, or rent a high-quality microphone to record sound.

Figure 6-14 A video sequence shot with a cheap video camcorder. The rough quality was acceptable at this point, as it was only intended as a quick way to build a rough prototype. For a more polished prototype, a higher-end camcorder would be necessary.

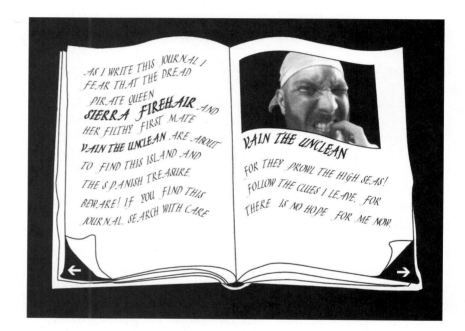

Figure 6-15 This screen shows how the video sequence was placed within this rapidly developed prototype.

Categories of Video

There are two big categories of video: analog and digital. **Analog** video records sound and light waves in a continuous stream, without any subdivisions. Most videotape produced in the twentieth century has been recorded as analog video. **Digital** video records sound and light waves as individual "bits" of information.

Analog video is recorded onto a magnetically charged videotape; when that videotape is copied, the copy suffers a loss of image quality. Digital video records individual bits of informa-

tion to disks or tape; since these bits have a numerical value, digital video can be infinitely copied without generational loss of quality. Digital video, because it already exists in the computer language of "bits" of information, allows maximum flexibility for interactive designers.

INTEGRATING VIDEO INTO INTERACTIVE DOCUMENTS

Integrating video into an interactive project requires more work than finding or shooting good video. The next steps are to reduce the data size of the video clips (motion media is notorious for consuming large amounts of disk space), fit the size and shape of the video window stylistically in with the rest of the screen elements, apply transitions when appropriate, and determine how long the video will play. The following sections explain important information that will help you address these tasks.

Compression

Video data is often enormously detailed, and in order for the computer to access the video information and play it back at a reasonable speed, the data must be reduced in size. A full color frame of video at 640×480 pixels, for example, is about 900 kilobytes. To play 30 frames per second, 27,000 megabytes a second would have to be read, processed, and displayed by the computer. Many computers simply do not have the memory and processing power to play back video at this rate. To play back at a faster speed, the video must be compressed.

Compressing the data streamlines the storage, processing, and transfer speeds of video within the computer. The most commonly used ways of compressing digital video (or, for that matter, still image files) include making the height and width of the image smaller, reducing the color bit-depth to 8 bits or smaller, or using image compression or data compression methods. Image compression methods (commonly called **lossy** compression methods in the graphics field) actually reduce the file size by discarding image data.

Lossy methods remove redundant pixels by comparing adjacent pixels and averaging them together. One disadvantage of the

lossy method is that the more an image is compressed, the more artifacts will appear in the image (see Figure 6–16). **Artifacts** are flaws in the picture such as misplaced pixels, blurred details, and pixel smudges. Images that have been compressed too much typically exhibit numerous artifacts and have large areas of the same color of pixels, resulting in a "blocky" look (see Figure 6–17).

Data compression, commonly called **lossless** compression, searches for redundant file information and removes it, reducing the size of the file. The image itself is not altered, as the compression method only removes nonimage data (usually error-correction file data).

Whatever the compression method used, there is a tradeoff to

Figure 6-16 The top image shows the original, uncompressed image. The middle image has been moderately compressed, while the bottom image has been heavily compressed.

Figure 6-17 A detail from the compressed images in Figure 6–16 showing artifacts.

be made when compressing video. The more video is compressed, the faster the video will play back, but the poorer the image quality. Video with little compression applied to it, conversely, will look better (since there is more data available about each frame), but will require more processing power to display onscreen. It therefore plays slower.

Since different computers have different processing speeds, high-quality video will play well on some computers, while other computers lack the processing power to play it at all. Even on the latest-greatest computer, processors have a limit on how much data can be read and transferred. When that limit is exceeded, the video clip will drop frames, causing gaps and jerks in the motion. And because the processor is attempting to read and transfer complex video data, any other active interactive elements onscreen (such as an animated rollover button) will slow down or pause until the video data is processed.

For now, you will have to experiment to find out how much compression is acceptable, and limit the *frame rate* (the number of frames per minute) to a rate that most of your proposed audience's equipment can play.

◉ Interactive Design Principle

Until the technology improves, you will have to weigh image quality versus playback speed.

Size of Video Onscreen

While large video windows look good, the larger the size of the video window, the more the computer has to work to display it. Large video windows can, on some computers, slow down playback speed and cause frames to drop out. A good compromise in size is the standard multimedia video window size of 320 pixels wide by 240 pixels high, or about a quarter of a screen (see Figure 6–18).

To lessen the demands on the computer processor, this quarter

Figure 6-18 The actual size of a 320 × 240 pixel video window.

screen size is often combined with a slow frame rate (for example, 15 frames per second). The 15 frames per second speed is quoted because, practically speaking, many computers lack the power to process the television broadcast NTSC (National Television Standards Committee) standard of 30 frames per second. This frame rate of 15 frames per second, while far from fluid, does convey the message.

Video Windows

One way to merge video more successfully with the rest of the style and look of the interactive document is to change the shape of the video window. Standard video windows naturally follow the shape of the video frame, a rectangle with straight edges. This standard shape may not always fit visually with the other elements in the interface; at times, a custom shape is desirable. Fortunately, many desktop video programs and interactive authoring programs allow you to design custom masks to the video image to alter its shape (see Figure 6–19).

Duration of Play

One of the decisions you will have to make is how long a video clip will play. Obviously, you want the video segment to play

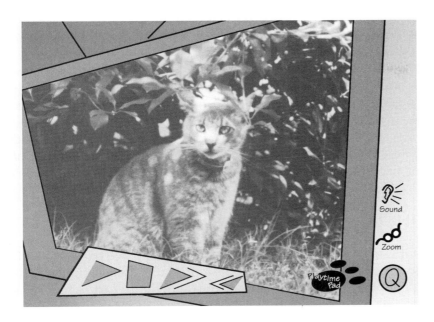

Figure 6-19 Video windows do not have to be a standard rectangular shape.

long enough to get the point across. On the other hand, the longer the video segment, the more disk space the file will occupy (30 seconds of video or animation equals 5 megabytes or more of disk space). This fact becomes critical if there are several motion media clips, such as video and animation, to include into the document. (Imagine how much disk space 30 minutes of motion media could consume!)

> **NOTE**
> A quick way to frustrate the user is to build in a long video clip that cannot be halted or fast-forwarded. Building in interactive controls that let the user stop, restart, and fast-forward the sequence adds to the overall user-friendliness of the product.

Transitions

As mentioned in the animation section, a **transition** is a special visual effect used to ease the changeover from one image or element to another. A transition can introduce changes in subject matter, provide a unifying element to the structure of the project, and enhance the dramatic tempo. Good transitions are rarely noticed, while bad transitions can seem jarring and out of place.

Most users are accustomed to the use of transitions through TV

and film, and understand the conventions of transitions. Most users, for instance, recognize that a *fade-out* (where the scene fades to black) signifies the end of a scene, while a *fade-in* (where the scene fades from black to an image) signifies the beginning of a scene. *Cuts* are where one image simply replaces another onscreen. A cut can be used as a dramatic device, as a straightforward cut is often a startling transition. *Dissolves*, where one image gently fades into another, are often used to link scenes and are an effective way to signify the passing of a short amount of time in the story line.

SOUND

Vibrant sound does wonders for an interactive document. Choosing the right music, narrator, or audio special effects adds depth and richness to the interactive experience just as surely as the right color or picture makes the interface more exciting and meaningful. Sound is an often-overlooked aspect of interactive design. Ignoring the importance and impact of sound, however, is a mistake, as the right sound can make or break a project. Background music can set an emotional tone, dialogue and narration supplement written passages, and sound effects clue the user in to interactive functions (such as a button that "clicks" when clicked).

Choosing the right sounds can open your message to a broader audience. For instance, children with learning disabilities often gain a better understanding of the content if a narrator vocalizes the text. Using a narrator who varies vocal inflections with events in the text quickly conveys emotions and stresses content in unique ways. Good sound, teamed with interesting images, shapes a richer, more meaningful interactive experience than a solely visual interface.

Poorly recorded or chosen sound works against your message. Annoying hisses and crackles originating from low-quality recording equipment can distract and ruin the experience. Inappropriate volume or music choice influences the user's impressions of the message. (Imagine the odd effect of a quiet violin solo playing during an interactive game laser battle.) Choosing an appropriate sound will help focus and refine your interactive project.

Whether you choose to hire a sound designer (the audio spe-

cialist who creates the sound) or tackle recording sound effects yourself, you should have an understanding of basic audio concepts, where or how you can obtain sound clips, and how to deal with basic interface issues such as volume and timing.

ADDITIONAL RESOURCES

The Musician's Home Recording Handbook, Ted Greenwald, Miller Freeman/GPI Books, 1992, San Francisco, CA. A good book that covers the basics of acoustics and recording issues.

SOUND IS ANALOG

When you listen to a live musical performance, you are hearing analog sound. Acoustic sound generated in the real world is always analog, that is, it changes continually over time without discrete steps. In order to use analog sound in the computer, it has to be converted into the distinct steps of digital sound. Digital technology is a relatively new technology, and a great many music segments have been recorded and stored in analog formats.

With that in mind, it is quite likely that sooner or later you will need to convert analog sound to a digital format. This translation process is called *transduction*, which essentially converts the continuous analog signal into discrete digital units. The equipment used to do this is called an *analog-to-digital* converter (or A-to-D). Many multimedia computers have an A-to-D built in, allowing you to plug a microphone into the computer to record sound in a digital format.

Be aware, however, that plugging a microphone directly into your computer and recording sound usually results in pretty poor sound quality. To boost the recorded sound quality, you may have to invest in high-quality sound cards, microphones, and a soundproofed recording room.

> **Tip:** Aim for the highest quality possible in recording sound and video. High-quality data can always be reduced to play on virtually any computer and offers the greatest flexibility for reuse in the future, when the average user's computer will likely have more processing power.

RECORDED DIGITAL SOUND CONCEPTS

Digital sound, like all digital information, consists of **bits** of data—either ones or zeros. The more bits of data recorded, the more accurate the reproduction of the sound. *Sample rate* and **bit-depth** are two terms used to refer to the fineness of the recording of the discrete digital steps. The higher sample rate and bit-depth recorded, the better the quality, and the more of the sound's natural details and range will be preserved. Sound recorded in *stereo* (where the sound is in two channels, right and left) also takes up more data space than *monophonic* sound (sound recorded to one channel) The more true-to-life the sound, the more data space the sound file will occupy.

Interactive sound is often sampled at 22 kHz mono or stereo, at 8 bit. In contrast, most CD-quality stereo sound is often 44 kHz, at 16 bit. Bit-depth is also used in determining the quality of sound. An 8-bit sound recording has 256 different amplitude levels in which to reproduce the sound. A 16-bit sound recording uses 32,768 different amplitude levels to reproduce the sound. As mentioned, the better the sound quality, the more data space the sound will occupy. For example, a minute of 22 kHz stereo recording takes up over 2 megabytes of information; a 44 kHz recording occupies over 10 megabytes.

Sound Formats and Bit Depth

Sound Format	Sampling Rate (kHz)	Sample Size (bits)	Channels	KB/min
CD stereo	44	16	2	10,560
High-end Mac stereo	22	16	2	5,280
Best Mac stereo	22	8	2	2,640
Best Mac mono	22	8	1	1,320

Because CD-quality stereo sound takes up so much data space, it is often acceptable to use 22 kHz sound, at 8 bit. Most stock computers can play back this level of sound. This standard, however, will inevitably change as newer computers are introduced into the market that are capable of handling the increased data space and speed demands of CD-quality stereo sound.

SOURCES OF SOUND

The right or wrong sounds can make or break your interactive document. Finding the right sounds depends on knowing what your options are on where to go to get good quality, properly licensed sound clips. In general, there are a number of sources you can use to get sound for your document. These include using commercial recordings, hiring professional studios for original soundtracks, using prerecorded clip media, or recording and editing some of the sounds yourself.

Commercial Recordings

Oftentimes it is easy to pinpoint a style and mood appropriate for your document in popular music recordings. Simply "acquiring" a version of the music for the project can be tempting; however, acquiring music without permission has legal consequences. A more prudent course is to secure permission rights to use the recording from the copyright holder. Be forewarned, though, that securing permission rights to use popular commercial music is often costly. If your budget cannot stretch to cover this expense, you may want to follow a different course.

Hiring Professionals

A surprisingly viable alternative is to hire professional musicians and studios to create original soundtracks. Smaller studios are often reasonably priced, and often provide composition, performances, and recording services. Many of these studios can also convert analog recordings to digital files. Studio professionals are also a great networking resource; if they lack the time or ability to compose or perform musical scores themselves, they can often refer you to other studios, composers, and musicians.

Clip Sound

A growing number of clip media sources are providing audio libraries. Clip sounds are produced in a wide range of styles and moods, so there is a pretty good chance you will be able to find something usable. Clip sound CDs commonly include musical scores, special effects, and interactive feedback sounds (such as short beeps, boops, clicks, whoops, and whirs that can be linked

to an interactive button or hot spot). In many cases, the permission rights to use these clip sounds can be purchased up front for a limited fee.

An advantage of clip sound is that it is already digitized at several different sampling rates and bit-depths. This digital sound is ready to import into audio editing programs for modification.

Recording Sound

If a suitable sound cannot be located (or if the budget is limited), you may need to record the sound yourself. You will need both good hardware (such as speakers, mixers, microphones, and cabling) and a quiet space in which to record (preferably sound-proofed).

It is important to run a sequence of sound checks to test the performance of your equipment. During a sound check, you will be assessing the performance of the sound talent, where to place microphones for optimum acoustics, and how to eliminate as much background noise as possible. After you have achieved an acceptable balance between all of these elements and have recorded, mixed, and input your tracks into your computer, you are ready to move on to editing the digital sound.

EDITING SOUND

Audio editing programs make accessing and modifying the digital sound a relatively easy task. Because digital sound exists in discrete steps, audio editing programs can translate the digital data into a visual waveform display. A *waveform* is simply a graphical depiction of the amplitude of a sound stretched across time (see Figures 6–20 and 6–21). Knowing how to edit these audio waveforms is an invaluable skill, as many interactive designers find themselves at one point or another having to edit a digital audio track. Common audio editing tasks might include:

❑ replacing one word with another. Sometimes even professional voice talents have trouble pronouncing words properly. With a sound editing program, it is a simple matter to find a waveform that represents a properly pronounced word (if there are any instances of it), copy the waveform, and paste it over the top of garbled word;

Figure 6-20 Two examples of a waveform.

Figure 6-21 A detail of a waveform showing the individual bits of sound.

❑ cleaning up and condensing a narrated passage by trimming out breaths, coughs, or excess "umms";
❑ lengthening a musical score by copying parts of the notes and tacking them onto the end,
❑ creating a seamless music loop to play during periods of inactivity (called a *wait state*). Arcade games, for instance, go for long periods of time without use. Game designers often create a sound and animation loop to try to attract the attention of potential users; and
❑ combining several soundtracks together to form a more complex soundtrack.

Sound editing software also lets you synchronize sounds with visual elements. The lip movements of characters, for example, should coincide with the words they are "speaking." Many audio editing programs provide time readouts to assist in the synchronization of images with sound (see Figures 6–22 and 6–23). Time readouts are also useful as a measurement to help you in determining whether a soundtrack segment is too long and in need of

Figure 6-22 A waveform with a time readout.

|0 **Timecode** |00 :00 :00 :05 |00 :00 :00 :10 |00 :00 :00 :15 |00 :00 :00 :20

Figure 6-23 Example of a time readout bar.

trimming, or whether it should be slightly extended in length. Fortunately, there are a number of good audio editing programs available to do all of these tasks and many more.

USING SOUND IN YOUR DOCUMENT

The decision to use sound in your document should not be left to the last minute. Planning ahead and considering how sound can be reasonably worked into the project should take place as early as possible—ideally as early as the flowchart and storyboard stage. This leaves time for you to determine what style of music, narration, and special effects will fit with your images and message.

> **Tip:** Let the user have the option of turning off sound clips and repeated phrases, or code them to play only a few times per session. If the same "Welcome to the main menu" musical jingle plays every time the user links to the home page, it can become, at best, repetitive and, at worst, annoying.

Music

Imagine exploring the dungeon of a castle in an interactive game. Soft, vaguely ominous instrumental music plays in the

background as your game figure roams through the silent dim corridors, corridors lit only by the flames of flickering torches. When you turn a corridor, the drum beat in the music picks up in volume and intensity. A skeleton warrior appears behind your game figure, and the music rises in volume and speed. Alerted by the change in tempo and volume, you pivot the game figure just in the nick of time and, with a gigantic "whoosh" sound, lob a "magic" fireball at the skeleton. The skeleton warrior explodes with a series of loud dry cracks. Now imagine this scene without any sound at all.

Music has the power to excite and lend emotion to visual experiences. Movie makers have known this for years, and they spend a great deal of time and effort creating elaborate musical scores that play almost continually throughout the whole picture. Depending upon the dramatic impact of the scene, the music can play low during slow portions of the picture, or loud and fast during moments of intense action or drama. Music can help establish a dramatic tempo in a motion picture, and it can be equally as powerful in interactive design.

NOTE

Most interactive projects operate on a more modest budget than multimillion dollar Hollywood movies. Therefore, you will most likely have to deal with a limited budget. A money-stretching strategy is to pick a long musical piece with plenty of instrumental variety. You can either play the piece continually in the background or use segments for different portions of the content. Using segments of the same background score also has the advantage of contributing to a consistent stylistic "feel."

Narration

Choosing the right voice talent is critical in establishing a stylistic "feel" and placing the right emphasis on the content. The right voice can add a personal, warm touch and character to the content. The wrong voice, accent, or inflections can seem inappropriate or even grating to the user.

When working with voice actors, it is important to define what gender, age, accent, and intonations will best enhance the content. This decision is reached by considering the content, audience, and goals of the project.

Another factor to consider is whether an image of the narrator will appear onscreen. A moving image of the narrator can visually distract the user enough that slight flaws in pronunciation or vocal characteristics, such as throat clearings and "umms," go unnoticed. If all the user hears, however, is a disembodied voice, they are more apt to notice vocal flaws as well as be more critical about the length of the narration. Long passages of narration can be especially annoying when there is little opportunity to interact. Voice in interactive documents should be concise, meaningful, and easy to halt or bypass.

Sound Effects

Sound effects can add interest and meaning to images. Imagine encountering the image of a steering wheel and dash of a car. Now imagine rolling your pointer over the key in the ignition and hearing a powerful roar as the engine kicks over. What would be your impression if, instead of a healthy roar, you heard a series of clanks, pops, and a gigantic "BAABOOM!"? Or, if, as soon as the cursor rolled over the key, you heard a loud shrill voice say, "Don't EVEN think about it!"? The three different sound effects result in three different interpretations of the image: the healthy vroom implies a powerful engine at your command, the explosion suggests mechanical failure, and the third effect encourages you to hunker down in your chair in surprise (and guilt if the voice achieves recognizable "mom" tones).

Although sound effects can add depth and richness to the user's experience, if they are used too often or the volume is too loud, they can quickly annoy the user. This experience is comparable to listening to the canned laughter on a television sitcom. If the story line is not funny, it rapidly becomes painfully obvious how artificial the laughter is. Choose sound effects wisely, and use only those sounds that add meaning to your project.

Sound Effects as Feedback

Sound effects can also be used to provide valuable clues about the interface. Transitions from one topic screen to another, for instance, can be accompanied by a short sequence of tones. When used consistently throughout the document, the user comes to associate that sequence of tones with a change in topic matter.

Another way to use sound as feedback is to alert the user to

potential interactions. For example, when the user rolls the pointer over certain areas in the screen, sounds are produced, inviting the user to click on those areas. This could serve to alert the user to interactive buttons or simply encourage the user to stay and explore the screen for awhile.

Synchronizing Sound with Other Elements

Using sound along with other media demands a careful consideration of timing, tempo, and length of soundtracks. Conversations should be properly lip-synched with characters onscreen. Rapid-paced animation should be accompanied by a fast-paced musical score. Music should play neither too short nor too long. Sound that is properly synchronized with other elements will strengthen the overall interactive experience. Conversely, sound that is not synchronized properly will detract from the experience.

VIRTUAL REALITY

ADDITIONAL RESOURCES
Creating Cool 3D Web Worlds with VRML, Paul M. Summitt and Mary J. Summitt, IDG Books, 1995. A good introduction to VRML.

3D Sound for Virtual Reality and Multimedia, Durand R. Begault, AP Professional, 1994. An introduction to 3D sound theory and applications.

Virtual reality is a simulated electronic 3D environment that seems so real that the user's senses interpret it as real.

Virtual reality is considered by some to be the purest refinement of the interactive experience. The potential of virtual reality to offer a simulated 3D interactive environment promises experiences limited only by technology and the creativity of the human mind. In a virtual reality school, children could explore the craggy, desolate surface of a virtual moon. Thrill-seeking gamesters could combat alien creatures in a virtual battlefield. Wheel-chair bound paraplegics could hike up Mount Everest using a healthy, powerful virtual body.

While virtual reality has exciting and vast potential for dra-

matically extending the human experience, in reality (the reality of budgets, time constraints, and the physical world), the current state of technology cannot yet support widespread use of virtual reality systems. Currently, virtual reality systems are expensive and require special equipment such as visors and gauntlets, the programs and programming languages are crude and limited, and commercial applications have met with limited success.

Virtual reality is being discussed in this book due to the *potential* of virtual reality to be distributed as an interactive phenomenon in both the multimedia and online formats. Although the technology does not yet exist to economically distribute virtual reality interactive documents (buying the special visors and other equipment is hideously expensive), the technology to achieve this electronic reality is right around the corner. Anyone doubting this should experience the tremendous impact of the highly detailed and rendered 3D cyberspace of video games. Figure 6–24 shows

Figure 6-24 A prototype screen from a game under development by Push Design Partnership. Notice the 3D modeling of the environment.

a still from a 3D environment developed as part of a prototype proposal for a computer game.

> **NOTE**
>
> The term *cyberspace* was coined by William Gibson in his 1984 science fiction book *Neuromancer.* Computer-based professionals quickly seized the term to describe the electronic world of digital communication. The Internet and the World Wide Web are considered forms of cyberspace.

Interactive designers working on the Internet and World Wide Web have the capability of designing a limited form of virtual reality using a programming language called VRML (virtual reality modeling language, pronounced "ver-mul") (see Figure 6–25). VRML lets interactive designers create 3D objects and integrate them into the web. Despite its name, VRML essentially is a 3D modeling language, and not a true virtual reality experience (see Figure 6–26). It does, however, point to the growing interest in virtual reality as a potential online experience.

```
#VRML V1.0 ascii
Separator {
    Separator {       # Simple track-light geometry:
        Translation { translation 0 4 0 }
        Separator {
            Material { diffuseColor 0.1 0.83 0.83 }
            Cube {
                width   0.5
                height  0.5
                depth   5
            }
        }
        Rotation { rotation 0 1 0  1.58088 }
    Separator {
        SpotLight {
            direction 0 0 -2
        }
        PerspectiveCamera {
            position   -8.6 3.1 5.7
            orientation -0.1462 -0.9773 -0.1341  1.1527
            focalDistance      15.8
        }
```

Figure 6-25 An example of VRML code.

PRINCIPLES FOR DESIGNING FOR VIRTUAL REALITY

Even though virtual reality in interactive documents is in its infancy, it is still possible to begin to rough out a few principles of design for virtual reality. This list is far from complete, but should

Figure 6-26 Two views of a VRML environment.

provide some food for thought if you choose to experiment in creating 3D virtual reality environments in online or multimedia design.

Engage as Many Human Senses as Possible

The five senses—sight, hearing, touch, smell, and taste—are the primary ways with which we perceive the environment around us. Of those five, sight and hearing are the easiest senses to engage in virtual reality environments. Visors display views of the virtual world, and built-in speakers add the ability to hear sounds from the virtual reality environment.

Devices That Enhance the Virtual Reality Experience

The more of our senses that are involved in a virtual reality environment, the more realistic that environment will appear. Virtual reality engineers have developed special equipment to help us experience virtual reality more fully, including:

❏ *head-mounted visors (HMD),* which display views of the virtual world. Built-in speakers play sounds from the virtual environment, while microphones let the user talk to other users;
❏ *body suits* with computerized sensors allowing the user to participate more fully in the virtual reality sensory experience;
❏ *gloves and wands* that let the user pick up, move, drop, and otherwise interact with 3D objects within the virtual environment; and
❏ *multi-control mice, joysticks, and trackballs.*

Provide an Avatar for the User

Even in virtual reality space, people like to have a sense of who they are and what they look like. Therefore, one of the first questions a user will ask when entering a virtual reality space will be "What do I look like here?" Answering this question requires a virtual avatar, or "body representation," of some sort. This avatar may be a human or animal form, a floating crosshair, or any other form the designer creates. Whatever the form, the user should be

Figure 6-27 A view of the user's virtual hand in a virtual reality environment. Providing information such as this helps orient the user to the experience by giving them a point of reference

able to glimpse at least part of it. For example, if the avatar is a humanoid form, the user should be able to see at least a hand (see Figure 6–27).

Let the User Do Something

Another question users will ask when they are introduced to a virtual reality environment is "What are my abilities?" The purpose of building a virtual reality space is to let the user experience this new environment, which requires at least a small ability to move around within the space. It almost goes without saying that a virtual reality space that a user cannot navigate within is not really much of a virtual reality experience. Therefore, two basic abilities in virtual reality are the ability to move around the space and the ability to manipulate objects. These two abilities allow the user to begin to experience, control, and alter the environ-

ment (at least in a small way).

Provide Orientation Clues

It is extremely important to include orientation clues to the user to help them adapt to the virtual environment. Orienting users quickly to the special circumstances of the virtual reality can determine whether the user will be back for more in the future. A disorienting or confusing environment, while attracting a limited audience, will nonetheless drive the majority of users away. The following section details a few ways that you can provide orientation clues to the user.

ESTABLISH A VIRTUAL HORIZON. While we inhabit a virtual world, we also simultaneously inhabit the real world. In the real world, our bodies are constantly under the pull of the earth's gravity, which, together with our inner ears, helps us determine which way is down. If what we see in the virtual environment conflicts with what our bodies are feeling in the real world—for instance, if the virtual world proposes that the "floor" is where our physical bodies are insisting is the "wall"—there is a perceptual conflict. These conflicts can cause disorientation and physical discomfort.

INCLUDE PLENTY OF DEPTH CUES. Including depth cues in the environment helps the user determine the size and location of objects and provides a sense of spatial depth. Railroad tracks, grids, roads, the edges of buildings, and other elements drawn in linear perspective are all good depth cues.

USE METAPHORS TO HELP THE USER ADJUST TO THE VIRTUAL WORLD. Metaphors let users understand the interaction by comparing a virtual reference to a more familiar one. Using a virtual saw, virtual hammer, and other virtual tools to build a virtual home is an example of using metaphors.

You do not, however, have to, build your virtual reality world exclusively on metaphors. For instance, the virtual toolbox that contains the virtual saw and hammer might also contain a couple of mystery tools that the user will have to pick up and experiment with to determine their functions. A few metaphors built into the interface can provide enough clues to help the user be more comfortable in the virtual reality environment.

Create an Acoustic 3D Space with High-Quality Sound

Try to establish a difference between ambient and directional sound. If a sound is supposed to be an ambient sound, then diffuse the noise through the environment. If a sound is supposed to originate from a thing (as in the case of directional sound), then try to have the sound arising from the thing "making" the noise. For instance, it could be somewhat disconcerting to be walking through a virtual barnyard and hear a "cluck" that seems to originate from the vicinity of a virtual cow. Directional sound should actually match up with the object or thing creating it.

THE FUTURE OF VIRTUAL REALITY

While virtual reality is currently difficult to design, implement, and distribute, its promise of expanding the human experience will keep researchers working on refining its forms. In the future, virtual reality could become as influential (and probably more so) than the TV and motion picture industries.

PUTTING IT ALL TOGETHER

In This Part:

CHAPTER 7

■ PROTOTYPE AND TESTING

CHAPTER 8

■ ALPHA, BETA, AND
FINAL VERSIONS OF YOUR DOCUMENT

The most time-consuming and technical portion of the interactive design process is the creation of the project in digital code—and the subsequent testing of that digital project.

The prototype, testing, and production of your document is where you will use all your artistic and technical knowledge to bring all the interface elements, interactive controls, and resource media together in the authoring tool. This is also where, through trial by fire, it becomes clear which design features will work with the technology you have available and which features will not.

And in the end, the best designs will be characterized—as they always have been, no matter what the communication medium—by a clear presentation of the message.

PROTOTYPE
AND TESTING

OBJECTIVES

- ☐ To learn about prototypes
- ☐ To gain a better understanding of the role of the prototype in the design process
- ☐ To be able to make an informed decision about when it is appropriate to develop a prototype
- ☐ To become familiar with the elements, content, and specifications used in prototypes
- ☐ To comprehend the basic factors that will affect a document's performance onscreen
- ☐ To become familiar with the basic issues and concerns of usability and functionality testing

WHAT IS A PROTOTYPE?

A **prototype** is a preliminary onscreen model of the interactive document. A typical rough prototype usually fleshes out one or two topics and navigational pathways that were outlined in the flowchart and storyboard. A more developed prototype explores two or more topics and navigational pathways in full detail. You will need to create a prototype, as it is a critical developmental tool that translates the storyboard into a partially or fully functional digital document. It is also a useful (and necessary) way to test:

- ❏ how well the content is organized and presented,
- ❏ the functionality and usability of interactive controls and navigational pathways,
- ❏ how well media integrates into the interface, and
- ❏ how well the layout design works when applied to multiple screens containing lots of different kinds of elements.

The prototype very quickly points out the strengths and weak-

nesses of your ideas and solutions in all their glory. Oftentimes, creating a prototype is a process of exploration, trials runs, and evolving ideas.

You will find that shaping a prototype is an iterative process as you figure out how to best present the content, work with the authoring tools, and bend the technology to your needs. You may have to develop several prototypes before finding ways that successfully merge all these factors together. Thoughtful experimentation at this stage is vitally important to helping establish the methods and techniques you will later use to integrate the technology, media, and interface design into a functional document.

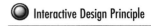 **Interactive Design Principle**

Don't be afraid to experiment. This is still a new medium, and the rules are still being established. Don't be afraid to push the envelope and help define a new way of working with interactivity.

> **Tip:** Assign a time limit to the prototyping process. It is all too easy to overrun project schedules in building and rebuilding prototypes. On the other hand, do not rush through this valuable exploration stage.

In the midst of figuring out how to bend the technology to your needs, you will use the experience of creating the prototype to help give you a sense of how much time, effort, and resources are necessary to create the final document. If there is a client involved, you will convey this information back to them along with the prototype to help sell the project.

What Elements Should Go into a Prototype?

A prototype should include a representative sample of every interface element that will eventually be used in the final interactive document. Each part of the interface will need to fit together into a cohesive and functional whole. A typical prototype might contain the following elements:

❏ *Interactive controls.* A good sample of all the buttons, icons, imagemaps, navigation bars, and any other tools the user will manipulate to navigate around in the document.
❏ *Text.* A selection of headlines, subheads, and text copy shown in the variety of sizes to be used in the document. If text fields

● Interactive Design Principle

Construct prototypes with enough detail that everyone on the team *and* in the user testing group clearly understands how the rest of the project will work

are necessary for large amounts of detailed information, you will also need to include a functional text field.

❏ *Graphics.* A representative sample of photographs, illustrations, diagrams, charts, and any other graphics at the proper size and aspect ratio.

❏ *Video.* A sample of digitized video complete with soundtrack (if used) to test how well it synchronizes with other screen elements and plays on the target platform.

❏ *Sound.* All music, narration, and special sound effects. It is a good idea to test audio on a wide range of different quality speakers. Remember, many users will play back sound through the built-in speakers in their computers. Others will have invested in higher-quality external speakers.

❏ *Animation.* Any motion created outside the authoring platform (such as a rendered computer animation generated in a specialized animation program) and any special effects or screen transitions created inside the authoring platform.

❏ *Virtual reality.* It is vitally important to create a good sampling of a virtual reality environment and thoroughly test it using the same kind of virtual reality devices available to the user.

❏ *Backgrounds.* A good selection of backdrops, not only to test the readability of any type that crosses the background, but also to see how the backdrop helps set the style and tone of the document.

❏ *Windows and panels.* Pick a variety of sizes, shapes, colors, and screen placements to quickly see how windows and panels integrate with other graphics, type, and motion media.

❏ *Any other special visual elements or special effects.* If you are considering using a special visual element or effect in your document, it should be thoroughly tested in the prototype to help determine the usability and functionality of the idea.

WHEN IS IT APPROPRIATE TO DEVELOP A PROTOTYPE?

A prototype usually begins when enough working content has been gathered. There is enough working content available when

there is a representative sample of every proposed media to be integrated into the document, for instance, illustrations, video, sound, and text.

Ideally, this working content is nearly finished and of the same quality as that which will be used in the final document. Realistically, many times the content you will use in the prototype may or may not be in final polished form. Text may be available only in first draft, illustrations may be only partially completed or may need redrawing to better support the concept, and video footage may have been shot quickly to test out compositions and lighting. Such rough items of content often serve as representative "placeholders."

Placeholders are rough samples of content—a hand-sketch suggesting a final piece of artwork, a quick video capture, a snippet of unrefined audio—that are placed into the prototype (see Figure 7–1). Working with samples of content inserted as placeholders speeds up the process of rapid prototyping. For instance, creating sample screens with low resolution imagery and sample type is a good way for you to simulate the "style" of the proposed project, allowing you to gauge the effectiveness of the layout. Furthermore,

Figure 7-1 An example of a rough drawing used as a "placeholder" in an interface.

employing representative samples of content in your prototype allows the testing of how well the content's format and data size integrates with the authoring program. Testing format and media interactions at this stage can help you avoid time-consuming technical problems later when you are in the last big push to produce the final product.

Although not all prototypes need to use highly detailed placeholders or working content, there are times when you should try to use finished content. This is usually the case when working with memory-intensive media such as 3D animation and virtual reality. In part, this is because these media consume massive amounts of disk space, which tends to slow down playback speeds. Experimenting with these media at close to real data size in your prototype helps you plan the best approach to maximize playback speed of these media in your final document.

HOW IS A PROTOTYPE CREATED?

Ideally, a prototype should be created using the same authoring tool and delivery platform on which you will make the alpha, beta, and final product versions. (For more information about alpha, beta, and final product versions, see Chapter 8.) Authoring tools range from computer languages such as C and C++ to simple, user-friendly authoring programs such as Macromedia Director. Scripting the interactive document in C++ naturally has many advantages, including that you can program your interactive document to do almost anything that you can think of. The disadvantage is that the programming process is time-consuming, and you can not learn C++ overnight. So, if you do not have professional experience in programming, you might consider trying a simpler authoring program such as Director.

▣ _____

A Partial List of Authoring Programs

❏ Authorware
❏ Macromedia Director
❏ mTropolis
❏ HyperCard
❏ Apple Media Tool

Authoring Languages

❏ Lingo
❏ HyperTalk
❏ HTML
❏ C++
❏ C
❏ JAVA
❏ Assembly Language

An authoring program is an application that contains preformatted options and a (relatively) simple interface that lets you author an interactive document. There are a number of good authoring programs available; some excel in certain areas (such as handling animation, video, or virtual reality), while others do not. That said, the best way to figure out which one will work for you is to talk to professionals in the field who make interactive documents.

Whatever authoring tool you decide upon should be capable of handling a wide range of media. As stated earlier, your prototype needs to include a representative cross-sampling of all the media that will be used in the project, allowing you to test the compatibility of the media formats with the capability of the authoring program. For example, if you are planning on using video clips in your project, then at some point, the prototype should contain at least one sample clip to test usability and performance.

Tip: Invest in more high-capacity hard drives and backup drives than you think you will need. Original data images, experimental files, prototypes, and backup copies take up a sizable amount of space. Maintaining up-to-date duplicates and triplicates of files will, in part, guard against disastrous loss of data.

After you have a prototype (or several prototypes) put together, it is time to move on to usability and functionality testing. Testing is an ongoing task you will visit and revisit all through the rest of the design and production stage. (For more information about usability and functionality testing, see the sections on those topics later in this chapter.)

Basic Factors Affecting a Document's Performance Onscreen

❏ How much disk space the document needs

❏ How much memory the document requires to run. Too little memory available on the user's computer will result in the product running slowly or not at all.

❏ How fast the user's computer microprocessor runs

❏ The access time of the delivery media. **Access time** is the time it takes to search and retrieve data on the media. Not all media have the same access time, for example, products will run faster off a CD–ROM than off a floppy disk.

❏ The total amount of graphics, video, animation, and other complex memory-hogging media that is built into the interface. More elaborate interfaces tend to run slowly.

❏ The degree to which small images, video, animation, and other media are compressed. Files with little compression look good but play slowly; files with a lot of compression have a poorer image quality but play faster.

❏ If online, how fast the document downloads. Users usually react one of three ways to long downloads: (1) they patiently wait for the complete document to download, (2) they turn off the image-viewing capabilities of the browser and only read the text, or (3) they stop the download and move on to another web site.

❏ The platform the document will play back on and the capabilities of the computer

❏ What special formats are required by the target platform

❏ The resolution of the display screen

❏ Color choices

PROJECT SPECIFICATION AND STYLE SHEETS

A tool useful in helping you apply content consistently through a project is a specification and style sheet. A *specification and style sheet* is simply a listing of project guidelines telling everyone involved with the project how certain media will be handled. For example, the specification and style sheet might

SPECIFICATIONS GUIDE

PROJECT: Basics of Winemaking

FORMAT: Multimedia CD-ROM for PC &
 Mac

DATE: January 3, 1998

PROGRAMS: Director
 Illustrator
 Photoshop
 Painter
 SoundEdit
 Lightwave
 Premiere

SCREEN
DIMENSIONS: 640 x 480, main screen
 320 x 240, motion media

COLOR DEPTH: 8-Bit, 256 colors

SOUND QUALITY: 22Khz, 16 bit

MOTION (fps): 15 fps

 cont'd

Figure 7-2 An example of a project specification and style sheet.

delineate the typefaces, the size of video windows, the color bit-depth, and what kind of special effects are to be used throughout the document (see Figure 7–2).

Not all projects need specification and style sheets; however, complicated projects with several people working on them benefit from this practical organizational tool.

USABILITY AND FUNCTIONALITY TESTING

Usability and functionality testing is an important activity that confirms whether your prototype is sound. **Usability testing** checks the overall user-friendliness of the document by letting a representative group of users from your proposed audience run through the product. **Functionality testing** analyzes how well the product performs on the user's equipment. Testing the prototype of a simple project may be an informal, in-house endeavor completed by the interactive designer and a few colleagues, but more complex projects may benefit from more formalized usability and functionality testing.

◉ Interactive Design Principle

Conduct usability
and functionality
testing to confirm
that your project
performs as desired.

Usability Testing

Conducting usability testing on a sample group of users quickly focuses attention on the flaws and brilliance of your interactive document. Employing actual users to test the document harnesses their fresh outlook to help analyze the usability of the interface, navigation, and interactive controls, and the overall appeal of the project. The results from usability testing can be a surprise to the designer who has been "down in the trenches" dealing with the day-to-day design details, but despite the unexpected surprises, the opinions of individuals in the user group are invaluable. Their opinions can quickly help you determine what makes sense and works in your document and what does not.

One tendency you should avoid at all costs is to provide too much explanation and guidance for the users testing your project. Restrict your explanations to the essentials, and set the user loose on the project. Above all, refrain from grabbing the mouse and showing the user how to perform an action. Keep in mind that you will not be present at the side of every user who uses your document. If a project requires too much explanation or the user cannot figure out how to use or navigate through the document, that is a clear indication that you need to redesign the interface.

> **Tip:** Usability testing is often an intense experience as the users explore the interface design for the first time. Since it is difficult to remember every comment that the testers make about the document, it is a good idea to videotape the session. You can then review the tape at your convenience.

◉ Interactive Design Principle

Let the usability
testers figure out the
document on their
own.

At a certain point in the testing process, usability testing will blur into functionality testing. This point occurs when usability testing takes place on the same equipment that the final audience will use. To truly simulate the final user's experience, you will have to conduct usability testing with the same delivery platform and equipment that your target audience will most likely use to interact with your project. For example, users testing a multimedia CD–ROM should use the same computer platform and kinds of monitors as the final audience—making sure that all resources,

fonts, and extensions load properly from disk and that images and colors display well onscreen.

Content Checklist

The fresh outlook the user testing group brings to the project often provides the impetus to review the relevance of the content. This is a good time not only to decide if the content communicates the message clearly, but also to thoroughly proof the content. The following list is provided as a reminder and a checklist for you when reviewing the content.

❑ Has *all* the text been thoroughly proofread for grammar, flow, and spelling errors?

❑ Is the text, even at small sizes, clearly legible and easily readable?

❑ Are all dates, numbers, and mathematical figures correct?

❑ Are all content items, including text, graphics, sound, animation, video, and so on, properly placed within the interface?

❑ Do all the time-based content items play when they are supposed to? Are time-based elements properly synchronized with other elements, when required? For example, does a soundtrack play for the same length and duration as an animation, or does it start too early or continue to play after the animation finishes?

❑ Do the graphics, buttons, illustrations, diagrams, maps, and so on match up with the appropriate text?

❑ Are all the content items depicted onscreen in the right color and size?

❑ Are the correct versions of the content placed in the document?

❑ Have the copyright permissions been obtained for *all* content?

❑ If required, are the correct copyrights or credits given with the content?

❑ Are all trademarks and logos properly depicted onscreen?

Functionality Testing

Functionality testing checks how well the project runs on the target audience's computers. During this period of testing, the

performance of the project is thoroughly examined by loading and running it on the intended delivery platform and equipment. This means that the project should be thoroughly tested not only on the latest and greatest computer, but also on the slowest computer that individuals in your audience may still be using. If the product runs too slowly or images and colors display oddly, you will have to redesign the project.

As you go on to develop and test your prototype, keep in mind that you want to develop an interactive document that will hold the user's attention and be user-friendly and functional. If the prototype does not fit the bill, this is the time to reassess the game plan and redesign the project. Spending the time to focus the project now will save time and money later in the production process.

Questions to Ask When Conducting Functionality Testing

❏ Does the program load and run successfully?
❏ Can the program compensate for unavailable fonts and other resources?
❏ Can the program compensate for unavailable extensions?
❏ Does the program run reasonably well on a wide range of platforms and different equipment configurations?
❏ Can the program run even in low memory situations?
❏ Does the program conflict with other open programs or extensions?
❏ Do all input devices (keyboards, mice, joysticks, touch screens, and so on) function properly?
❏ Are all output devices (monitors, speakers, printers, and so on) accessible, and do they function properly?
❏ Do all the navigation links function correctly?
❏ Do all interactive controls function correctly and consistently?
❏ What happens when the user inputs unexpected entries?
❏ Are all the icons, dialogue boxes, help screens, text fields, and terminology used consistently and work correctly for each situation, and with each element and object?
❏ Are the images and text readable on a black and white monitor as well as a color display?
❏ Does the size of the screen fit into the smallest monitor with-

out parts of the screen getting cut off?
❏ Are you able to interrupt or skip through all time-based media?
❏ Can the user access the main menu or home page at any time?
❏ Can the user quit at any time?
❏ Does the program end successfully?

A WORD ON PROGRAMMING

Not all projects need the guidance of a professional programmer. Simple interactive documents that depend heavily on the preprogrammed default options available in the authoring platform may not require the attention of a programmer. However, if the plan for the document involves a lot of customized bells and whistles, or the document is intended for release across multiple computer platforms, you should seriously consider securing the services of a programmer.

ALPHA, BETA, AND THE FINAL VERSIONS OF YOUR DOCUMENT

OBJECTIVES

☐ To be able to discern the differences between alpha, beta, and final versions of a project

☐ To be able to identify major flaws in a project

☐ To understand the basic options in dealing with flaws and bugs in a project

☐ To see the importance of reviewing all of the supporting materials for the project

☐ To learn more about the potential of reusing parts of a project in other projects

ALPHA, BETA, AND FINAL VERSIONS

In order for a document to be considered an **alpha version,** it has to have a well-rounded assortment of features, interactivity, and content. All of the initial programming must be scripted, the levels of interactivity clearly defined, interactive controls functional, all links enabled, and, ideally, final content in place. (In some instances, you may still be employing "placeholder" content, as some of the images may not yet be in final form.) The alpha version undergoes the first full testing period, so therefore, it must be nearly complete in scope.

> **NOTE**
> Before entering the production stage, the concept, goals, interface designs, and content should be clearly defined. Changes during the production process can result in cost and time overruns.

During the alpha version, testing goes on continuously to detect any major bugs in the document. (A **bug** is a glitch or problem in the programming or in the compatibility of the hardware and software.) Since the object of testing the alpha version is to

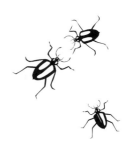

find, document, and eliminate any and all bugs, the testers should keep a log of all problems encountered. The major bugs that testers are on the lookout for are those that crash the system. An interactive document passes a major milestone when all of these crashing bugs have been found and corrected.

When several rounds of testing and finessing the document have passed and the document works as it was intended to—in other words, the system does not crash, all interactive controls function and lead where they are supposed to lead, and all the content plays—then it is time to officially classify the document as being in beta version. The **beta version** is the last chance for production and testing before the project is ready to master and distribute.

During the beta version, the focus is on getting the project ready for distribution. All the features should be finalized an, all of the remaining programming flaws debugged. Only after these activities are completed can the project be considered in final version. The **final version** is exactly that, the last version of the project, finished and ready to be mastered and distributed. If the project was commissioned by a client, normally this would be the end of your tasks (at least until the next version, which is discussed later in this chapter). If the project is one that you have taken on yourself, you will have to follow it through the mastering and distribution process.

In the case of an online document, the site is completely finished and ready for web surfers. In the case of a multimedia CD–ROM project, this final version is burned onto the master disk—the **golden master.** This disk is the master from which all subsequent discs will be duplicated. After duplication, the project is assembled (packaged) and distributed.

HOW TO DEAL WITH FLAWS AND BUGS

Inevitably, the complexity of all of the elements going into your document virtually guarantees that there will be flaws and bugs. Bugs range from minor problems such as a highlight button not highlighting to major problems that crash the machine. The best way to deal with the multiple flaws and bugs that come up during the alpha and beta testing process is to record and track the errors (see Figure 8–1). This is especially critical when there are numerous people involved in testing and correcting the document.

ERROR LOG

Project: *Personalized Architectural Walkthroughs*

BUG NO.	WHO FOUND	VERSION	LOCATION	DESCRIPTION	COMMENTS	FIXED	
						Yes	No
15	Curt	Alpha	W.3.4	Click on Wireframe Button & machine Crashes.	CANNOT FORCE Quit		X
16	Curt	"	W.3.5	Sound Does not play			X
17	Curt	"	W.3.5	Sound skips	I think the sound should be replaced		X
18	Curt	"	W.3.7	Image missing	Replace Doorway Wireframe		X

Figure 8-1 An example of an error log.

A good record of errors will include basic information such as a description of the problem, the actions performed right before the problem occurred, what kind of machine and platform the problem showed up on, which version of the program was tested, and who performed the testing. Without this information, hours can be spent trying to repeat the bug or to fix a problem that has already been fixed.

There may be occasions when a bug is so severe that it cannot be fixed by the project deadline. You have several options at this point, including:

❏ deleting the programming or feature that is suspected to cause the problem;

❏ hiring additional support personnel (such as programmers) to work round-the-clock to fix the problem;

❏ if possible, rerouting around the problem;

❏ ignoring the bug and hoping the comments that come back from the reviewers are not too bad; or

❏ missing the deadline and redesigning the feature.

Hopefully, if the document has undergone rigorous and ongoing testing, you will avoid having to make one of these decisions. Test early and often.

A LAST WORD ON TESTING

As has been repeatedly discussed throughout the last two chapters, testing is an ongoing task that continues from the prototype through to the final version of the document. This point cannot be overstressed, as testing early and often is the best way to avoid costly redesigns in the eleventh hour of the project deadline. As you move toward the final version of the project, however, the testing should become more intensive and cover as many "What ifs?" as you (or your colleagues) can imagine. For example, in a multimedia game that can be played over a network, how many users can log on and participate in the game before the game's performance speed is affected? How is the overall speed affected when users on fast computers and users on slow computers are sharing the game on a network? Or what happens when someone pulls the plug on one of the computers while playing the game? As you can see, testing the interactive document thoroughly requires keen attention to detail and deep thought on how, where, and who will be interacting with the document.

Testing also includes any supporting materials that accompany the document. Since these materials contribute to the overall impression of the quality of the product, they should be created and proofed with as much attention to detail as the document itself.

■ ───────────────────────────────

Don't Forget to Review the Supporting Materials

It is easy to forget, in the rush to complete a project, to thor-

oughly proof and test any supporting materials bundled with the document. The following list highlights a few points you should consider before releasing the final product.

- ❏ Are all of the printed materials easy to understand?
- ❏ Has the copy been proofed and edited?
- ❏ Are the installation procedures clear, easy to follow, and correct? (There are few things as annoying as following installation procedures to the letter and still not being able to get the document or program to run!)
- ❏ If screenshots or motion media stills (from video, animation, and virtual reality) are used in the documentation, do the positions of the stills match what the user will see on the screen?
- ❏ Does the terminology used in the manual or installation materials correspond with the terminology used in the interactive document?
- ❏ Are the company address and phone numbers for technical support correct?
- ❏ Are all of the images, motion media stills, and screenshots in the documentation and product advertising from the final version of the interactive document?

THE NEVER-ENDING PROJECT

◉ Interactive Design Principle

A well-defined set of project goals and specifications will help you know when to stop testing.

One danger to ongoing testing is getting caught up in an ongoing loop of refinement after refinement. The way to avoid this loop is to make sure you have composed a list defining the project goals and specifications. This list will help you determine which features, programming, and interface problems really need to be fixed before releasing the project, and which ones can be left alone. Most projects have a number of flaws in them; even major programs may have multiple bugs. If the product runs without crashing the machine, everything is functional, and the major bugs have been fixed, time and budget constraints may dictate releasing the project.

Keep in mind that the ideal interactive document will be perfect, with *absolutely no flaws or bugs*. In reality, most projects will have a few flaws. Too many flaws, however, and there will be

user complaints and poor reviews. The overall points to keep in mind are to come up with a good concept, schedule plenty of time and money to complete it, test and test again, and release a document with as few flaws as possible.

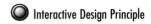 **Interactive Design Principle**

Know when to stop testing and refining your document.

REUSING PARTS OF THE PROJECT

After your project has been released and it has been well received by the users, the potential exists to reuse the most successful features in a new project *or* make a new version of the document. Keep in mind, as you consider these options, that this is a great opportunity to correct any problems that slipped through the cracks in the first release.

One of the major advantages of making a new version of your document is that you have overcome that initial steep learning curve. The technology is more familiar (even though parts of it have inevitably changed with new versions), you have experienced the planning and implementation process, and you have the existing document after which to pattern a new document. Having a firm understanding of the entire interactive design process, you can often create the next version (or project) with a significantly lower developmental cost and a shorter schedule.

The creation of the final versions (or even a second version) of your document is a time of intense work, testing, and excitement at the possibility of finally getting the document "out there." You will participate in an ongoing loop of testing, revision, more testing—and if all goes well, your document will join a growing group of interactive documents experienced by an ever-enlarging user audience.

Glossary Of Terms

A

Access time The time it takes to search and retrieve data from the computer hard drive or media.

Aliased The transition between one area of color or tone to another. Normally used to describe the jagged, stairstepped edges of lines, shapes, text, or objects onscreen in a raster-based program.

Alignment Aligning elements onscreen so that the viewer can draw visual connections between the edges or axes of type, images, lines, shapes, or any other element.

Alpha testing An intensive testing period during which the software or interactive document is examined for functionality and correctness of information.

Alpha version The first complete (or nearly complete) version of the product.

Analog Information in a continuous signal without discrete substeps.

Animated button A button that displays an animation sequence, either before or after being clicked.

Animation A rapid sequence of images that, when played back quickly enough, give the illusion of continuous motion. Animation used in interactive documents typically is either 2D animation or 3D animation.

Anti-aliasing The technique of slightly blending the colors in the edges of an object with the colors in the background in order to achieve a smoother, more natural-looking edge. Anti-aliasing smoothes out the stairstepped edges of an aliased object.

Archiving Storing digital files for backup or long-term purposes.

Artifacts Flaws in digital pictures such as misplaced pixels, blurred details, and smudges.

Audio (Sound) In interactive documents, this includes narration, music, sound effects, and ambient sound.

Authoring program The program used to choreograph content

and build an interactive interface and document. Authoring programs usually contain a number of preformatted options and a relatively simple interface.

B

Balance An equal distribution of visual weight within a screen layout.

Banding The visible break within a gradient of colors.

Bandwidth The capacity of a data transmission cable or a computer channel. Bandwidth is often expressed in bits or bytes per second.

Beta testing The second testing period of a software product.

Beta version Beta versions of software are released to users for real-world testing prior to the commercial marketing of the software.

Binary A digital data system with two possible states, on or off, represented by 1 or 0.

Bit Each binary place is called a bit. Bits are arranged in groups of 8.

Bit-depth The number of bits used to display black and white, grayscale, or color values onscreen.

Bitmap A digital image made up of pixels or dots.

Body copy The text portion of an interface that provides more information about content. Body copy is typically smaller than headline type.

Browser A computer program used to view online documents. The program reads and interprets the computer language used to build each document.

Bug A glitch or problem in the programming or in the compatibility of the hardware and software.

Buttons Interactive controls that serve much the same function as buttons in the real world—when you push a button, something happens.

Byte 8 bits of information.

C

CD-ROM Compact Disk–Read Only Memory. A disk used to

store digital data. CD–ROMs have space for about 650 MB of data information.

Chat Sending messages online back and forth between two or more users.

Clip art Images sold in digital format on disk.

Clip photos Photographs sold in digital format on disk, usually on a CD–ROM.

Clip sound Audio sold in digital format on disk, usually on a CD–ROM.

Clip video Video sequences sold in digital format on disk, usually on a CD–ROM.

Color Light energy in the form of waves and particles that is interpreted by the human eye as mixtures of red, green, and blue.

Color palette The collection of colors available to a program or system.

Comprehensives (comps) A very detailed mock-up of one or more sample screen layouts.

Compression The process of applying special algorithms to images in order to reduce the size of the image file.

Content The information and media used in an interactive document.

Content expert An individual with specialized knowledge about a subject or media who serves as an advisor to the interactive designer(s).

Control panels A group of interactive controls deliberately located together to improve the ergonomics of the interface.

Cross-platform Developing interactive documents to play on more than one type of multimedia player or computer.

Custom palette A specially created palette tailored to enhance the display of a specific image.

D

Database A digital information file structured in such a way that the data can be sorted and retrieved easily.

Debugging Finding and eliminating all programming glitches (bugs).

Decompression Expanding a file from its compressed state to its

original format.

Demographics The social and economic characteristics of a selected group of people, including age, sex, education, and income.

Digital Data represented by discrete substeps called bits.

Dithering A technique that mixes two colors of pixels to simulate a third color. For instance, dithering red and blue pixels can simulate purple.

DPI Dots per inch.

DRAM (Dynamic Random-Access Memory) The dynamic memory that the computer momentarily uses to process data and information. Also known as RAM. Information stored in DRAM is lost when the power is turned off.

E

8-bit color Color displayed using 8-bits of available information per pixel in an image. An 8-bit color monitor is capable of displaying 256 colors at one time.

E-mail Electronic mail sent and received through computers hooked up to a network, Intranet, Internet, or the World Wide Web.

Emphasis The concept that certain pieces of content are more important than others and consequently should be more noticeable than other elements.

F

File a set of digital data created within a software application and stored by a name.

Final version The last version of the project, finished and ready to be mastered and distributed.

Flowchart A diagrammatic box outline of the navigational scheme of the project. Used as an early developmental tool to define the project.

Focal point The most emphasized element or part of a design.

Font The complete collection of all the characters (letters, numbers, and symbols) in a given typeface at a specific size.

FPS Frames per second.

Frame In analog media, a single exposure on a film or video strip.

In digital media, a measure of a complete unit of media data.

Full motion Animation or video that plays at 24 to 30 fps, fast enough to appear in continuous, smooth motion.

Functionality How well (and reliably) all interactive controls, media, and programming in the document perform on the target platform.

Functionality testing The testing process that analyzes how well the product performs on the target platform.

G

Gigabyte One thousand megabytes.

Global interactive control A control used over and over within most of the screens in a document—for instance "next," "previous," "main menu," and "quit."

Golden master The final version of a CD–ROM based project.

Grid A system of guidelines, usually horizontal or vertical lines, that divide up the screen format and provide a way to consistently align elements in your layout.

H

Headline The main title onscreen that is designed to attract the attention of the users.

Highlight button A button that "highlights" when the user clicks on it, typically by displaying an altered graphic.

Home page The welcome page of an Internet or World Wide Web site. The starting point of a series of linked online pages.

Hot spot An area of the screen currently designated as active. A hot spot can have buttons, imagemaps, or other interactive controls parked on it.

HTML (HyperText Markup Language) The set of commands used to format an interactive document for the World Wide Web. HTML specifies how the browser will present the document.

Hypertext A word, phrase, or paragraph that, when clicked, takes the user to another piece of content in the document.

I

Imagemap An image, symbol, or icon with an interactive function (usually a link) assigned to it.

Image-processing program The computer program used to create or process raster files for use in an authoring program.

Indexing The technique of reducing the color bit-depth of an image to a lower color bit-depth.

Interaction speeds How fast controls function and how quickly images and text cycle on timed loops.

Interactive controls These controls add functionality to an interactive document by allowing the user to activate interactive features. Examples of interactive controls are buttons, imagemaps, and hypertext.

Interactive design The meaningful arrangement of graphics, text, video, photos, illustrations, sound, animation, 3D objects, virtual reality environments, and other media in an interactive document.

Interactivity The combination of different types of media into a digital presentation that allows the user to make choices.

Interface The visual layout of content and interactive controls that lets the user interact with the program.

Interface design Designing the interactive features (controls, buttons, navigation bars, and so on) of a document, with emphasis on ease of use.

Internet An international online network of networks. The Internet was originally established by the United States military.

Interpolation A method used to insert new pixel information into an image by averaging the value of existing neighboring pixels.

J

Jaggies A term referring to the irregular, square, stairstepped edges of an object displayed in low resolution in a raster image.

K

Kilobyte One thousand bytes.

Kiosk A multimedia presentation installed for advertising or educational public use.

L

Layout The arrangement of type, images, media, and interactive controls within the interface in a visually pleasing, balanced, easy-to-read, and functional way.

Leading The vertical space between lines of type.

Letterform The style and form of individual letters.

Letterspacing The space between the letters within a word.

Links Connections between content or documents that, when activated ("clicked"), bring that content or document onscreen.

Local interactive control A control that occurs infrequently or only in association with certain topics or media.

Lossless Nondestructive compression and decompression algorithms that keep all pixel information with no degradation of picture quality.

Lossy Compression and decompression algorithms that produce images containing less pixel information than the original source. In some cases, the information subjected to lossy compression and decompression algorithms loses image quality.

M

Main menu The screen that, much like the table of contents in a book, provides a summary of the contents of the document.

Mastering The creation of the master CD–ROM mold, diskette, videotape, or other media master used to make copies.

Megabytes One thousand kilobytes.

Metaphor A reference to an experience, location, object, or tool using the more familiar terms of another experience, location, object, or tool.

Morphing A special effect that merges two separate images into a single image.

Multimedia Combining multiple media into a presentation distributed or played back from a hard drive or a disk such as a CD–ROM.

Multi-state buttons Buttons that, when clicked, display a second visual image or even a short animated sequence.

N

Navigation The process by which a user explores all the levels in an interactive document, moving forward, backward, and through the content and interface screens.

Navigation bar A grouping of global or local interactive controls. Navigation bars, like a drawer in a dresser, expand when "pulled out."

O

Online The state of a computer when it is connected to a network or to another computer via a modem. When you access the web, you are online.

Onscreen Short for "on the screen."

P

Palette A collection of colors available in a color system.

Panel Any shape placed beneath other elements and media such as type or photos to separate them from the background.

Pixelization A condition that occurs when an image is of such low resolution that each individual pixel can be clearly seen.

Pixels Short for "picture elements." The smallest unit on a screen or image that can be assigned value and color.

Placeholders Rough samples of content —a hand-sketch suggesting a final piece of artwork, a quick video capture, a snippet of unrefined audio—placed into the prototype to hold the place of more refined content to come later.

Playback environment Everything that the user can hear, see, smell, touch, and taste when they use your interactive document.

Playback technology The hardware and software used by the user to access and interact with the interactive document.

Point size The height of a letterform, traditionally measured in points. There are 72 points to an inch.

PPI Pixels per inch.

Prototype The preliminary onscreen model of the interactive document.

Q

QuickTime A method developed by Apple Computer for storing and playing movie and audio files on Macintosh computers and Windows computers.

R

RAM Random-access memory.

Raster Images made up of individual pixels.

Real time A term referring to image or audio information playing with little or no waiting for computer processing.

Registration Alignment down to the pixel.

Repurpose Reusing or recycling existing content, either from analog sources or from another existing interactive document.

Resolution The number of dots per inch (or pixels per inch) of a display or image. The higher the resolution, the more detailed the image.

RGB (Red, Green, Blue) The colors a monitor uses to display a full spectrum of color.

Rollover button A button that displays a second image when the user's pointer "rolls over" it.

Roughs Sketches that are more refined than thumbnail sketches. They are typically larger and show a more detailed design layout.

S

Sans serif A typeface without serifs.

Screen real estate Available space onscreen.

Serif A typeface with small strokes on the ends of its characters.

Splash screen The initial screen of a multimedia project that serves much the same purpose as the cover of a book.

Storyboard The screen-by-screen illustration and narration of the content in an interactive document.

T

Thumbnail sketches Small, quick drawings created by designers in order to rapidly capture ideas on paper.

Timeline diagram A planning paper document that shows *what*

will be completed *when* and by *whom*.

Transition A movement from one scene or image to another scene or image. Common transitions are dissolves, wipes, and cuts.

24-bit color Displaying colors using 8 bits of information for red, green, and blue in an image, with a capability of over 16.7 million color possibilities.

Typeface A single set of letterforms, numbers, and symbols unified by a common design. Examples of typefaces are Times and Helvetica.

Type family A set of typefaces sharing the same basic design characteristics, but in different weights, such as regular, light, italic, bold, and ultra bold.

Typestyle Variations within a typeface that expand the design variety of the typeface, such as condensed, expanded, outline, and shaded.

U

Unity Unity is achieved when all of the elements and media within an interactive design look like they belong together.

Usability testing Testing that checks the user-friendliness of the document.

User A person using or performing an action in an interactive document or computer software.

V

Virtual reality A simulated electronic 3D environment that seems so real that the user's senses interpret is as real.

Visual hierarchy Arranging elements and media within a screen layout to establish and emphasize their importance in relation to one another.

VRML (Virtual Reality Markup Language) A language used to describe virtual reality environments online.

W

Warping The controlled distortion of an image.

Web site: Either the server (the computer) that sets up the inter-

active document on the World Wide Web, or the complete interactive document presented by the interactive designer.

Weight The thickness of the strokes of a letterform. Weight includes light, regular, and bold.

Word spacing The amount of space between words.

World Wide Web (WWW, or W3) A portion of the Internet that uses hypertext-linked interactive documents to display graphics, audio, video, and other multimedia content. The web is formed by a scattering of computers located around the world.

INDEX

A

Access time, 194
Additive color method, 104-105f
Aliased image, 84-84f
Alignment, 96-98
Alpha version, 17, 200-201
Analog sound, 171
Analog-to-digital converter, 171
Analog video, 164-165
Animated button, 64f, 64-65
Animation:
 color cycling, 155-155f
 2D, 149-150f
 3D, 149-151f
 filters, 157-157f
 interactive controls, 154-154f
 in interactive documents, 152
 in the interface, 152-153
 loops, 154-155f
 morphing and warping, 158-159f
 rendered, 159-160f
 rolling textures, 155-156f
 transitions as, 157-158f
Anti-aliasing type, 84-84f, 134-136f
Artifacts, 166-167f
Asymmetrical design, 99
ATMs, 31-31f
Audience, 21-22f
 assessing playback technology, 32-33f
 demographic data, 22
 disabled, 25f, 25-28f
 engaging interest of, 29-30f
 market and technology research sources,
 22-23